Late Modern

Late Modern: The Visual Arts since 1945

Edward Lucie-Smith

NEW YORK AND TORONTO OXFORD UNIVERSITY PRESS

FOR AGATHA SADLER

© THAMES AND HUDSON 1969 AND 1975

Library of Congress Catalogue Card Number 75-18959

All rights reserved

Printed in Great Britain

Contents

CHAPTER ONE 'Late modern'	7
CHAPTER TWO Abstract expressionism	25
CHAPTER THREE The European scene	52
CHAPTER FOUR Post-painterly abstraction	94
CHAPTER FIVE Pop	119
CHAPTER SIX Op and kinetic art	164
CHAPTER SEVEN Sculpture: as it was	193
CHAPTER EIGHT The new sculpture	217
CHAPTER NINE Super realism	250

CHAPTER TEN Conceptual art, Environments and Happenir	261 ngs
Text References	278
Further Reading	279
List of Illustrations	280
Index	286

'Late modern'

In 1945, a world war ended. Such dates form convenient dividing lines for the historians of art. In this case, the line is more than merely 'convenient', as it coincides with a genuine crisis in the development of twentieth-century painting and sculpture. It was at about this time that the visual arts embarked on a new course, whose direction might have been difficult to predict in 1939. In part, the changes were due to the war itself. Where so much had altered, art could not expect to survive untouched by events. Europe was battered and exhausted. In the countries invaded by the Germans, modern artists had had great difficulty in surviving. The energies of the Ecole de Paris had been drained by a massive emigration. Meanwhile, the United States had been established (together with Russia, where Stalinism and socialist realism still reigned) as one of the two world powers, and the richer and more powerful of the two. From the early 1930s onwards, the artistic life of America, and especially of New York, had been enriched by wave upon wave of émigrés, in flight from the Nazi terror. These new arrivals were absorbed more easily than they would have been elsewhere, because the population of the United States was itself an amalgam from all the European homelands.

It would be too much to claim, however, that post-war art represented something wholly new and unprecedented. Its roots lay deep in the rich soil of modernism, which had got its start as the century dawned. Indeed, the art we now see being created by our contemporaries seems to me 'late modern' almost in the sense that Giovanni Battista Tiepolo is 'late baroque'. If one accepts that modernism can be regarded as a stylistic category – like mannerism, the baroque, or neoclassicism – then it has certainly had a remarkably long run.

7

Even the second stage of its development, which forms the subject of this book, has lasted for a quarter of a century. This phase, like mannerism, or the concluding phase of the baroque, pushes forward tendencies which were already latent in an earlier, and in some ways more solid and interesting, cultural context. In the strict sense, it has been more notable for taking existing ideas to extremes than for new invention. This process of exaggeration and ossification has produced a number of striking inconsistencies in mid twentieth-century attitudes towards both art and artists.

On the one hand, there has been a continued emphasis on the sacredness of the artist's own individuality. In many cases, this individuality, or sense of uniqueness, has become the subject of the work of art. On the other hand, the artist has wanted to abandon this position, and sink himself in technology; to imitate the procedures of science, and conduct experiments rather than make works of art. While modern art has flourished perhaps most conspicuously in the most capitalist society in the world, that of the United States, the process of democratization has made artists increasingly unhappy with the idea that they

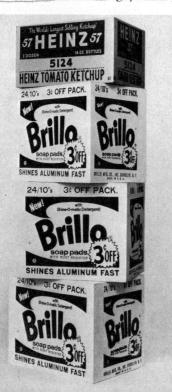

to charry

I ANDY WARHOL Brillo boxes 1964

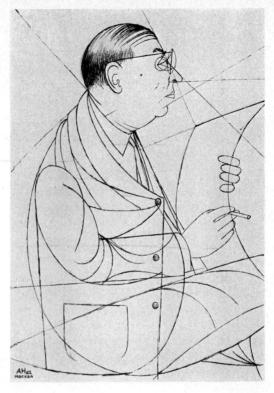

2 ADOLPH HOFFMEISTER Jean–Paul Sartre 1962

are producers of goods for a luxury market – goods whose rarity is reflected by the high price which is asked for them. And yet, again, as the emphasis shifted from the artist's product to his personality, many painters and sculptors have been unable to resist the temptation to turn the human being as well as the work into a marketable commodity. The purchaser of certain kinds of pop art – Andy Warhol's Brillo boxes, for example – is buying not so much an object as a franchise in a certain mode of existence.

The position of the artist as a kind of favoured outcast in our society creates many difficulties for us in our attempt to define his role. Perhaps the most logical way of dealing with it is to adopt the existentialist position and see the man who makes art as one who offers a challenge to the rest of society and at the same time accepts a kind of bet with existence. In his famous

Ill. 1

lecture 'Existentialism is a Humanism', delivered in 1946, Ill. 2 Jean-Paul Sartre avowed that a basic tenet of his philosophy was that 'existence comes before essence - or, if you will, that we must begin from the subjective'. For Sartre, the individual should strive to be 'man to the very limit, to the absurd, to the night of unknowingness'. Though existentialism was the most popular of philosophies in the immediate post-war period, it cannot be said that the artists themselves have succeeded in fulfilling its programmes. What existentialism did do, however, was to promote a general feeling that man was alone in the world, was now detached from all systems of belief, and that the creator must find his salvation in art alone, reinventing it from the very beginning. Hence the somewhat tendentious emphasis on the idea of 'originality' - the artist was willing to have descendants, but not ancestors, and was, to that extent at least, as subjective as Sartre could have wished.

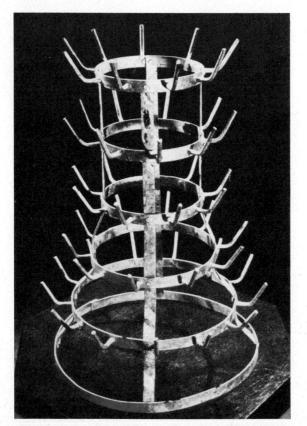

3 MARCEL DUCHAMP Bottle rack 1914

And yet, ironically, the history of the visual arts during the past quarter of a century has been the story of a series of other, narrower -isms and movements, which have succeeded one another in ever more rapid tempo. Abstract expressionism was succeeded by assemblage, pop art, colour painting, op art, kinetic art, minimal art, conceptual art and super realism. The violence and the rapidity of the changes which have overcome the art world have tended to conceal certain basic facts. One is that all these movements represent a resifting and re-evaluation of ideas which were already known before the war. Abstract expressionism is rooted in surrealism; assemblage and pop art reached back beyond surrealism to dada; op art and kinetic art are founded upon experiments made at the Bauhaus; minimal art interestingly combines both dada and Bauhaus influences. Though art has swung from the extremely and almost desperately personal to the coolly impersonal, the terms of the conflict were pre-set. But most of these stylistic 'revivals' differ from the pre-war originals in that they develop and exaggerate the borrowed form, while playing down or entirely jettisoning the content.

Perhaps the most conspicuous example is the relationship of pop art to dada. One of the original dadaists, Raoul Hausmann, remarked gnomically that 'Dada fell like a raindrop from Heaven. The Neo-Dadaists have learnt to imitate the fall, but not the raindrop.' The late Marcel Duchamp was more outspoken, and said in a letter addressed to Hans Richter in 1962:

This Neo-Dada, which they call New Realism, Pop Art, Assemblage, etc., is an easy way out, and lives on what Dada did. When I discovered ready-mades I thought to discourage aesthetics. In Neo-Dada they have taken my ready-mades and found aesthetic beauty in them. I threw the bottle-rack and the urinal into their faces as a challenge and now they admire them for their aesthetic beauty.¹

Ill. 3

These criticisms are just, but perhaps beside the point. Where dada challenged the existing aesthetic and social order, post-

II

war art has built that challenge *into* an order. One symptom of what I have called the 'ossification' of modernism has been the shift from the concept of the *avant-garde* to that of the 'underground'. The underground artist differs from his predecessors of the *avant-garde* in believing himself to be so permanently alienated that little can be done about it. The only solution he can offer is a utopian one, that of setting up an alternative society altogether. Meanwhile, he retreats into a fortress of art about art. Or so he would like to think, for the members of the underground can seldom resist the limelight.

A frontal attack on this attitude was delivered by the leading critic Clement Greenberg, in the course of a discussion of minimal art – that is, art which seeks to shed everything extraneous to the aesthetic process, and perhaps most of that process itself. Greenberg said:

In the Sixties it has been as though art – at least the kind that gets itself most attention – has set itself as a problem the task of extricating the far-out 'in itself' from the merely odd, the incongruous, the socially shocking. Assemblage, Pop, Environment, Op, Kinetic, Erotic and all the other varieties of Novelty art look like so many moments in the working out of this problem, whose solution now seems to have arrived in the form of what is called Primary Structures,

4 CARL ANDRÉ 144 pieces of aluminium 1967

⁵ SOL LEWITT A7 1967

A B C, or Minimal art. The Minimalists appear to have realized, finally, that the far-out in itself has to be the far-out as an end in itself, and that this means the furthest out and nothing short of that. They appear also to have realized that the most original and furthest-out art in the past hundred years always arrived looking as though it had parted company with everything previously known as art. In other words, the furthest out usually lay on the borderline between art and non-art. The Minimalists have not really discovered anything new through this realization, but they have drawn conclusions from it with a new consistency which owes some of its newness to the shrinking of the area in which things can

Ills 4, 5

safely be non-art. Given that the initial look of non-art was no longer available in painting, since even an unpainted canvas now stated itself as a picture, the borderline between art and non-art now had to be sought in the three-dimensional, where sculpture was and where everything material that was not art also was.²

Like the more rarefied of the sixteenth-century mannerists, modern artists have been trying to find out what art can do when only art is in question. The answer often seems to be 'very little'. The only point at which I would disagree with Greenberg's analysis is with his feeling that minimal art, then the 'latest' style, somehow came about through an effort of the will.

Yet, despite this, there is more popular interest in modern art than ever before, and willy-nilly, the artist continues to play a role in society. It is worth pausing here, before giving detailed consideration to the various movements I have mentioned, to consider a number of typical patterns in the world of post-war art. It does not seem too naïve, for instance, to bring up the question of the way in which contemporary works of art are exhibited and sold.

Most artists depend for their success on what has been called the 'dealer-critic system'. The means whereby a reputation is made in its early stages still lies for the most part in the one-man show in a private gallery, accompanied by favourable notices in the newspapers and specialized art-magazines. A consistent, coherent show obviously has an advantage. It is easier to promote, from the dealer's point of view, and much easier to discuss, from the critic's. In America, especially, a successful artist during the post-war years has tended to become a 'product', packaged and promoted as such. Pop art gave an open blessing to already established procedures. Once an artist has become established in the hierarchy, a large number of museums, and a certain number of big collectors, feel compelled to buy an example of his work. Once this need is filled,

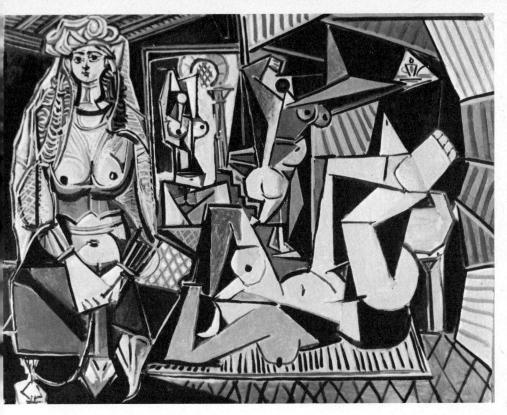

6 PABLO PICASSO The Women of Algiers 1955

however, they may well wait to make another purchase until the artist concerned changes his style.

Inevitably, this has had a certain practical effect. Picasso, with his various styles or periods, each marked by a break in style and a new beginning, had already canonized the idea that the artist should take a single theme or idea, press it to a conclusion, then choose a new path. In the post-war period, his variations on set themes (*Las Meninas, Women of Algiers*) formed a very large part of his production, and have exercised an important influence. Picasso's example, allied to purely commercial considerations, has encouraged the contemporary artist to standardize his product, and to move forward, when he needs to, only

15

by dramatic leaps. More often than not, an artist who is holding an exhibition now presents a group of interrelated works which serve to interpret one another; then, after a decent interval, a new and different group will be shown.

To speak only of the artist's relationship with his dealer, the critics, and his immediate patrons is, nevertheless, to misrepresent the role of contemporary art. Any account of the evolution of the visual arts since the war must now take into account the fact that work of an extremely 'advanced' and hermetic nature now reaches the mass public through the medium of ambitious exhibitions, usually staged in museums, and for the most part under government or other official sponsorship.

Immediately after the war, the great figures of modern art were honoured by a spate of shows, all over the world. In one sense, this seemed a reparation for the hostility of the Nazis; in another, it was a way of marking the fact that culture was getting off to a fresh start. The public was ready for these exhibitions; they became, to however minor an extent, an accepted part of mass entertainment. As the years went by, it was no longer simply the established masters who were honoured by these shows. Contemporary art was 'news'; it became part of the common currency of journalism. There was a spate of books about modern art; these in turn helped to educate the public, and thus created an appetite for more exhibitions. Museum directors were for ever on the scent of novelty. A new tendency was no sooner discovered than a show was arranged to consecrate it.

The acceptance of modern art in the post-war world created an anomalous situation which has yet to be resolved. Not only was art in a newly self-regarding phase, but the basic myth of modernism, inherited from before the war, was a myth of revolt against what was established and accepted. And yet, gradually and inevitably, modern art has become involved with the machinery of the State. The State became one of its principal patrons; and the great international art-fairs, such as the Venice

when we we

Biennale, the Biénale des Jeunes in Paris, the São Paulo Biennale, and the 'Documenta' exhibitions in Kassel, were soon a matter of national prestige. Art aligned itself with sport as one of the means of peaceful warfare among nations. At the same time, modernism, in its new guise, became one of the things which the underdeveloped nations envied and tried to copy from the developed ones.

In places such as India and Japan, traditional culture between the wars was already in a state of decay; it was natural therefore that artists in those countries should try and rebuild upon the European and American model. This worked better in some places than in others. Japan, by then endowed with a technological, urban culture which closely resembled those to be found in the United States and in Europe, produced after the war a crop of artists who rivalled their Occidental equivalents. Even so, though artists like the informal abstractionist Jiro Yoshihara are undoubtedly distinguished, with a flavour of their own which comes from the Japanese calligraphic tradition, they do not strike us as the key artists of their time; they are important on a national, not an international scale. The same is true of the pop and neo-dada artists who represent the younger generation in Japan. It is significant that one of the most interesting of these, Arakawa, now lives in New York.

Similarly, the various kinetic artists whom I discuss in a later chapter of this book are for the most part expatriates; national exhibitions, brought to Europe from various South American countries, have done nothing to suggest a new idiom, significantly different from that used by artists in Europe itself, or in the United States. There has been no recurrence of the phenomenon of Mexican populist art, the murals painted by Diego Rivera and his school which aroused great interest in the United States, although the populist tradition has continued in attenuated form in Mexico itself. Of all the great reputations of the 1930s, Rivera's seems to have fallen lowest in recent years.

What has occupied the scene, internationally, has been the struggle for primacy between Paris and New York, which has

17

supplied contemporary art with part at least of its rather factitious dynamism. American minimalists waspishly criticize European 'complication'; American critics vaunt American 'rawness'. Meanwhile, in Paris, there are complaints of American arrogance, and puzzlement over American dislike of 'our' artists. But, though Paris has been forced to share the dominion with New York, each is still the only real challenger of the other. A new style tends to spread by degrees, outwards, from these two centres. Informal abstraction was new in Delhi when New York and Paris were already tiring of it. The 'modern art' so consistently supported by the communist government of Cuba is for the most part ten to fifteen years behind the fashions in Europe. Any visitor to one of the great international artfairs is familiar with the pattern.

An especially important event in the struggle for primacy between Paris and New York was the triumph of abstract expressionism in Europe during the late 1940s: the first American raid on the European stronghold. The economics of modern art were profoundly affected by it. The United States had long been a good market for European art. American collectors had been early, though not the earliest, purchasers of paintings by the impressionists. The eccentric Dr Albert Barnes once bought the entire contents of Soutine's studio. But there is much testimony to show how difficult it was, in the early years of modernism, to sell contemporary American art to American patrons. Abstract expressionism changed this by triumphing in Europe. It changed it at a moment when, more than ever, the United States had become the world's dominant economic power. In the art boom of the 1950s, American artists were the greatest beneficiaries of a surge of interest in collecting contemporary art. The economic aspect reinforced the stylistic one. Europeans were impressed with American vitality, then with American purchasing power, and thirdly with the importance of American opinion. The lesser art centres of Europe - Milan, Brussels, Zurich, and most of all London - were, perhaps, in the long run, more profoundly affected than Paris.

In fact, England presents an especially interesting case. In the years between the wars, the small and struggling group of English *avant-garde* artists looked almost exclusively to Paris. Clive Bell, one of the most important critics of the period, once expressed the opinion that a first-rate English painter would never rank higher than a second-rate French one. He was thinking of the distance between Sickert and Degas. It would never have occurred to him to make a comparison with an American artist. Today the English art world is much more visibly influenced by the United States than it is by France: the Channel is suddenly wider than the Atlantic.

But if modern art has had nationalism foisted upon it, there are certain social effects which it has generated on its own account. The example which immediately springs to mind is that of pop art. The painting and sculpture of the immediate post-war years seemed, in their various manifestations, to offer a refuge against the pressures of the urban environment, and a protest against its mechanization and inhumanity. Pop art put forward the view that this environment offered experiences which could be structured. The point went home, notwithstanding the fact that pop art itself contained a strange dichotomy, being as much concerned with the syntax of representation as with what was being represented. A whole new territory became available to artists. For the most part, it was the very territory they lived in the things which surrounded them.

There grew up, chiefly as a result of this, a sympathy between contemporary art and what has been called 'pop culture' which went deeper than the superficialities of most pop painting. The visual arts began to broaden their popular base still further. It was no longer merely a matter of crowds flocking to the museums, to enjoy the art that the bureaucracy provided. The visitors took note of what they saw, and post-war art, despite its frequent thinness and exaggeration, began to generate new modes. Indeed, these very deficiencies made it in some ways more easily assimilable. The modes it generated did, however, spawn something solid: a new range of social attitudes.

Modernism, and in particular modern art, had begun to create its own social groupings almost from the beginning. Those who gathered in Picasso's studio in 1908, for the purpose of honouring (or mocking) the great self-taught painter Henri Rousseau, formed a society at least as cohesive as that of the young romantics who turned out for the first night of Victor Hugo's Hernani. Throughout all the successive phases of modernism, artists have continued to band together with likeminded friends. Sometimes these groups have assumed, or have been given, a title; sometimes they have existed without benefit of baptism. But there was more to it than this. The years between 1918 and 1939 show a slow but ever-increasing acceptance of modernism on the part of at least one segment of the educated public. The surrealists did not lack for rich patrons and fashionable admirers. But acceptance did not extend very far down the social scale. With rare exceptions, avant-garde art remained an upper-class, or at least an upper-middle-class, concern.

The post-war years were to change this situation. Modern art was far more widely publicized; it had attracted official support; more and more people came in contact with it. These factors outweighed its hermeticism. While it would be untrue to say that it made conversions en masse among the older generation, there began to be an unspoken agreement, even among those who did not like or understand it, that here, for better or worse, was the representative art of the day, and that nothing could be done to put the clock back. There were also more positive effects. Modern art made a particular appeal to the young, and not necessarily only the middle-class young, because it was something by tradition rebellious. In the affluent society, the struggle between the classes was transforming itself into the struggle between the generations. Meanwhile, young people everywhere had more leisure and more education than ever before. They began to create a way of life which was their own. It was to this way of life and this youthful public that modern artists began to address themselves.

The effects of the meeting were explosive. Pop culture consumed ideas at an enormous rate, for its very rhythm seemed to require that no idea be much developed. It was easier to drop one notion and replace it with another. Many of these ideas now came, directly or indirectly, from the painters and sculptors. Op patterns in fabrics are a good example. The dynamism of contemporary art, its quick turnover of styles, matched the pace of a culture which based itself on obsolescence. There was also the fact that the nature of fashion was itself changing: more and more, a fashion was not merely the arrival, triumph, and decline of a preference or style, but what might be described as style about style, just as painting and sculpture were art about art. The narcissism of contemporary fashion has often been commented upon.

Gradually, a new phenomenon began to make itself felt: the alliance of the ends against the middle. Art was still slow in disseminating itself when it moved away from its principal centres. But in those centres, it was no longer a matter of an idea slowly filtering out, finding its way from the elect circles by successive stages. Rather, new ideas leapt straight from the leading artists into the world of popular culture, creating a world where the bizarre was accepted as a matter of course, and by-passing the middle aged and the middle class on the way.

Britain supplied a striking example of this kind of development. Here, the post-war period saw a great expansion in the number of art schools, to the point where these began to offer a liberal education which rivalled that to be got from the universities, while being quite different from it in principle (in America, where universities and art schools are often linked, the division is less sharp). In Britain, an art-school education tended to be freer than its university equivalent; it demanded less formal study, but a greater degree of intellectual flexibility. Because it centred upon visual phenomena, it was international rather than national in its emphasis: there was no question of teaching English art as universities taught English literature or English history. While it is difficult to prove that the various experiments in art education which have been made in Britain over the past thirty years have produced better artists, the impact upon popular culture has been undeniable. To take one specialized but important example, the Beatles had close connections with Liverpool College of Art, and practically every major popgroup in Britain since the rise of the Beatles has had some kind of link with an art school. Many of the musicians began to play when they were art students. Popular music took over the modern art life-style; and where the musicians led, the fans followed.

The connection between developments in modern art and those in popular music can be seen at its closest in the lightshows which are now staged in one form or another by many groups. The ancestry of the light-show can of course be traced back to the 1920s, and the Bauhaus, where light environments and light theatres were planned, but never executed. The rise of the light-show in recent years coincided with the widespread use of hallucinogenic drugs, and these shows are popularly supposed to provide the spectator, or participant, with the same range of sensations.

The light-show is an extreme example of the tendency to redefine the nature of art itself – a theme which runs throughout this book. Art, it seems to me, has been making steady progress in one direction at least: it tends to concern itself less and less with the tangible object, and is merely the agent which sets in motion a series of physiological and psychological changes within the spectator. It is at this point that the romantic doctrine of *le dérèglement de tous les sens*, and the worship of technology, finally contrive to link hands with one another.

An art of the kind I have just described is naturally hostile to the dealer-critic system. For this system, which grew up amid the capitalism of the late nineteenth century, is based on the assumption that the work of art *is* in fact tangible, that it is a physical object which must be sold to a customer, this customer being an individual or an institution with the desire to possess

Ill. 7

7 L. HIRSCHFELD-MACK Crossplay c. 1923

the object in question and the money to pay for it. Big-time commercial art-dealing is a classic example of a free market economy, now hard to discover elsewhere in so pure a form.

But this method of marketing the artist's work is out of touch with the audience I have been describing. The young are rich collectively. Their buying power is legendary in the big advertising agencies. From their pockets flow the huge sums netted by the pop musicians. But singly, though they can often afford an exhibition entrance fee or the price of a poster, they cannot afford to pay the artist a fair sum for the time and energy required to produce a 'unique' sculpture or a 'unique' painting. Indeed, it is doubtful if the 'popular culture audience' would want to buy unique works of art even if the money were available. Certainly, such works would have to be disposable, in conformity with the trend to rapid obsolescence which governs the economic and cultural life of this wider public.

The tendency for the work of art to democratize itself has

23

been subject to widely differing interpretations. The French critic Pierre Restany is approving and optimistic:

Abandoning the old concept of the unique object, the 'luxury product' for individual use, the artist is in the process of inventing a new language of communication between men. Renouncing his ambiguous role, that of the marginal adventurer and independent producer, the artist will be prepared for his overriding role in the society of the future: the organization of leisure.³

Certainly, I think the general pattern of development, as it is shown in this book, suggests that art may be moving from extreme subjectivity towards relative objectivity; from the almost defiantly hand-made to the object created in series; from hostility towards technology to intense interest in its possibilities.

Abstract expressionism

Abstract expressionism, the first of the great post-war art movements, had its roots in surrealism, the most important movement of the period immediately before the war. Surrealism had routed dada in Paris in the early 1920s. It is perhaps most satisfactorily defined by its leading figure. André Breton, in the First Surrealist Manifesto of 1924.

SURREALISM, n. Pure psychic automatism, by which an attempt is made to express, either verbally or in writing, or in any other manner, the true functioning of thought. . . . Surrealism rests on the belief in the higher reality of certain neglected forms of association, in the omnipotence of dream, in the disinterested play of thought. It tends to destroy the other psychic mechanisms and to substitute itself for them in the solution of life's principal problems.¹

Since 1924 its history, under the leadership of the volcanic Breton, had been one of schisms and scandals. In particular, the surrealists had become increasingly preoccupied with their relationship with communism. The question was: could artistic radicalism be reconciled with the political variety? So much time and energy was wasted in controversy, that, by the time the war came, the movement was visibly in decline. Maurice Nadeau in his authoritative history of the movement, remarks: 'The adherence to the political revolution required the adherence of all the surrealist forces, and consequently the abandonment of the particular philosophy which had constituted the movement's very being at its origin.'²

By the time the war came, it looked as if this, the most vigorous and important of the art movements of the period between the wars, had exhausted its impetus. But the 'particular

25

Aper

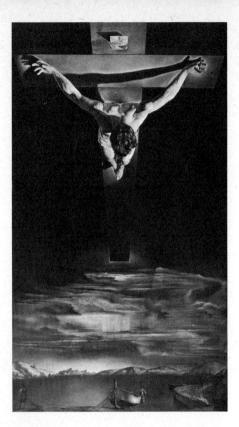

8 SALVADOR DALI Christ of St John of the Cross 1951

philosophy' of which Nadeau speaks was still very much alive when the surrealist movement arrived, almost *en bloc*, in New York shortly after the outbreak of war. The exiles included not only Breton himself but also some of the most famous surrealist painters: Max Ernst, Roberto Matta, Salvador Dali, and André Masson. Peggy Guggenheim, then married to Ernst, supplied the group with a centre for their activities by opening the Art of This Century Gallery in 1942. Many of the most important American painters of the 1940s were later to show there.

The situation of the surrealist exiles was governed by several factors. For example, in the midst of the conflict, the old, rending political arguments were no longer relevant. New York provided a fresh and challenging territory for their activities, and they began to make converts among American artists.

Ills 8, 10 Ill. 9

As I have said, the United States had long been hospitable to the avant-garde art of Europeans. New York had a tradition of intermittent avant-gardism which stretched back to the Armory Show of 1913, and, beyond that, to the pre-First World War activities of Alfred Stieglitz, who presented a series of exhibitions by artists such as Rodin, Matisse, Picasso, Brancusi, Henri Rousseau, and Picabia in a small gallery at 291 Fifth Avenue. During the First World War there had been an active group of dadaists in the city, among them Marcel Duchamp, Picabia, and Man Ray. But the Depression years of the 1930s turned American art in upon itself. American critics, for instance Barbara Roselin her classic book American Art since 1900, stress the fact that this period of introspection and withdrawal was crucial for American artists. They point to the effect, in particular, of the Federal Art Project, the measure by which the American government sought to give relief to artists suffering from the prevailing economic conditions. Miss Rose contends that 'by making no formal distinction between abstract and representational art',3 the Project helped to make abstract art respectable, and that the esprit de corps which the scheme created among artists carried over into the 1940s. Nevertheless, in 1939

9 ANDRÉ MASSON Landscape with precipices 1948

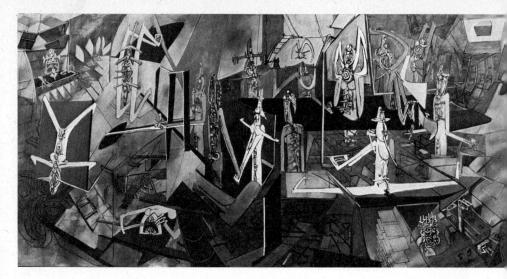

10 ROBERTO MATTA Being With 1945-6

American art counted for little where the European *avant-garde* was concerned, though a few distinguished *émigrés*, such as Josef Albers and Hans Hofmann, were already preparing the ground through their teaching for the change that was to come. Albers taught at Black Mountain College in North Carolina, Hofmann at the Art Students' League in New York and at his own schools on 8th Street and in Provincetown, Mass.

Yet it was not these, but the more-recently arrived surrealists who provided the decisive stimulus. Without their presence in New York, abstract expressionism would never have been born.

The transitional figure, the most important link between European surrealism and what was to follow, was Arshile *Ill. 11* Gorky. Gorky was born in Armenia in 1904, and did not arrive in America until 1920. His early work (undertaken in conditions of the bitterest poverty) shows a steady progression through the basic modernist styles, typical of an artist in a provincial environment who is conscious of his own isolation. He absorbed the lesson of Cézanne, then of cubism. In the 1930s, under the spell of Picasso, he was already veering towards

Ills 16, 70

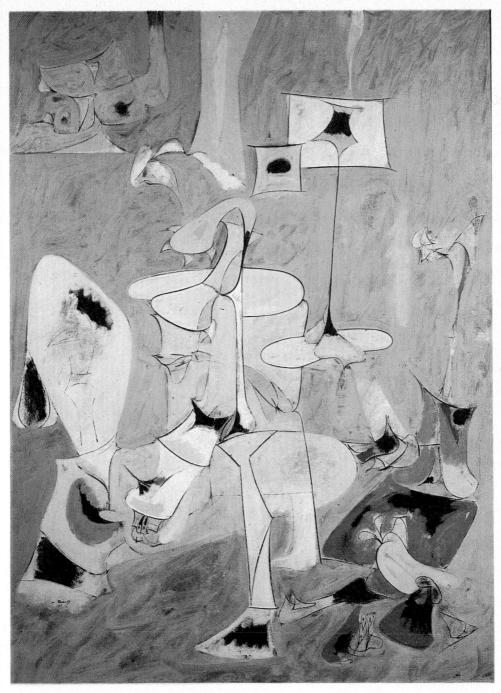

II ARSHILE GORKY The Betrothal II 1947

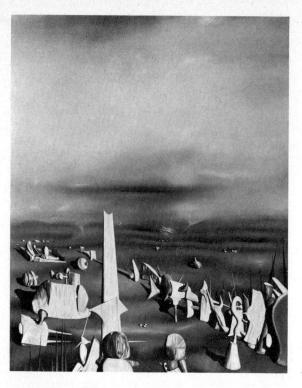

12 YVES TANGUY The Rapidity of Sleep 1945

surrealism. Then came the war, and he started to explore more boldly. Basically, the surrealist tradition seemed to offer the convert two choices. One was the meticulously detailed style of Magritte or Salvador Dali. Even in those of Dali's pictures where the distortions are most violent, objects to some extent retain their identity. The other choice was the biomorphic style of artists such as Miró or Tanguy, where the forms merely hint at a resemblance to real objects, usually parts of the human body – breasts, buttocks, the sexual organs. Gorky adopted this method, and used it with increasing boldness. Harold Rosenberg speaks of the characteristic imagery of Gorky's developed style as

> ... overgrown with metaphor and association. Amid strange, soft organisms and insidious slits and smudges, petals hint of claws in a jungle of limp bodily parts, intestinal fists, pudenda, multiple limb folds.⁴

30

The painter himself, in a statement written in 1942, declared:

I like the heat the tenderness the edible the lusciousness the song of a single person the bathtub full of water to bathe myself beneath the water... I like the wheatfields the plough the apricots those flirts of the sun. But bread above all.⁵

Gorky was especially influenced by the Chilean-born painter Roberto Matta and his work is often close to that which was being done by the veteran French surrealist André Masson, during the years the latter spent in America. He did not finally come into contact with Breton until 1944, and this completed his liberation as an artist. By 1947 he had begun to outstrip his masters, and the way in which he outstripped them was through the freedom with which he used his materials. The boldness of his technique can be seen in the second version of *The Betrothal*, which dates from 1947. The philosophy of art which Gorky

13 RENÉ MAGRITTE Exhibition of painting 1965

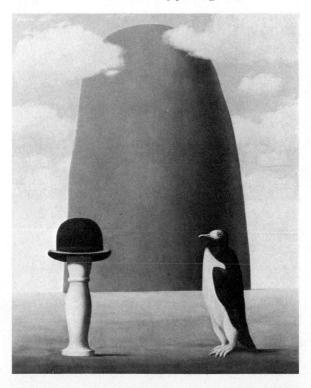

Ill. 10 Ill. 0

Gorky

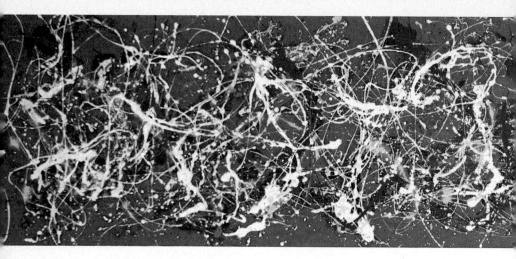

put forward in an interview with a journalist the same year had important implications for the future of American painting:

When something is finished, that means it's dead, doesn't it? I believe in everlastingness. I never finish a painting – I just stop working on it for a while. I like painting because it's something I never come to the end of. Sometimes I paint a picture, then I paint it all out. Sometimes I'm working on fifteen or twenty pictures at the same time. I do that because I want to – because I like to change my mind so often. The thing to do is always to keep starting to paint, never finishing painting.⁶

This idea of a 'continuous dynamic' was to play an important part in abstract expressionism, and especially in the work of Jackson Pollock. Gorky himself was unable to press it further. After a long series of misfortunes, he committed suicide in 1948. He was perhaps the most distinguished surrealist that America has produced.

Far less 'European' was the work of Jackson Pollock, though it was Pollock who became the star of the Art of This Century Gallery. Like Gorky, Pollock developed very slowly. He was

GORKY nevel stop

32

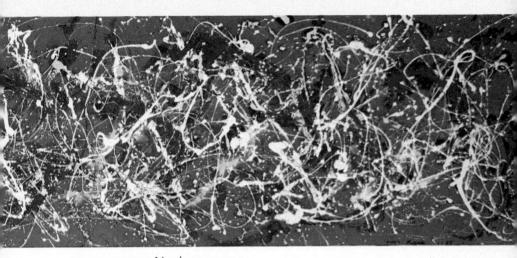

14 JACKSON POLLOCK Number 2 1949

born in 1912, and spent his youth in the West, in Arizona, northern California, and (later) southern California. In 1929 Pollock left Los Angeles and came to New York to study painting under Thomas Benton, a 'regionalist' painter. During the 1930s, like many American artists of his generation, he fell under the influence of the contemporary Mexicans. Diego Rivera's enthusiasm for a public art 'belonging to the populace' may well have helped to develop Pollock's sense of scale. Later he fell under the influence of the surrealists, just as Gorky had done, and Miss Guggenheim put him under contract for her gallery. By 1947, Pollock had broken through to the style for which he is now best known: free, informal abstraction, based on a technique of dripping and smearing paint on to the canvas. Ill. 14

Here is Pollock's own description of what took place when he worked on such pictures:

My painting does not come from the easel. I hardly ever stretch my canvas before painting. I prefer to tack the unstretched canvas on the hard wall or floor. I need the resistance of a hard surface. On the floor I feel more at ease. I feel nearer, more part of the painting, since this way I can walk around

it, work from the four sides and literally be *in* the painting. This is akin to the Indian sand painters of the West.

I continue to get further away from the usual painter's tools such as easel, palette, brushes, etc. I prefer sticks, trowels, knives and dripping fluid paint or a heavy impasto with sand, broken glass or other foreign matter added.

When I am *in* the painting I'm not aware of what I'm doing. It is only after a sort of 'get acquainted' period that I see what I have been about. I have no fears about making changes, destroying the image, etc., because the painting has a life of its own. I try to let it come through. It is only when I lose contact with the painting that the result is a mess. Otherwise there is <u>pure harmony</u>, an easy give and take, and the painting comes out well.⁷

Compare this to Breton's instructions as to how to produce a surrealist text, as given in the manifesto of 1924:

Have someone bring you writing materials after getting settled in a place as favourable as possible to your mind's concentration on itself. Put yourself in the most passive, or receptive, state you can. Forget about your genius, your talents, and those of everyone else. Tell yourself that literature is the saddest path that leads to everything. Write quickly, without a preconceived subject, fast enough not to remember and not to be tempted to read over what you have written.⁸

I think it is clear that in many ways Pollock's and Breton's attitudes correspond. It is important, for example, to remember that even in so-called 'gestural' or 'action' painting there is a large element of passivity.

One of the more radical consequences of Pollock's method of working, so far as the spectator was concerned, was the fact that it completely changed the treatment of space. Pollock does not ignore spatial problems; his paintings are not flat. Instead, he creates a space which is ambiguous. We are aware of the surface of the picture, but also of the fact that most of the calligraphy

Ill. 15

seems to hover a little way behind this surface, in space which has been deliberately compressed and robbed of perspective. Pollock is thus linked not only to the surrealists, but to Cézanne. Indeed, when we think of the illusionist perspective used by Dali and even by Tanguy, it will be clear that this is one of the points where Pollock differs most strikingly from his mentors. The shuttling rhythms which Pollock uses tend to suggest a spatial progression across the canvas, rather than directly into it, but this movement is always checked, and in the end returns towards the centre, where the main weight of the picture lies. As will be seen from his own description, these characteristics reflect Pollock's method of work. The fact that the image was created before the actual boundary of the canvas was settled (it was trimmed afterwards, to fit what had been produced) tended to focus attention on lateral motion. This rather primitive method of organization was to have important consequences.

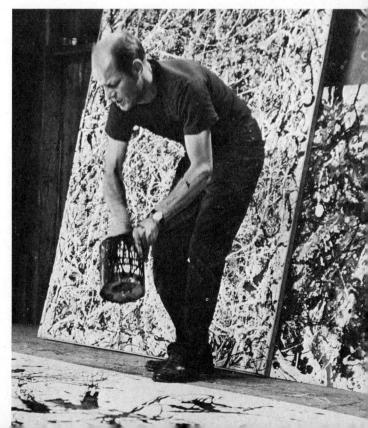

15 Jackson Pollock at work

Both by temperament and by virtue of the theories he professed - themselves largely the product of his temperament -Pollock was an intensely subjective artist. For him, inner reality was the only reality. Harold Rosenberg, the chief theorist of abstract expressionism, describes the style as a 'conversion phenomenon'. He goes so far as to call it 'essentially a religious movement'.9 But it was a religious movement without commandments, as appears from Rosenberg's remark that 'the gesture on the canvas' was 'a gesture of liberation from Value - political, aesthetic, moral'.¹⁰ One might add that in Pollock's case as in some others, it also seems to have been a gesture of estrangement from society and its demands. Frank O'Hara describes the artist as being 'tortured with self-doubt and tormented by anxiety'.11

Pollock would not, however, have made the impact he did, first in America and subsequently in Europe, if he had been completely isolated as a painter. The real father-figure of the New York school of painting during the post-war years was probably the veteran Hans Hofmann, who exercised great influence as a teacher, and whose late style shows how keen was his sympathy with what the younger men were doing. Hofmann was typical of the things which go to make up the American amalgam. He had lived in Paris from 1904 to 1914, and had been d'éfferent in contact with Matisse, Braque, Picasso, and Gris. It was Matisse's work that he particularly admired, and it is this which can be thought of as underlying the more decorative side of abstract expressionist painting. That the new painters were not without roots in the past is something that can be judged from Hofmann's own career. He had begun to teach in the United States in 1932, and had founded the Provincetown Art School in 1934. His last phase, upon which he embarked when he was over sixty, was both logical in the artistic climate of the time, and in human terms wonderfully unexpected: an example of a talent at last unfolding to its full extent when the right atmosphere was provided for it. Some of these late pictures are at least as bold as the work of younger men.

Ill. 16

16 HANS HOFMANN Rising Moon 1964

The 'organizer' of the abstract expressionist movement, in so far as it had one, was neither Pollock nor Hofmann, but Robert Motherwell Motherwell is an artist whose intellect and energies range wide. As a painter, he began his career under the influence of the surrealists, and, in particular, under that of Matta, with whom he made a trip to Mexico. He had his first one-man exhibition at the Art of This Century Gallery in 1944. As the abstract expressionist movement got under way, the range of Motherwell's activities continued to expand. He was co-editor of the influential but short-lived magazine *Possibilities* in 1947–8, and in 1948 founded an art school with three other important painters, William Baziotes, Barnett Newman, and Mark Rothko. In 1951 he published an anthology of the work of the dada painters and poets which was one of the earliest signs of the arrival of 'neo-dada'.

17 WILLIAM BAZIOTES Congo 1954

Ill. 17

18 ROBERT MOTHERWELL Elegy to the Spanish Republic no. LV 1955–60

The variety of these activities did not prevent Motherwell from having a large output as a painter. His best-known works are the long series of canvases known collectively as the *Elegies* to the Spanish Republic. These pictures serve to correct some erroneous ideas about abstract expressionism. It's significant, for instance, that Motherwell's theme is one drawn from the recent history of Europe: recent, but not absolutely contemporary. Motherwell was in his early twenties when the Spanish Civil War broke out, and is looking back with nostalgia on his own youth. His choice of subject suggests that the 'subjective' painting which flourished in America during the late 1940s and early 1950s was by no means incapable of dealing with historical or social issues, but that these issues had to be approached in personal terms, and obliquely. The *Elegies* are certainly far more oblique than *Guernica*. The nostalgic rhetoric of Mother-

not straight

39

III. 18

19 ADOLPH GOTTLIEB The Frozen Sounds Number 1 1951

well's paintings, sustained in painting after painting, is reminiscent of the tone to be found in a good deal of post-war American poetry: in that of poets as different from one another as Allen Ginsberg and Robert Duncan, for example. It is a mood which has few equivalents in the painting of post-war Europe, and which acts as a reminder both of the essentially American character of the style and of the fact that it was not necessarily the 'instantaneous' art which European painters at times mistook it for.

Essentially, there are two sorts of abstract expressionist painting, rather than one. The first kind, typified by Pollock, Franz Kline, and Willem de Kooning, is energetic and gestural. Pollock and de Kooning are much involved with figuration.

40

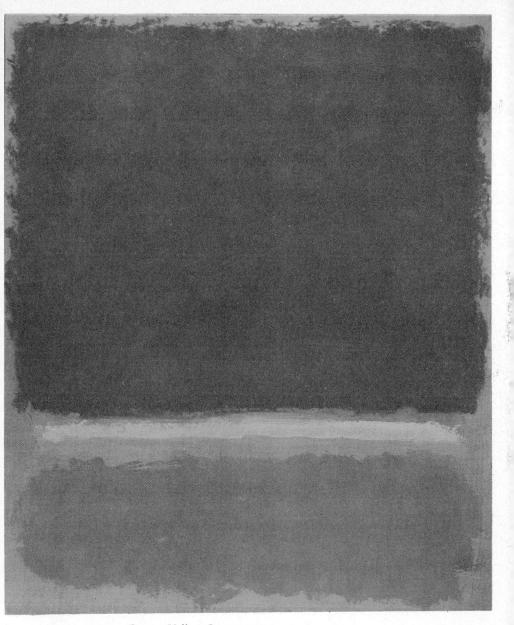

20 MARK ROTHKO Orange Yellow Orange 1969

The other kind, typified by Mark Rothko, is more purely abstract and more tranquil. Rothko's work, in particular, serves Ill. 20 to justify Harold Rosenberg's use of the adjective 'mystic', when describing the school. Rothko, like several other leading American artists of the post-war period - Gorky, de Kooning, Hofmann - was born abroad; he came to America from Russia in 1913, when he was ten. He began as an expressionist, felt the influence of Matta and Masson, and followed the standard pattern by having an exhibition at the Art of This Century Gallery in 1948. Gradually his work grew simpler, and by 1950 he had reached the point where the figurative element had been discarded. A few rectangles of space are placed on a coloured ground. Their edges are not defined, and their spatial position is therefore ambiguous. They float towards us, or away, in a shallow space of the kind that we also find in Pollock - it derives, ultimately, from the spatial experiments of the cubists. In Rothko's paintings the colour relationships, as they interact dot within the rectangle and within this space, set up a gentle rhythmic pulsation. The painting becomes both a focus for the spectator's meditations and a screen before a mystery. The weakness of Rothko's work (just as the subtlety of colour is its strength) is to be found in the rigidity and monotony of the compositional formula. The bold central image has become one of the trademarks of the new American painting - one of the things that differentiates it from European art. Rothko is an artist of real brilliance imprisoned in a straitjacket; he exemplifies the narrowness of focus which many modern artists have imposed upon themselves.

Ill. 19

The lesson is reinforced by the work of an artist who in many ways resembles Rothko: Adolph Gottlieb He is also linked to Motherwell, in that he is a rhetorician – by 'rhetoric' in painting, I mean the deliberate use of vague, expansive, generalized forms. An interest in Freud led Gottlieb towards an art which he deliberately fills with cosmic symbolism. The likeness between Gottlieb's most characteristic style and the paintings done by foan Miro in the late 1930s is something that bears

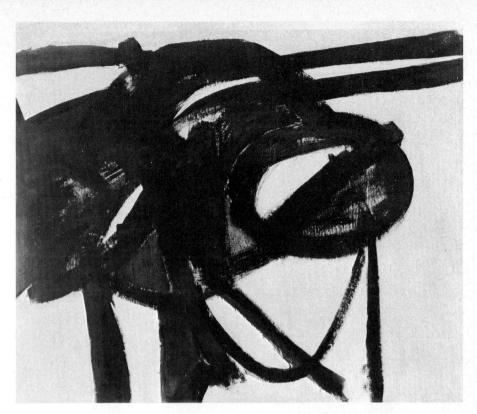

21 FRANZ KLINE Chief 1950 (Collection The Museum of Modern Art, New York)

investigation. Miró, too, is fond of cosmic symbols, but paints them more lightly and crisply, without too much stress on their deeper meanings. Gottlieb's work makes me feel that I am being asked to take a weighty significance on trust. This significance is not inherent in the colour or the brushwork; one has to recognize the symbol and make the historical connection.

The limitations I find in the work of Rothko and Gottlieb seem to me to be shared by Philip Guston and Franz Kline. Ills 21, 24 Guston typifies the boneless aspect of abstract expressionism. Too often, his pictures are no more than a riot of lush paint and sweet colour: something to prompt another Tallulah Bankhead to remark, 'There's less in this than meets the eye.' Kline, like Rothko, is an artist who runs to rather sterile extremes, and he

22 MARK TOBEY Edge of August 1953 (Collection The Museum of Modern Art, New York)

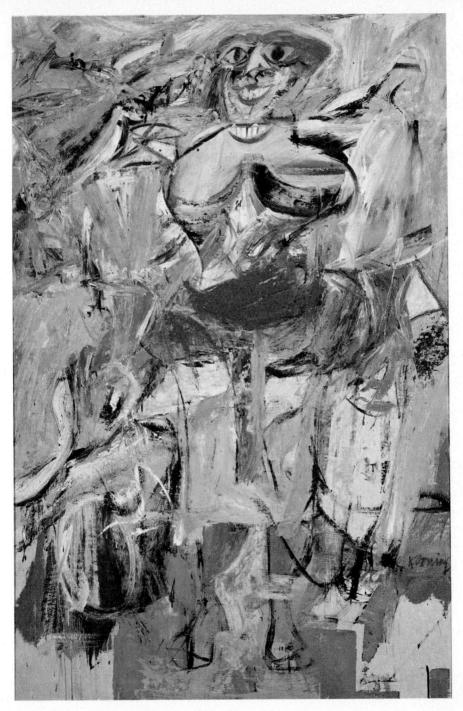

23 WILLEM DE KOONING Woman and bicycle 1952-3

is speeded on his way to them by abstract expressionist doctrine. Unlike Rothko's, his work is gestural, and his technical affiliations are with Pollock. What he most frequently did was to create on the canvas something which looked like a Chinese character, or part of one, enormously magnified. These strong, harsh ideograms relied for their effect on the harsh contrast of black strokes on a white ground. Paint seems to be used only for reasons of breadth and scale: there is little in most of the paintings that could not have been said with Indian ink and paper. When, in the last years of Kline's life (he died in 1962), colour began to play a more important part in his work, the results were not usually happy because we are never made to feel that the colour is essential to the statement already being made by the design. Its purposes are purely cosmetic.

Kline was always very wary about admitting to any sort of Oriental influence in his work, yet influences of this kind have undoubtedly been important in American painting since the war. Not only is there an element of passivity which grows increasingly powerful with each successive stylistic revolution – Rothko invites the spectator to contemplation, Morris Louis collaborates almost passively with the demands of his materials, Andy Warhol accepts the image and refuses to edit it – but the techniques of Oriental artists, as well as their philosophies, have made an important impact.

It is interesting to compare Kline's big gestural symbols with the work of an artist who has a very different sense of scale: Mark Tobey. Mark Tobey is not, strictly speaking, an abstract expressionist painter. Rather, he has pursued a parallel development, modified by different experiences and a different context. Tobey's career has been centred not on New York but on Seattle – that is, until a recent move to Switzerland. He is widely travelled, and has visited the Near East and Mexico, besides making several visits to China and Japan. In Japan he stayed for a while in a Zen monastery, and became a convert to Buddhism (thus anticipating a similar conversion on the part of one of the most important of the American Beat poets, Gary Snyder).

Ill. 22

Kline's

Tobey's journeys to the Orient were made with the specific purpose of studying Chinese calligraphy, and they had an avowed and decisive effect on his painting. He adopted a technique which he labelled 'white writing', a way of covering the picture surface with an intricate network of signs which are like Kline's hieroglyphs writ small. In many ways Tobey's work is a critique of Kline's, and of abstract expressionism as a whole. The thing which is impressive about Tobey's paintings, however tenuous his formal devices may sometimes appear, is the fact that what he produces is always complete in its own terms. Tobey's discoveries reinforced those of Pollock: in his later work, the canvas, or 'field', is articulated from end to end by the rhythmic marks of the brush. But he, more than the true abstract expressionists, gives the spectator a feeling of possibility. The marks, one feels, might at any moment rearrange themselves, but would retain a sense of ordered harmony. This is not an art straining against its own limitations, but one which is exploring a newly discovered and infinitely flexible means of expression.

24 PHILIP GUSTON The Clock 1956–7 (Collection The Museum of Modern Art, New York)

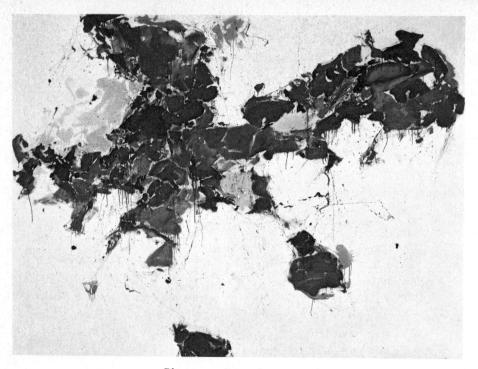

25 SAM FRANCIS Blue on a point 1958

Yet it would be a mistake to assume that abstract expressionism itself was entirely inflexible. The school was at any rate flexible enough to incorporate the art of Willem de Kooning Ill. 23 an artist who, in his best pictures, stands next to Pollock in force and originality of talent. De Kooning was born in Holland, and did not arrive in America until he was already an adult. His style tends to emphasize the expressionist component of abstract expressionism, at the price of abstraction. He deals with imagery which seems to rise up out of the texture of the paint, and then to relapse again into the chaos which momentarily gave it form. What marks him off from contemporary European expressionists is the characteristically American boldness - one might even say rawness - and sense of scale that appear in his pictures. When de Kooning bases himself on imagery taken from landscape, the work is so broad that it

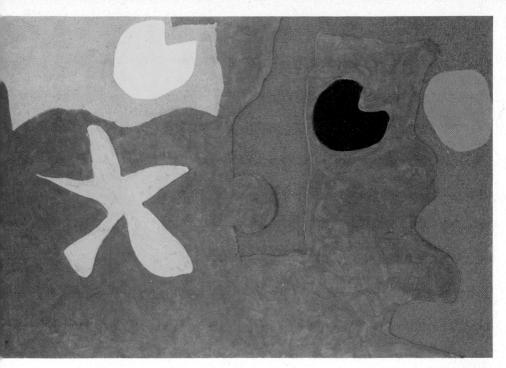

26 PATRICK HERON Manganese in deep violet: January 1967

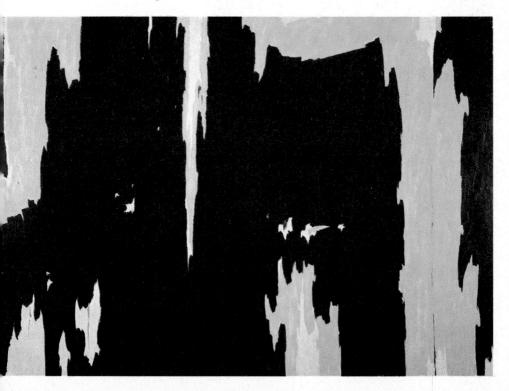

seems as if he has discovered a way of using oil-paint as the boldest Chinese and Japanese scholar-painters used ink: yet his grip on the original source of the image is never quite broken. When he paints in a more directly figurative way, as in the series of *Women*, the whole force of the sexual impulse is there in the painting. These Kali-like figures correspond to the kind of work which Jean Dubuffet did in his earliest period, and again in the *Corps de Dame* series of 1950. De Kooning's work is an important point of contact, therefore, between European and American art. In addition to this, it predicts certain aspects of pop art. De Kooning's *Women* are the forerunners of Warhol's *Marilyns*.

The enormous success scored by abstract expressionism was to have important consequences for the arts on both sides of the Atlantic. Pollock's legend grew with tremendous rapidity in the years between the first European showing of his work in 1948 and his death in a car crash in 1956. Some of the effects of this success were all too predictable. An attempt was made to set up abstract expressionism as the only conceivable kind of art. A rapid succession of yet newer and more radical adventures seemed to disprove this claim almost immediately. Ironically enough, there was something in it. Abstract expressionism looked both forward and back. Despite the huge scale on which they worked, Pollock and Kline seem to have had perfect faith in canvas and paint as a viable means of communicating something. That faith has since been questioned, and one reason for the questioning is the degree to which the abstract expressionist painters strained traditional categories of art; nothing further evolved from what they did. If one compares the work of a painter such as Clyfford Still to the superficially very

Ill. 65

Ill. 27 Ill. 25

similar work of Sam Francis, one gets some idea of the extent to which abstract expressionism was at home only in America. Francis, as a Paris-domiciled American, introduces the European element of 'taste', which immediately compromises the rigour of the style. And again, if one compares the work of one of the few good abstract expressionists of the second generation, Helen

Frankenthaler, with that of the pioneers, one sees how difficult it was to build on what those pioneers had achieved. This least academic of styles made an astonishingly rapid descent into academicism. The art boom of the middle and late 1950s created a spate of bubble-reputations.

The effect of the new American art on Europe was not altogether happy. One reason for this was that Europeans misunderstood it, and tried to make use of criteria which had been suddenly outgrown. In England, for example, one now encounters a certain bitterness among early supporters of abstract expressionism. The British painter-critic Patrick Heron, who welcomed his American colleagues very generously when they first appeared, now complains of their ingratitude.¹² He goes on to suggest that the monotony of the central, heraldic image to be found in much abstract expressionist painting could be remedied by a resort to more sophisticated European methods of composing the picture space. This shows that his initial enthusiasm was based on a misapprehension, as such methods of composition were just what the Americans had been most concerned to reject from the very beginning, even at the price of losing their freedom to develop and manœuvre.

The importance of abstract expressionism was arguably more to culture as a whole than to painting in particular. The success made by the new painting, and its attendant publicity, drew the attention of writers and musicians who were discontented with their own disciplines. Earle Brown, one of the most radical of the new composers, claims to have found new inspiration for his own work in that of Pollock. At first, it was the gesture of liberation which counted, rather than any specific resemblance between the disciplines of the various arts. The so-called 'mixed media' and 'intermedia' were to come later, partly as a result of experiments with assemblage and collage.

Ill. 26

Ill. 77

CHAPTER THREE

The European scene

The course of events in France, and on the Continent as a whole, was very different to that in America. Paris was naturally the place towards which Europeans looked as soon as peace was restored. Equally naturally, it was the artists of the 'great generation' who began by attracting the most attention. Indeed, the six-year gap had served to establish these artists more, rather than less, firmly in the public mind. They were no longer outsiders; they had come to seem like representatives of the civilization which the Allies had been fighting for; and the Nazi condemnation of 'decadent art' was now of some considerable service to their reputations. Picasso became as much an object of pilgrimage to American GI's in liberated Paris as their own compatriot, Gertrude Stein.

On the other hand, there was a sense in which these senior artists found themselves cut off from their roots by what had happened. A feeling of change was in the air, and they, who had been the instigators of so many changes, were not the promoters but the victims of this one. The new eminence they were accorded often brought a certain aridity to their work.

This verdict applies particularly to Picasso. Immediately after the war he was awarded his final status as a mortal god: the most universally acclaimed and celebrated artist since Michelangelo. It says something for Picasso's furious creativity that, even when he had been placed in this uneasy situation, it showed no sign of slackening. His production after 1945 was prodigious, and new aspects of it were almost constantly revealed to the public. In 1966, for example, his extensive but previously almost unknown production as a sculptor was shown in exhibitions in London, Paris and New York. But his later sculpture, like nearly all the rest of his later work, seems

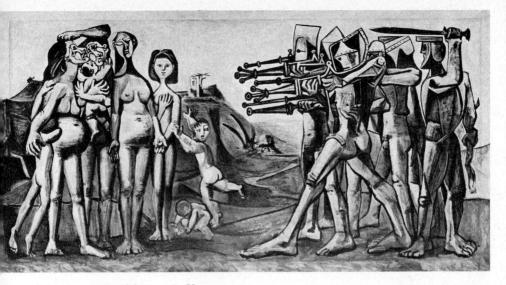

28 PABLO PICASSO Massacre in Korea 1951

to have small bearing on the development of European art as a whole.

In general, the work which Picasso did after the war grew steadily drier and increasingly more mannered. His Arcadian visions of nymphs and fauns, and his occasional propaganda pictures, such as *Massacre in Korea*, which was painted at the time of the Korean War, have shown a tendency towards arid stylization.

Among the most characteristic works of Picasso's 'late' period were the series of variations upon famous paintings by the great masters of the past, such as the *Las Meninas* of Velázquez, or the *Women of Algiers* by Delacroix. When we look at one of these variations, we realize how thin it would seem, if placed beside the original that inspired it. Picasso has conducted a kind of unpacking process, taking from the original various ideas and qualities, and holding these up for our inspection, adding at the same time comments of his own. Often the spectator is conscious of a sort of hostility towards the achievements of the past: some of the variations might Ill. 28

Ill. 6

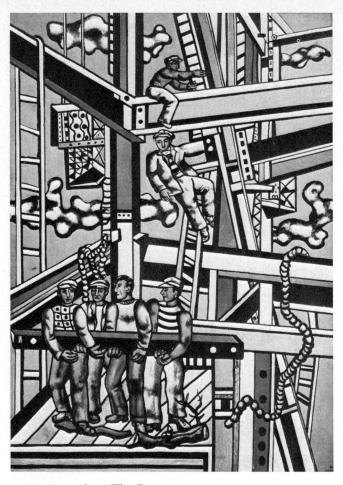

29 FERNAND LÉGER The Constructors 1950

socies

54

almost be described as rapes or dismemberments. The same hostile ingenuity appears in the recent sculptures, though here the dexterity of the performance often conquers us.

These pictures painted in series do, as it happens, have certain things in common with the work of younger artists. The first, as I have noted, is the idea of a series, where no single canvas seems a complete statement. The second is the dependence on some previously established image: the painter is unable to work except with previously 'cooked' ingredients. This has also been the case with pop art. Such resemblances, however, are not enough to overcome the sense of remoteness which one feels when confronted with Picasso's work of the final two and a half decades. Georges Clouzot's film of Picasso at work, *Le Mystère Picasso*, made in 1956, suggests a reason. As the artist draws, using special inks and semi-transparent paper, restlessly transforming one image into another, it more and more begins to seem that he is the prisoner of his own skill.

The careers of several other painters of the great generation show an equal isolation from the main current of events, though the work they did was often impressive Georges Braque, for example, painted some undoubted masterpieces in his old age, such as the series of pictures devoted to the theme of the studio. These tranquil, monumental paintings sum up all the lessons of the painter's long lifetime. Yet it is surely significant that they are inward-turned without being truly introspective. They look, not at the world outside, nor at the psyche, but at the familiar paraphernalia of the artist's workshop. Their greatness comes, not from new invention, but from refinement of invention. Braque is giving a final polish to ideas which he first began to use in the days of cubism, and he deploys these ideas less radically in the late than in the early work.

More willing to get to grips with the world around him was another veteran, Fernand Léger. In a picture such as *The Constructors*, painted in 1950, we see an attempt to bring a Poussinesque classicism to terms with properly modern and Marxist subject-matter. The results have been duly admired by Marxist critics. Nevertheless, a reversion to Poussin seems curiously eccentric and wilful even in the wilful world of post-war art.

Even the two acknowledged masters whose work seems most relevant to the post-war scene seem to have achieved this relationship almost by accident. The most conspicuous triumph was that of Matisse, who became in his old age almost as radical an artist as he had been at the time of the fauves. Between the wars Matisse had specialized in a fluent hedonism which made

Ill. 29

mayl

Ill. 34

formes

Ill. 30

increasingly few demands on his talent. In 1941 he underwent a series of operations, and emerged from them a permanent invalid. In some ways this ordeal and even the war itself seem to have sharpened his perceptions. In the late 1940s he painted a series of splendid interiors, flooded with light and colour, which form a parallel to the *Studios* of Braque. But he was to go beyond this. By 1950, the patches of colour in his pictures (for example, the *Zulma* in Copenhagen) had begun to enjoy an autonomy of their own. It was at about this time that, because of his increasing feebleness, Matisse began to use the *papier découpé* technique which was the chief creative resource of his last years. Pieces of paper were coloured to the artist's specification, and these were then cut and used to form designs. Thus

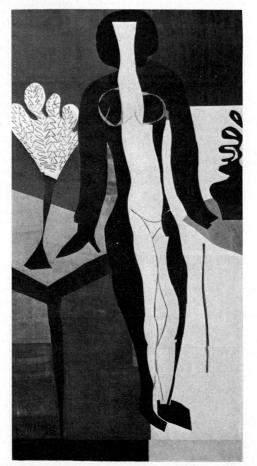

31 HENRI MATISSE ► The Snail 1953

30 HENRI MATISSE Zulma 1950

the old man could create works of considerable size without too much strain. The method encouraged extreme simplification, and helped to discipline Matisse's decorative gift. The Snail is Ill. 31 one of the most abstract of all the designs of this period, severer even than the work which Matisse did around 1910. The activation of colour which Matisse achieved in these works was to mean something important to painters much younger than himself.

57

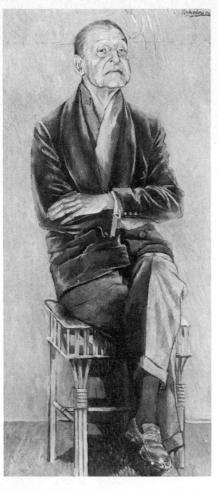

33 JOHN BRATBY Window, self-portrait, Jean and hands 1957

32 GRAHAM SUTHERLAND Somerset Maugham 1949

Ill. 36 The other painter who had something to contribute was Miró whom I have already mentioned while discussing abstract impressionism. Miró's great simple canvases of recent years are certainly close to the abstract expressionists, and even to some of the 'colour painters' whom I have yet to discuss. His sculpture, too, has links with Dubuffet. But Miró remains strangely elusive as an artistic personality: an artist who keeps so many options open is difficult to interpret satisfactorily.

Ill. 35

Other major artists, such as Max Ernst, have continued their careers, but produce work which seems increasingly remote

from the current scene. Some important painters have acknowledged this dilemma quite openly. One seems to find a confession of it in the powerful realistic portraits which the British painter Graham Sutherland has produced since the war, numbering Sir Winston Churchill and Somerset Maugham among his sitters. These seem a surprising development of style for an artist who certainly began in the surrealist tradition, and who has continued, in other paintings, to produce work which is still reminiscent of surrealism.

'Realism' itself is not, however, an irrelevant issue, where the post-war painting of Europe is concerned. In fact, the sombre mood of immediately post-war Europe did seem to produce at least a theoretical leaning towards realist art. There was a feeling that artists should now face up to their responsibilities, that they should participate in building a new and better world, and, in particular, that they should fall into line with filmmakers and authors, both of whom were attracted towards a documentary style. In Italy, for example, Rossellini's early neorealist films, *Città Aperta* and *Païsa*, were important – infinitely more so than the *Manifesto del Realismo* issued by leading Italian artists in 1945. Ill. 32

34 GEORGES BRAQUE Studio IX 1952-6

35 MAX ERNST Cry of the seagull 1953

36 JOAN MIRÓ Blue II 1961

37 DAVID BOMBERG Monastery of Ay Chrisostomos, Cyprus 1948

38 FRANK AUERBACH Head of Helen Gillespie III 1962–4 39 LEON KOSSOFF Profile of Rachel 1965

On the whole, social realism took root only in those countries which could be counted as markedly provincial. In England, for example, the so-called 'Kitchen Sink' painters enjoyed a considerable vogue. Their leader, David Bomberg, had begun his career as a pioneer modernist, under the influence of vorticism, but later developed in a way which showed that his true masters were the German expressionists. Bomberg tried to create a balance: he wanted the spectator to be able to enter into his work, both in its role as a representation and in its role simply as paint. His followers tended to emphasize one of the terms of this occasion at the expense of the other. The work of Frank Auerbach and of Kossoff, for example, is concerned with a reality that is achieved literally: by means of the solidity of paint, which is piled up on the canvas in ropes and mounds. Though the approach is different, the final result has something in common with the French 'matter painters' whom I shall discuss in a moment.

62

Ills 38, 39

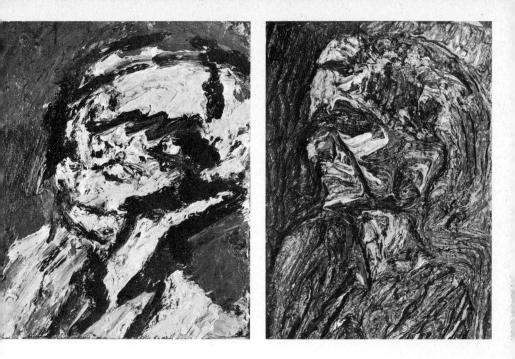

The realism of the other 'Kitchen Sink' painters (those to whom the term more properly applies) was more descriptive, and their allegiance to it proved more fragile. The early work of artists such as Jack Smith, Edward Middleditch, and John Bratby dates only from the middle 1950s, and is the equivalent of the kind of realism which was then dominant in English literature and on the London stage: Kingsley Amis's novel *Lucky Jim*, John Osborne's play *Look Back in Anger*. None of these English painters produced work of the strength of that done by the Italian realist Renato Guttuso, who discovered a kind of neo-baroque idiom in which to describe the lives of 'ordinary people' – workers, people on the beach. Where Léger, in his late years, looked back towards the baroque of Poussin, in trying to create an 'art of the people', Guttuso based himself on the more tactile art of the Carracci, and of Caravaggio.

There is, however, one British figurative painter who ranks among the more distinguished European contemporary artists:

Ills 33, 43

Ill. 42

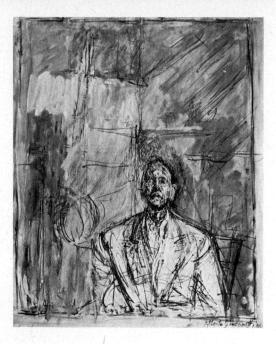

40 ALBERTO GIACOMETTI Portrait of Jean Genet 1959

Ills 41, 44, 45

Francis Bacon. Bacon and the Frenchman Balthus seem to me, in fact, to be the only two artists who have managed to make figuration work in a contemporary European context. Both are so strange and individual that it is worth considering them side by side.

Bacon seems to me to represent the degree to which the demands of traditional figurative painting can be forced into a compromise with those of modernism. By the standards of many of the artists whose work is described in this book, he is an extremely traditional figure. He works with the old materials, oil-paint on canvas, and he accepts the discipline of the old formats. In other ways he is far from orthodox. This is the way in which he described his method of work in a television interview with David Sylvester:

I think that you can make, very much as in abstract painting, involuntary marks on the canvas which may suggest much deeper ways by which you can trap the facts you are obsessed by. If anything ever does work in my case it works from that

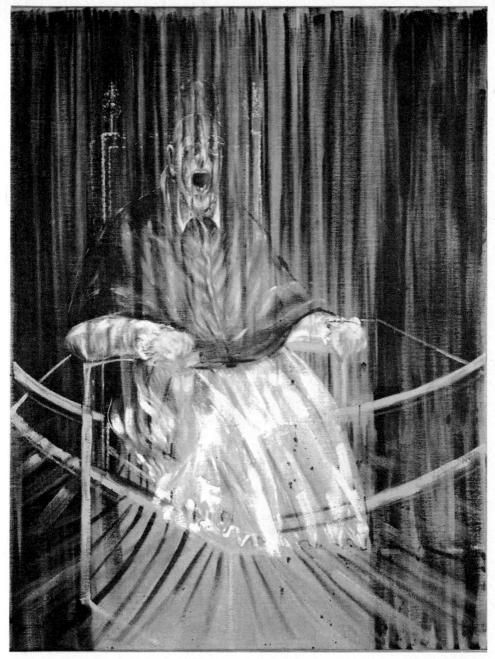

⁴¹ FRANCIS BACON Study after Velázquez: Pope Innocent X 1953

moment when consciously I didn't know what I was doing. . . . It's really a question in my case of being able to set a trap with which one would be able to catch the fact at its most living point.¹

This leaves open at least two questions: the precise one of the 'facts' the painter feels attracted towards, and the more general one of the future of figurative art. In Bacon's case the facts seem to be mostly those of terror, isolation, and anguish. A visit to the large retrospective exhibition of Bacon's work held at the Tate Gallery in 1962 was an oppressive experience. Bacon has been through a number of stylistic changes: the screaming popes and businessmen that made him famous have now given way to harder, clearer, and in a way more disturbing images. Distorted figures cower in glaringly lit rooms, which suggest both the luxury apartment and the execution chamber. These figures are not merely isolated, they are abject: man stripped of his few remaining pretensions.

Bacon's consistent, narrow art represents at least one of the positions that it is possible to take up, *vis-à-vis* mid twentieth-

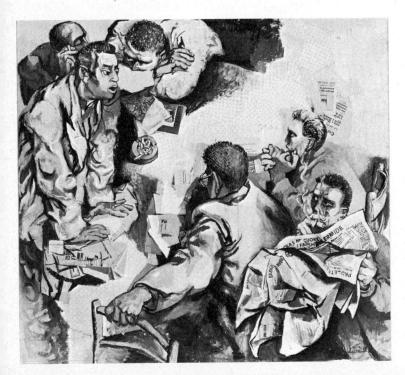

42 RENATO GUTTUSO The Discussion 1959–60

43 EDWARD MIDDLEDITCH Dead chicken in a stream 1955

century experience. But, though the unease of his work has impressed both the ordinary spectator and his fellow artists, there is no such thing as a 'school of Bacon', even in England. The attitudes he has taken up preclude membership of any group or movement.

Still more isolated from the main current of contemporary art is the work of Balthus. He differs from Bacon in being more naturalistic, in eschewing improvisation, in being influenced by artists such as Courbet and Piero della Francesca who could never be described as Bacon's masters (Bacon's debts are mostly to Velázquez). But they still have much in common. Like Bacon, Balthus broods on private obsessions; like Bacon, he often uses the symbolism of figures in a room which claustrophobically contains and shuts them in. If Bacon

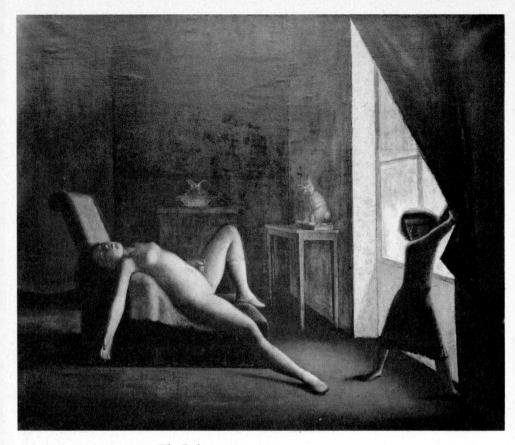

44 BALTHUS The Bedroom 1954

Ill. 44

4 occasionally seems to depict the aftermath of rape, Balthus gives its foretaste. Nude, adolescent girls sprawl in abandoned poses, inviting sexual violence. Light gilds their contours, with a hand which is secretive and loving.

Bacon and Balthus stand out among their contemporaries because each is endowed with a very special temperament, one which overrides all considerations of style. Few artists are endowed with the perhaps burdensome qualities which these two seem to possess, and the development of European painting was to go a very different way.

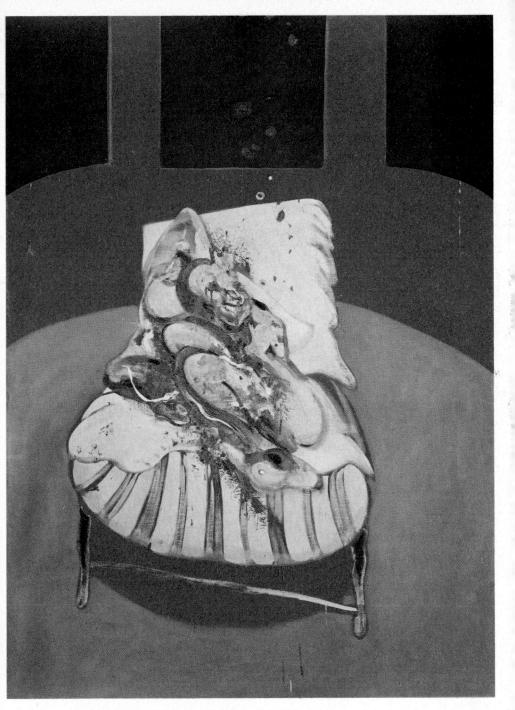

45 FRANCIS BACON One of three studies for a Crucifixion 1962

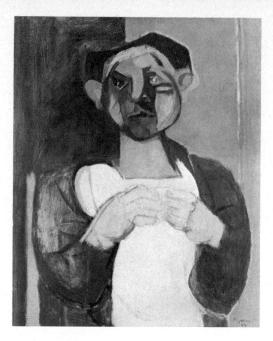

46 ÉDOUARD PIGNON The Miner 1949

47 MAURICE ESTÈVE Composition 166 1957

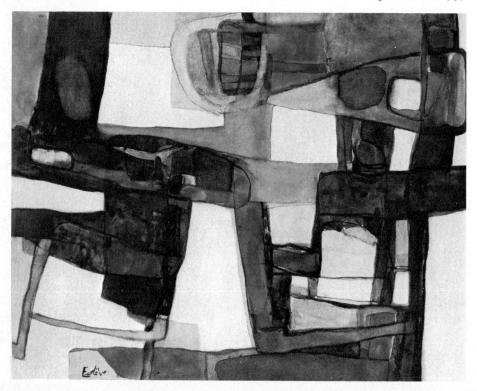

48 JEAN BAZAINE Shadows on the hill 1961

I have spoken of the sudden attention which was devoted to the great names of the Ecole de Paris immediately following the war. For younger artists in France, the process of growing up under the shadow of these giant reputations was bound to be a difficult one. Those artists most spoken of as 'promising' in Paris at this time were the so-called 'middle generation', which consisted of Jean Fautrier, Maurice Estève, Edouard Pignon, and Jean Bazaine among others. These men were expected to do several entirely contradictory things at the same time. It was their duty to maintain the impetus of the modernist revolution; it was equally their duty to maintain the prestige of Paris, and the whole apparatus of dealers and critics that went with Paris as a centre. Naturally they found themselves in two minds. Their development was not made any easier by the vigorous promotion they received.

Of the painters whom I have just mentioned, Fautrier is without question the most original and important, as well as

Ills 46-8

49 JEAN FAUTRIER Hostage 1945

50 WOLS The Blue Pomegranate 194

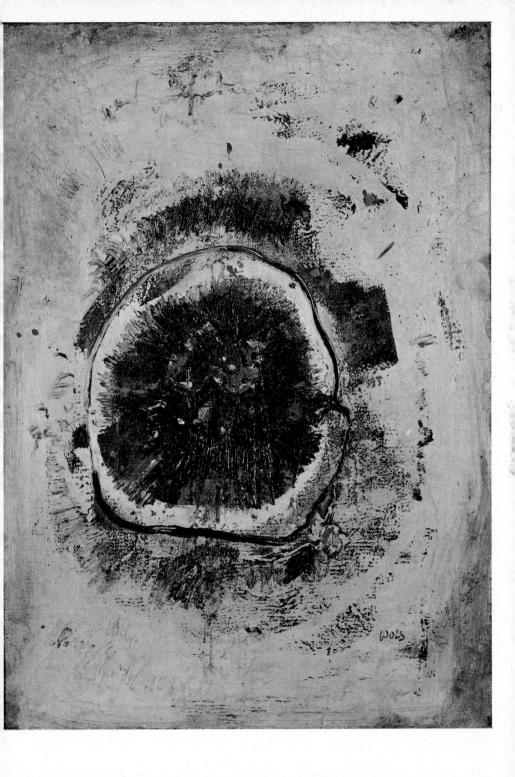

being the oldest. He was born in 1898, the other three in the middle of the next decade. Fautrier's first post-war show, at the Galerie Drouin in 1945, which consisted of the series of pictures called Hostage, did have a significance for the future. The ostensible subject was the mass deportations during the war, but the paintings put great stress upon the tactility of the painter's materials, the evocative quality of the surface itself. There is a narcissism in this which tells us something about the waning vitality of French painting, but it was also a genuine innovation. One sees in these pictures the first steps being taken towards art informel - art 'without form' - the style which was to dominate the next decade; and it is interesting to note that the step was made before the influence of the American abstract expressionists had reached France. Bazaine, Estève, and Pignon are lesser figures. In their work, fauvism, cubism, and expressionism jostled together to make an amalgam that had little that was new in it, save the fact of the mixture.

There were, however, better artists than these at work in the Paris of the late 1940s and the 1950s: men who did something, if not enough, to justify the critic Michel Tapié's claim, in his book *Un Art autre*, that there was now a kind of painting which started from premisses wholly different from the traditional ones. Most of the painters whom Tapié supported were working in a direction which paralleled that being taken by the abstract expressionists in America. The pioneer, almost the Arshile Gorky of this group, was the short-lived German artist Wols. Wols began by training as a violinist, then went to study at the Bauhaus in Berlin under Moholy-Nagy and Mies van der Bohe. In the early 1020s he moved to Paris and formed links

Rohe. In the early 1930s he moved to Paris, and formed links with the surrealists. The rest of the decade was divided between France and Spain: at this period Wols worked mostly as a photographer. In 1939–40 he was interned, and began to achieve his mature style in a series of drawings. These were successfully shown at the Galerie Drouin in 1945, and Wols began to exercise a real influence over his contemporaries. The paintings he made in the few years that remained to him (he

Ill. 49

died in 1951) seem to blend the graphic sensibility of Klee with the new and more freely abstract way of seeing things. Wols's fascination with the actual substance of which the picture is made, the thick impasto which can be scratched and carved, prompts a comparison with Fautrier.

Hans Hartung was a compatriot of Wols. During the art boom of the mid 1950s, he was to score a resounding success, thanks to a rather limited formula for picture-making which is correspondingly easy to recognize. Like Wols, Hartung left Germany in the 1930s, and settled in Paris, where he was encouraged by the sculptor Julio González. What he had to show now, in the years immediately following the war, was a vigorous calligraphy of bundled sheaves of lines. No picture of Hartung's is wholly without energy, but, once one has seen a group of them, it is certainly possible to wonder why a given mark, a given brushstroke, appears in one canvas and not in another.

51 HANS HARTUNG Painting T 54-16 1954

52 JEAN-PAUL RIOPELLE Encounter 1956

53 ANTONIO TAPIÉS Black with two lozenges 1963

Another very fashionable painter in the 1950s was the French-Ill. 52 Canadian Jean-Paul Riopelle. Riopelle, too, has an effective but limited formula. His work is an attempt to marry the spontaneity of 'informal' abstract painting to the rich texture and colour which are to be obtained from a heavy impasto. Here, as in Hartung's paintings, there is vigour of rather an obvious sort. The bright colour emphasizes the mechanical roughness of the surface, but the two elements – colour and texture – do not quite coalesce.

A stronger artist, whose work is akin to informal abstraction, but stands somewhat apart from it, is the poet-draughtsman Henri Michaux. Michaux seems to have turned to making drawings as a means of conveying meanings which it was impossible to catch in writing (he had been a prominent literary figure since the 1930s). Many of these meanings were connected with the altered states of consciousness induced by

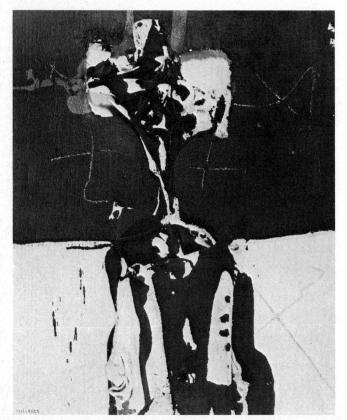

54 MANOLO MILLARES No. 165 1961

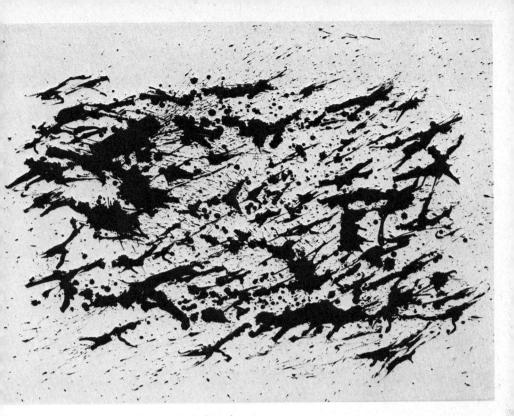

55 HENRI MICHAUX Painting in india ink 1960–7

hallucinogenic drugs. Michaux's drawings are so alike that, when they are seen in bulk, the effect becomes monotonous; but the best of them come surprisingly close to some of Pollock's work.

The new abstraction scored an enormous success not only in Paris, but in the rest of Europe. Painters such as Antonio Tapiés in Spain, and Alberto Burri in Italy are recognizably part of the same impulse. Both are interesting because of the way in which they relate an international tendency to a national situation. Tapiés, who is self-taught, began to paint in 1946, and had his first one-man show in Barcelona in 1951. His work shows a fascination with surfaces, textures, and substances which links him closely to the French 'matter painters', such as Fautrier,

who directly influenced him. Tapiés brings the spectator face to face with one of the paradoxes of the radical art of the postwar epoch. He is in politics a liberal, and it is not without significance that he comes from Barcelona, traditionally the centre of left-wing sentiment in Spain. Yet his work is by its nature and concepts too ambiguous to give much uneasiness to the government. With its 'hand-made' textures, it tends to align itself with the products of the Spanish luxury crafts, such as fine leatherwork. This may give us the reason why Tapiés, and other Spanish artists whose work in a general way resembles his, such as Manolo Millares, have enjoyed a certain degree of favour in the eyes of the authorities. What they create has become a form of prestige export, better known abroad than in its country of origin.

Burri is a rather similar case. He was a doctor during the war, and first began to paint in 1944, in a prison camp in Texas. When he was set free, he gave up his practice in order to continue painting. His first exhibition was held in 1947. Burri is best known for works made of sacking and old rags: his reason for using these materials was that they reminded him of the blood-soaked bandages he had seen in wartime. He has also made use of charred wood, of plastic foil burned and melted with a blow-lamp, and of battered plates of tin. The programme put forward to justify these works is the existentialist one of metaphysical anguish, but what strikes one instead is their good taste, their easy sensuousness.

Indeed, it is possible to feel that nearly all the European free abstractionists of the late 1940s and early 1950s suffer from a thinness of emotion and a restriction of technical means. At the same time, one must sympathize with their predicament. As can be seen from the work of Wols and Fautrier, they were exploring a kind of painting which had also attracted the leading Americans. The European experiments were, however, less radical and less sure of their direction than those being made in New York. The long-standing European (and especially French) tradition of *belle peinture* – of the painting as a beautiful

1 4

Ill. 54

⁵⁶ ALBERTO BURRI Sacco 4 1954

and luxurious object, a bed of delight for the senses – stood in the way of radicalism. The American worship of 'rawness' is to be found, although in another form, in Picasso's *Demoiselles d'Avignon*, but it is not visible in the art which was being produced in France some forty years later. When the new Americans began to be exhibited in Europe, as when Peggy Guggenheim's collection made a tour of European cities in 1948, the effect was overwhelming. One reason that the Americans triumphed so easily was to be found in the fact that their European colleagues were already partly converted – enough so to understand what they were being offered – but had not yet achieved so spectacularly radical a stance. Yet European artists found it difficult to use abstract expressionism as a starting-point, because the American statement had a completeness of its own. The dilemma is clearly shown in the work of Pierre Soulages, and in that of Georges Mathieu. Soulages can, on occasion, look like a sweeter and less committed version of Franz Kline, but his broad strokes of the brush do not have the energy or the constructional quality which one finds in the American artist.

Ill. 57

Mathieu is a more interesting figure than Soulages. His work Ill. 58 has affinities with that of Pollock, though he started painting in a freely calligraphic way so early (1937) that there can be no question of direct derivation. Rather, his has been an independent development along similar lines: which does not amount to a claim that Mathieu is an artist of the same stature as Pollock. For instance, his pictures, even the very large ones, are always far less complex than those painted by the American. Image and background have separate identities, which is not the case with Pollock; and there is in Mathieu's work little real feeling for space, even for the shallow, flattened version of it that Pollock uses. Mathieu writes on the canvas in a series of bravura scribbles. These scribbles do not blend with the ground; they dominate it. Rhythmical as they are, they express little beyond a delight in their own ease and dash. Mathieu seems very much the virtuoso, satisfied with his own tricks.

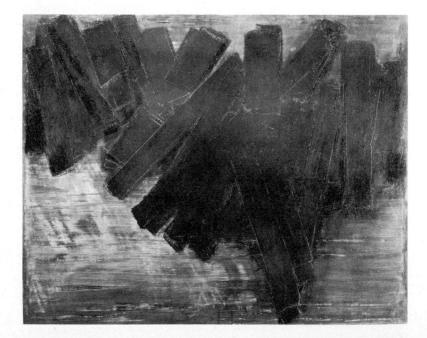

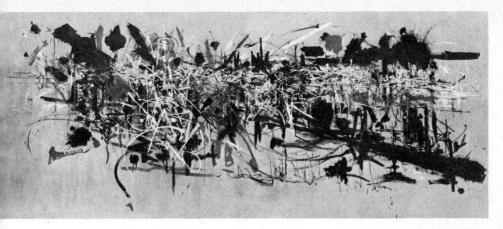

58 GEORGES MATHIEU Battle of Bouvines 1954

Nevertheless, he has an importance which is unconnected with the flashy triviality of so many of his pictures. He has been an efficient and intelligent publicist and organizer: it was he who arranged the exhibition in which the new French and American painters were shown together for the first time. More, he has been in all senses a forerunner, a man keenly attuned to the seminal ideas of the time. When, in 1956, Mathieu painted a twelve-foot canvas in the presence of a large audience at the Théâtre Sarah Bernhardt, he anticipated the 'Happenings' which American artists were to make fashionable a few years later, as well as recalling some of the antics of the dadaists and surrealists. Modern art has produced a crop of dazzling showmen, and Mathieu, like Salvador Dali, has been one of these.

Art informel, though the best publicized of the European developments after the war, was by no means the only new beginning. Even more significant, in many ways, was the shortlived Cobra Group of 1948–50. The name is taken from the names of the cities which the various participants hailed from: Copenhagen, Brussels, Amsterdam. Among its members were the Dane Asger Jorn, the Dutchman Karel Appel, and the Belgians Corneille and Pierre Alechinsky. Like the abstract expressionists, the artists of the Cobra Group were interested in giving direct expression to subconscious fantasy, with no

Ills 59, 61 Ills 62, 63

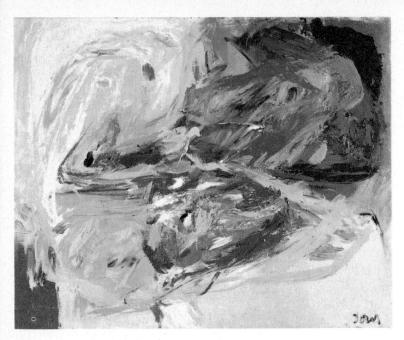

59 ASGER JORN You never know 196660 ALAN DAVIE The Martyrdom of St Catherine 1956

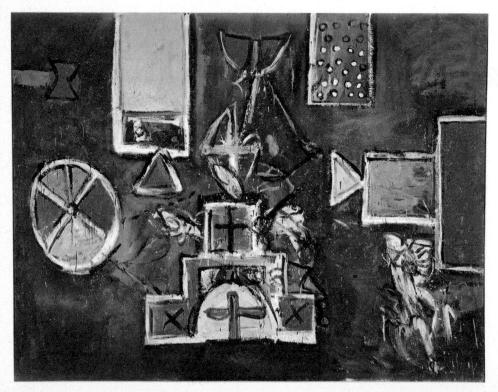

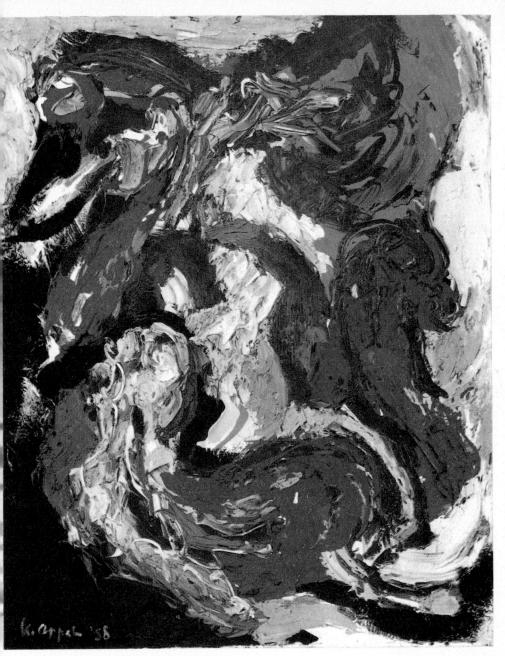

⁶¹ KAREL APPEL Women and birds 1958

censorship from the intellect. But they did not rule out figuration: in this they resembled Fautrier and Wols, rather than Hartung, Soulages, and Mathieu. Expressionism had struck deep roots both in Scandinavia (with Munch) and in Holland and Belgium. The Dutch-American de Kooning shows its impress just as clearly as Karel Appel, a Dutchman who has remained a 'European'. In one sense, therefore, the Cobra Group revives and continues an old tradition, rather than making a completely fresh start. This led to a greater complexity of reference than we usually find in the art of the immediately post-war period. An artist like Jorn veers from the cheerful to the sinister. His pictures incorporate a wide range of references; thanks to his interest in myths and magic, Jorn has access to a great range of signs and symbols. He is also a notably bold colourist. Yet he and his colleagues have had less impact than one might have predicted, and the same is true of an English artist whose work in some respects resembles theirs, Alan Davie. Davie formed one of the few real bridges between

63 CORNEILLE Souvenir of Amsterdam 1956

English and Continental art at this period, and was exhibited in European exhibitions where English painters were seldom seen.

More loosely linked to the Cobra group than Davie, yet working in a parallel style, is the Austrian Hundertwasser. In his work, expressionism becomes formal and decorative, under the influence of Art Nouveau.

Yet there is one European artist of crucial importance who is related to the Cobra Group painters, as well as to Wols and to Fautrier Jean Dubuffet is one of the few really major artists to have appeared in France since the war, though 'since the war' is perhaps the wrong phrase, for Dubuffet was at work as a painter long before 1945. But his first one-man show was held in 1945, a few months after the Liberation.

The picture illustrated contains the clues to many of Dubuffet's *Ill.* 65 preoccupations. He is interested in child art, in the art of madmen, in graffiti on walls and pavements, and in the accidental markings and maculations to be found on these surfaces. Dubuffet is the most persistent explorer of the possibilities

Ill. 64

64 HUNDERTWASSER The Hokkaido Steamer 1961

offered by materials and surfaces to have appeared during the past twenty years. He says:

In all my works . . . I have always had recourse to one nevervarying method. It consists in making the delineation of the objects represented heavily dependent on a system of necessities which itself looks strange. These necessities are sometimes due to the inappropriate and awkward character of the material used, sometimes to the inappropriate manipulation of the tools, sometimes to some strange obsessive notion (frequently changed for another). In a word, it is always a matter of giving the person who is looking at the picture a startling impression that a weird logic has directed the painting of it, a logic to which the delineation of every

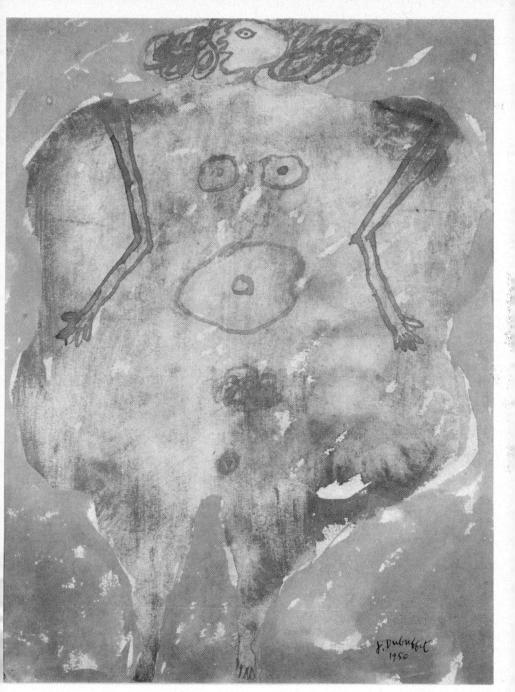

65 JEAN DUBUFFET Corps de Dame 1950

object is subjected, is even sacrificed, in such a peremptory way that, curiously enough, it forces the most unexpected solutions, and, in spite of the obstacles it creates, brings out the desired figuration.²

The artist here proclaims himself the ally of certain important creators in the other arts. There seems to be a real affinity, for example, between Dubuffet's methods and those adopted by the dramatist Eugène Ionesco. Dubuffet and Ionesco alike are heavily permeated with the idea of 'the absurd', perhaps more thoroughly so than Sartre, with whom it originated. Dubuffet appears in his statements about art as a man of culture who is sophisticatedly obsessed with the anti-cultural. His work shows how hard it is for the modern artist to break out of the prison of 'taste'. His remarks about the *Corps de Dame* series, which I have already mentioned in connection with de Kooning, show just how such considerations creep into his work, more or less by the back door:

It pleased me (and I think this predilection is more or less constant in all my paintings) to juxtapose brutally, in these feminine bodies, the extremely general and the extremely particular, the metaphysical and the grotesquely trivial. In my view, the one is considerably reinforced by the presence of the other.³

Dubuffet has spent his life, not so much in breaking new ground, as in trying to see what could be done with the existing heritage of the Ecole de Paris, by misusing it as well as using it. He has made sculpture out of clinker, foil, and papiermâché, and pictures from leaves and butterfly-wings. The result is an *œuvre* in which the individual works are nearly always fascinating, either in their grossness or their intricacy, or some intermingling of these two qualities. Dubuffet's creative limits are to be found in his selfconsciousness, and the degree to which his work is an exegesis rather than a truly original contribution to modernism. It comments both wittily and pertinently, but we are aware that, to savour these comments fully, we must

66 BERNARD BUFFET Self-portrait 1954

have at least some knowledge of modern art, its theories and its controversies.

Nevertheless, Dubuffet seems to me to sum up many of the leading tendencies to be found in the visual arts in the period immediately following the war. The priority given to the inner world of the artist, and the rejection of the traditional claims of art to be more coherent, more organized, and more homogeneous than 'non-art', or 'reality', were pointers to the future.

The difficulties of a more traditional approach can be judged from the work of two other painters who made their reputations at about the same period. One of them need not detain us long, however. Dubuffet's near-namesake Bernard Buffet *Ill. 66* had a spectacular <u>success</u> in the 1940s and 1950s with schematic figurative paintings which were literal interpretations of the gloomier and more superficial aspects of Sartre's existentialist philosophy. Buffet's interest really lies in the fact that quite a large section of the public received him so eagerly as an acceptable representative of modern art.

Another, equally popular and far more gifted painter was Ill. 67 the tragic Nicolas de Staël. In terms of natural endowments for painting, de Staël is the only French painter of the immediately post-war generation with serious claims to rival Dubuffet. The two artists pursued opposite courses. Instead of accepting absurdity and fragmentation, and exploiting them. as Dubuffet did and does, de Staël looked for a synthesis, and in particular for a synthesis between the claims of modernism and those of the past. He began as an abstract painter, with certain affinities to Riopelle. Abstraction dissatisfied him, and gradually he came closer and closer to figuration, first through a series of Football players, and then in the late landscapes and still-lifes for which he is best known. These extremely simplified paintings can be seen both in abstract terms and as representations. A skilful, delicate balancing-act is going on in them; the various planes must be made to advance and recede in such a way that the 'abstract' paint surface is never broken; so that we never feel that the representation is being forced on us, but rather, that it has come about naturally as the result of the play of form against form and colour-area against colour-area. In his best pictures, de Staël achieves his aim : the paint surface is placidly, creamily delicious; the colours have a sonority that reminds us of the painter's Russian ancestry.

But is this an art which lives up to the great claims that have been made for it since the painter's suicide in 1955? De Staël has been compared to Poussin (that high compliment of the academic art critic), has been called the greatest of post-war painters, and so forth. True, with his piquant combination of the traditional and the original, he appeals to many spectators: to find a Poussin-like scheme of forms under an apparently abstract and arbitrary surface is strangely reassuring. The question is if the power to reassure is enough to make a genius. De Staël's compromise between figuration and abstraction pales beside the obsessive force of Bacon or Balthus. The abrasive style of Bacon makes an especially interesting contrast, because Bacon, too, owes something to the arbitrary procedures of

⁶⁷ NICOLAS DE STAËL Agrigente 1954

abstraction but tries to yoke them to a figurative vision. While it would be foolish to deny the calm beauty of de Staël's best work, it seems obsessed with a perfectionism which in the end becomes sterile. As a painter, he succeeds rather as Whistler did before him, not through the invention of new forms, but through tact and taste in the manipulation of pre-existing ones.

The path of tact and taste was certainly not the one which the post-war arts were to pursue. Abstract expressionism and *art informel* were to be followed by a rapid succession of other styles, none of them owing much to traditional ideas about *belle peinture*.

Post-painterly abstraction

As it turned out, however, there was one style which held its own in the wake of abstract expressionism, and which, while owing something to the abstract expressionist example, had deep roots in the European art of the 1920s and 1930s. 'Hard edge' abstraction never completely died out, even in the palmiest days of Pollock and Kline. By 'hard edge' I mean the kind of abstract painting where the forms have definite, clean boundaries, instead of the fuzzy ones favoured, for example, by Mark Rothko. Characteristically, in this kind of painting, the hues themselves are flat and undifferentiated, so it is perhaps better to talk of colour-areas and not forms.

One of the progenitors of this kind of painting in America

Ill. 70

was losef Albers who has already been referred to because of his importance as a teacher. Albers had been closely connected with the Bauhaus during the 1920s: in fact, as student and teacher, he worked there continuously from 1920 to 1933, when it was closed, a longer period of service than any other Bauhäusler. During the 1930s, when he was already living in albury (olory (illusion) America, Albers took part in the annual shows mounted by the Abstraction-Création group in Paris. He was thus thoroughly cosmopolitan. Albers's cast of mind is very typical of the Bauhaus atmosphere: systematic and orderly, but also experimental. He was, for instance, very much interested in Gestalt psychology, and this led him towards an exploration of the effects of optical illusion. Later he was drawn towards a study of the ways in which colours act upon one another. The pictures and prints of the Homage to the Square series, Albers's best-known works, are planned experiments with colour.

94

68 MAX BILL Concentration to brightness 1964

Albers is interesting not only in himself, but because he seems to stand at the point where several attitudes towards painting converge. The systematic element in his work relates it to that of two Swiss artists, Max Bill and Richard Lohse Bill is also a Bauhaus alumnus, and, in his subsequent career, has become a sort of universal genius, at once artist, architect, and sculptor. The serial development of colour has been one of his interests throughout his career. Bill and Lohse are usually spoken of as exponents of 'concrete art', and Albers is lumped in as a third member of the triumvirate. On the other hand, Albers's interest in optical illusion relates him to the so-called op artists, while his particular treatment of form brings him into relationship with what critics have now labelled 'post-painterly abstraction'.

Ills 68, 69

If one looks for a difference between Albers and his two Swiss colleagues, it seems to lie in the treatment of form. Albers's squares are free, passive, unanchored, floating, and it is this passivity which has come to seem particularly typical of a great deal of post-abstract expressionist painting in America. The difference between 'hard edge' and 'post-painterly abstraction' is precisely that it is not the hardness of the edge that counts, one colour abutting firmly upon another, but the quality of colour. It does not matter whether the colour melts into a neighbouring hue, or is sharply differentiated from it: the meeting is always passive. Albers's squares are crisp enough, but generate no energy from this crispness of outline.

Another painter whose work has something of this quality, without qualifying as post-painterly abstraction in the strictest

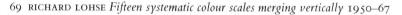

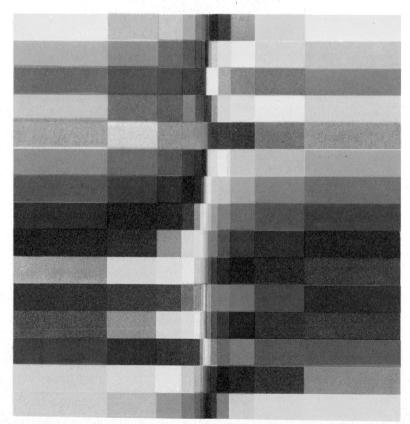

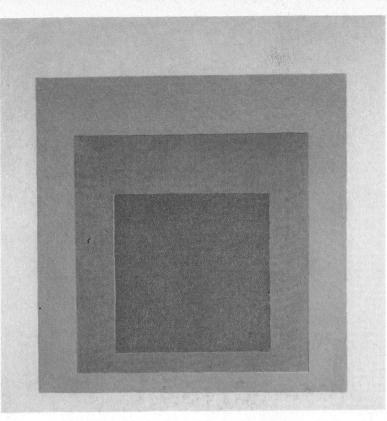

70 JOSEF ALBERS Homage to the Square 'Curious' 1963

sense, is Ad Reinhardt, who made a reputation as *the* professional nonconformist of the New York art world during the 1950s, and succeeded in retaining it until his recent death. Influenced by the abstract decorative art of Persia and the Middle East, Reinhardt went through a phase in the 1940s when his work came close to the calligraphy of Tobey. But these 'written' marks drew together, and became rectangles which covered the whole picture surface. From an orchestration of intense colours, Reinhardt moved towards black. The characteristic paintings of his last phase contain colours so dark, and so close in value to one another, that the picture appears to be

71 ELLSWORTH KELLY White – Dark Blue 1962

72 AL HELD Echo 1966

black, or almost black, until it is closely studied, at which point the component rectangles slowly emerge from the surface.

It is interesting to contrast Albers and Reinhardt with 'hard edge' painters who have a more conventional, but still very American, attitude towards composition. Among these are Al Held, Jack Youngerman and Ellsworth Kelly. Of these, Kelly is probably the best known. His painting consists of flat fields of colour, rigidly divided from one another. Sometimes one colour will contain another completely, so that the picture consists of an image placed upon a ground. These are usually Kelly's weakest works, especially when the image itself is derived from some natural form, such as a leaf. At other times it seems as if the canvas, already very large, has not been big enough to accommodate the form, which is arbitrarily sliced by the edge, and continues itself in the mind's eye of the

73 JACK YOUNGERMAN Totem black 1967 Ills 71-3

74 BARNETT NEWMAN Tundra 1950

spectator. As a device to impart energy and interest to the painting, this is quite successful, but there is something rather gimmicky and tricky about it. There is also the fact that 'energy' and 'interest' are traditional pictorial concepts which, in the sense in which I have just used them, Albers, Reinhardt, and the post-painterly abstractionists seem alike determined to reject.

What links Albers and Reinhardt with the so-called postpainterly abstractionists is, in part, the fascination not with pictorial means, but with aesthetic doctrine. The doctrinaire nature of post-painterly abstraction is striking. Rather as the logical positivists have concentrated on the purely linguistic aspects of philosophy, so the painters who adhere to the move-

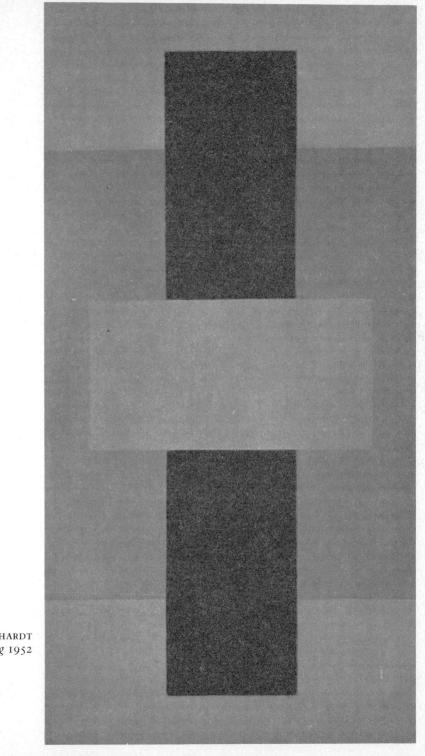

75 AD REINHARDT Red painting 1952

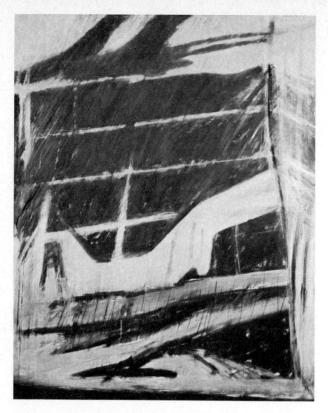

76 JACK TWORKOV North American 1966

ment have been concerned to rid themselves of all but a narrow range of strictly pictorial considerations. The American critic Barbara Rose notes that

in the process of self-definition, an art form will tend toward the elimination of all the elements which are not in keeping with its essential nature. According to this argument, visual art will be stripped of all extravisual meaning, whether literary or symbolic, and painting will reject all that is not pictorial.¹

Rising out of what Jacques Barzumon one occasion described as the 'abolitionist' nature of abstract expressionism (referring to its apparent desire to do away with the art of the past), the new style rejected stratagems even more completely than Albers and Reinhardt.

The two painters who can be thought of as its real originators are Morris Louis and the veteran abstract expressionist Barnett Newman, though other abstract expressionists, such as Jack Tworkov, also show some characteristics of post-painterly abstraction in their later work; an example is the use of thinned paint, which gives a 'flat' look to the canvas.

By 1950 - that is, while abstract expressionism was at the height of its success - Newman's aims were already clear. He wanted to articulate the surface of the painting as a 'field', rather than as a composition - an ambition which went considerably beyond Pollock. Newman's way of achieving the effect he wanted was to allow the rectangle of the canvas to determine the pictorial structure. The canvas is divided, either horizontally or vertically, by a band, or bands. This line of division is used to activate the field, which is of intense colour. with some small variations of hue from one area to another. The American critic Max Kozloff declares that, in Newman's work, 'the colour is not used to overwhelm the senses, so much as in its curious muteness and dumbness, to shock the mind'. He adds: 'Newman habitually gives the impression of being out of control without being in the least bit passionate.'2 Whether one agrees with this verdict or not, muteness and lack of passion - 'coolness' in the slang sense of the term - were certainly to be characteristic of the new phase of American art.

With Newman, however, we still get the sense that the canvas is a surface to which pigment has been applied. Morris Louis differs from this, in being not so much a painter as a stainer. The colour is an integral part of the material the painter has used, and colour lives in the very weave of it.

More even than the leading abstract expressionists, Louis was an artist who arrived at his mature style by means of a sudden breakthrough. This suddenness is one of the things which has to be taken into account when discussing his work. Louis was not a New Yorker. He lived in Washington, and New York was a place he was notoriously reluctant to visit. In April 1953, Kenneth Noland, a friend and fellow painter, persuaded him to

Ills 74, 78, 80 Ill. 76

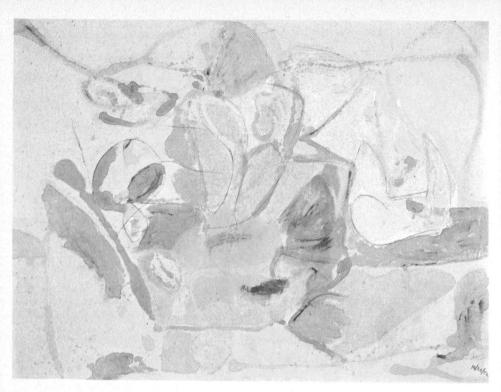

⁷⁷ HELEN FRANKENTHALER Mountains and sea 1952

make the trip, both to meet the critic Clement Greenberg and to see something of what was currently being done by the New York artists. Louis was then aged forty-one, and had produced no work of more than minor significance up to that point.

Ill. 77

The trip was a success, and Louis was especially impressed by a painting by Helen Frankenthaler, *Mountains and sea*, which he saw in her studio. The effect on his work was to draw him towards both Pollock and Frankenthaler as influences. Some months of experiment followed, but by the winter of 1954 he had suddenly arrived at a new way of painting. One aspect of its novelty was its technique, which Greenberg later described in this way:

Louis spills his paint on unsized and unprimed cotton duck canvas, leaving the pigment almost everywhere thin enough,

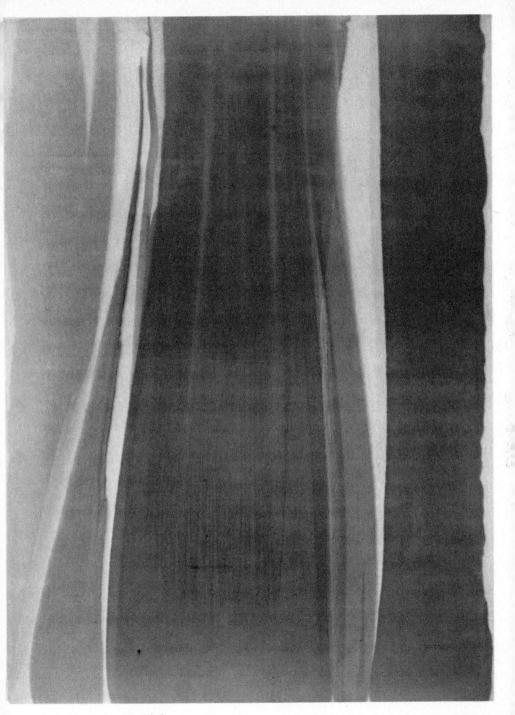

no matter how many different veils of it are superimposed, for the eye to sense the threadedness and wovenness of the fabric underneath. But 'underneath' is the wrong word. The fabric, being soaked in paint rather than merely covered by it, becomes paint in itself, colour in itself, like dyed cloth; the threadedness and wovenness are in the colour.³

In fact, Louis achieved his originality partly through the exploitation of a new material, acrylic paint, which gave his paintings a very different physical make-up from those of the abstract expressionists. The staining process meant a revulsion against shape, against light and dark, in favour of colour. As Greenberg remarked: 'His revulsion against cubism was a revulsion against the sculptural.' Even the shallow space which Pollock had inherited from the cubists was henceforth to be avoided.

One of the advantages of the staining technique, so far as Louis was concerned, was the fact that he was able to put colour into colour. His early paintings after the breakthrough are veils of shifting hue and tone: there is no feeling that the various colour configurations have been drawn with a brush. Indeed, Louis did not 'paint' even in Pollock's sense, but poured, flooded, and scrubbed the colour into the canvas. This departure from the process of drawing was in some ways rather a reluctant one. In later experiments, Louis was to try and recover some of the advantages of traditional drawing for the stain medium. This is particularly true of the series of canvases called *Unfurleds*, which were painted in the spring and summer of 1961. Irregularly parallel rivulets of colour now appear in wing-like diagonals at the edges of large areas of canvas which are otherwise left

The banked rivulets . . . open up the picture-plane more radically than ever, as though seeing the first marking we are for the first time shown the void. The dazzling blankness of the untouched canvas at once repulses and engulfs the eye, like an infinite abyss, the abyss that opens up behind the least

unpainted. Michael Fried remarks:

106

⁷⁹ KENNETH NOLAND Cantabile 1962

mark that we make on a flat surface, or *would* open up if innumerable conventions both of art and of practical life did not restrict the consequences of our act within narrow bounds.⁴

Louis's final period of activity (he died of lung cancer in 1962) resulted in a series of stripe paintings, in which stripes of colour, usually of slightly different thicknesses, are bunched together some distance from the sides of the canvases. Fried feels that these show, as compared to the *Unfurleds* which preceded them, a further strengthening of the impulse to draw. Yet, in their strict, undeviating parallelism, the lines of colour seem inert, and this is true even where, in three paintings of this series, the stripes run diagonally across the canvas. Inertia, strict parallelism, and the constructive impulse (as shown by the paintings with diagonal stripes) were all characteristics which Louis shared with the other post-painterly abstractionists.

Louis's friend and associate Kenneth Noland was slower in making his own breakthrough, and therefore belongs to a later stage of the development of this new kind of abstract painting. Noland, like Louis, adopted the new technique of staining, rather than painting, the canvas. And like Louis, he tends to

paint in series, using a single motif until he feels that he has exhausted its possibilities. The first important motif in Noland's work is a target shape of concentric rings. The pictures composed on this principle belong to the late 1950s and early 1960s. The target pattern was used, not as Jasper Johns used it contemporaneously, with the deliberate intention of alluding to its banality, but as a means of concentrating the effect of the colour. Often the targets seem to spin against the background of unsized canvas, an effect produced by the irregular staining at their edges. Fried notes:

The raw canvas in Noland's concentric-ring paintings . . . fulfils much the same function as the coloured fields in Newman's large pictures around 1950; more generally, Noland in these paintings seems to have managed to charge the entire surface of the canvas with a kind of perceptual intensity which until that time only painters whose images occupy most or all of the picture-field – Pollock, Still, Newman, Louis – had been able to achieve.⁵

80 MORRIS LOUIS Omicron 1961

81 KENNETH NOLAND Grave Light 1965

After experimenting with an ellipsoid shape which was no longer, in every case, in the exact centre of a square canvas, Noland began, in 1962, a series which used a chevron motif. Ill. 81 This was the signal for a growing concern with the identity of the canvas simply as an object. The framing-edge began to have an importance which, on the whole, had not been accorded to it since Pollock. At first, Noland allowed the raw canvas to continue to play its part. But the chevrons suggested the possibility of a lozenge-shaped support - a kind of picture which would be wholly colour, without any neutral areas, with the coloured bands moored to the bands of the frame. These canvases, like the late, diagonally striped paintings by Louis, have an obvious relationship to pictures by Mondrian, where the canvas is designed to be hung diagonally. The abstract expressionist and the constructivist traditions here begin to draw together.

After a while, Noland's lozenges grew narrower and longer, and eventually the chevron pattern was abandoned for stripes running horizontally on enormous canvases, some of them more than thirty feet long. Colour is thus reduced to its simplest relationship, as in the late paintings by Louis, and all pretence at composition is abandoned. These late pictures show the

109

extreme refinement of Noland's colour sensibility. As compared to his early work, the colour is paler and lighter. The tones are close together, which produces effects of optical shimmer, intensified by the sheer vastness of the field, which enfolds and swallows the eye. There is nothing painterly about the way in which the colour is applied; it does not even have the unevenness of Louis's stainings, and the colour-bands meet more crisply and decisively than Louis's stripes. Or, rather, they almost meet: on close examination they prove to be separated by infinitesimally narrow bands of raw canvas, an effect which Noland may have derived from the early paintings of Frank Stella.

Ills 82, 83

Stella though his work is often grouped with Louis's and with Noland's, is more of a structuralist than a post-painterly abstractionist. His concern is not so much with colour-ascolour, as with the painting-as-object, a thing which exists in its own right, and which is entirely self-referring. His work, however, does have a direct link to that of Barnett Newman.

The paintings which established Stella's reputation were those which were shown in the Museum of Modern Art exhibition 'Sixteen Americans' in 1960. They were all black canvases, patterned with parallel stripes about $2\frac{1}{2}$ inches wide, a width chosen to echo the width of the wooden strips used for the picture support. Stella went on to execute further series of stripe paintings, in aluminium, copper and magenta paint. With the aluminium and copper paintings, Stella began to make use of shaped supports. These made the paintings not only objects to hang on the wall, but things which activated the whole wallsurface. There was then a period of experiment with paintings where the stripes were of different colours, followed by one where the shaped canvases fitted together in series to make serial compositions. Most recently came asymmetrical canvases painted in vivid colours which segment the shapes, which are now sometimes curved. The effect is very much as if someone had cut up and systematized the 'orphic' canvases of Robert Delaunay, and there is also more than a hint of jazz-modern IIO

82 FRANK STELLA New Madrid 1961

patterns about them, which suggests a link to the most recent work of Roy Lichtenstein.

If Stella has seemed inclined to flirt both with the earliest modernism and with pop art, another colour painter Jules Olitski has been experimenting with what is essentially a critique of abstract expressionism. Olitski covers huge areas of canvas with tender stainings; in his recent work, these stained areas are often contrasted with a passage at the edge of the canvas in thick, luscious brushwork, reminiscent not so much of Pollock as of a European such as de Staël. The paintings themselves are usually vast. The paradox in Olitski's work is the hugeness of scale compared with the limitation of content – the pictures hint at an aesthetic position in order to deny it. The

Ill. 85

III

83 FRANK STELLA Untitled 1968

84 LARRY POONS Night Journey 1968

> 85 JULES OLITSKI Feast 1965

sweetness and prettiness are ironic, and yet at the same time truly meant and felt. More even than Noland's and Stella's work, these paintings address themselves to an informed <u>audience</u>.

Ill. 84

The same might be said about the work of Larry Poons. Though Poons has sometimes been called an op artist, his typical work makes it plain where his true allegiance lies. Essentially, his paintings consist of a coloured field, scattered at random with spots of contrasting colour. The eye is offered a multitude of points of focus, and skims about among them, without coming to rest. In Poons's earlier work, the optical effect is enhanced by the choice of tone and hue. The tones are close together, the hues in sharp contrast, which generates an afterimage in the eve. More recent pictures, however, tend to show that Poons's link to op art was accidental. The characteristic oval shapes have been enlarged until they are as big as, or bigger than, a man's footprint; the colour is muddy, the finish deliberately rough. The paintings now look like immensely enlarged microscope slides of slipper bacilli, and one feels that visual pleasure has been sacrificed to the characteristically strict application of a doctrine.

It is interesting to note that, while both abstract expressionism and pop art scored very considerable triumphs in Europe, post-

86 EDWARD AVEDISIAN At Seven Brothers 1964

87 JOHN HOYLAND 28.5.66 1966

painterly abstraction has not been nearly so successful in making an impact on the European art scene. When Parisians speak, sometimes rather bitterly, of the American rejection of 'our' painters, they are talking of the apparent dominance of postpainterly abstraction in New York. The one country outside the United States where its ideas have gained a considerable foothold is Britain, and this is something which symbolizes the transfer of influence over British art.

For example John Hoyland, one of the few British artists *Ill. 87* with an American command of scale, is essentially in the tradition of Louis and Noland. His use of the acrylic paint medium is enough to affirm it. But Hoyland sometimes gets a hostile reaction from American reviewers for not being sufficiently *pur sang*, sufficiently reductionist. He seems to owe something important to Matisse and to Miró, and his paintings have clearly not abandoned all traditional ideas on the subject of composition. One can even detect references to de Staël, whom Hoyland at one time admired very much.

115

Ill. 90 Robyn Denny's paintings, despite their strict bilateral symmetry, also remain more complex than the work of his American counterparts. The colours which Denny uses, either sombre or chalky, do not have the self-indulgence which one finds in Olitski, or in second-generation post-painterly ab Ill. 86 stractionists such as Edward Avedisian.

One of the things which seem to divide these British painters from their American colleagues is the fact that the British remain fascinated by pictorial ambiguity, and continue to juggle with effects of depth and perspective which are quite foreign to American art of the same kind. Work by painters such as John Walker, Paul Huxley, Jeremy Moon, and Tess Jaray all bears out this contention. Miss Jaray's work makes the

point particularly clearly, as one of its sources is perspective drawings of architecture.

88 TESS JARAY Garden of Allah 1966

Ills 89, 91 Ill. 88

89 JOHN WALKER Touch – Yellow 1967 90 ROBYN DENNY Growing 1967

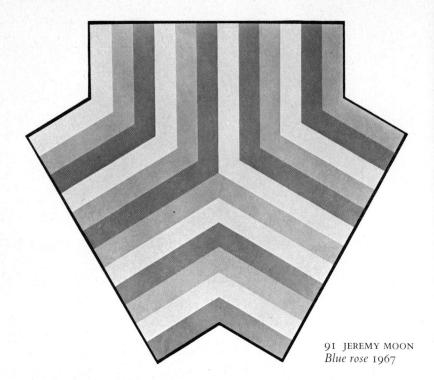

Post-painterly abstraction is a comparatively recent mode. Though Louis's breakthrough came in the mid 1950s, nearly all the painting I have discussed in this chapter has been done in the last ten years. In Britain and America it nevertheless enjoys the status of an orthodoxy. This has had one unexpected result. Where the partisans of abstract expressionism already spoke of it as an ultimate, a point beyond which art could not hope to progress, post-painterly abstraction seems yet more final. It has begun to be noticeable that artists who wish to find their way forward are now inclined to abandon the idea of the painting as a vehicle for what they want to do or say. Not only has this resulted in a great swing of attention towards sculpture, but it has led to an increasing number of experiments with mixed media, and in the field of kinetic art.

Pop

Post-painterly abstraction, as I have described it, was a continuation of abstract expressionism, at least in part. Pop art was a reaction against it, and to begin with it was pop which caused a greater degree of uproar. As I have explained in my first chapter, pop basically sprang from a shift of sources. Surrealism with its appeal to the subconscious, was replaced by dada, with its concern with the frontiers of art. But this was not a purely intellectual choice. There were forces within abstract expressionism and art informel which propelled artists towards the new mode. For example, as abstract expressionism began to exhaust many its impetus, the prevailing interest in texture led artists to everbolder experiments with materials. Some of these - with acrylic paint - were conducted by Morris Louis, and led to post-painterly abstraction. But most consisted of a re-exploration of the possibilities of collage. Using collage involved an important philosophic step for an artist already familiar with informal abstraction. There, an interesting texture was something which the artist created, but collage additions came to his hand ready-made; and Marcel Duchamp's idea of the 'readymade' was one of the central innovations of dada. Collage had been invented by the cubists as a means of exploring the differences between representation and reality. The dadaists and surrealists had greatly extended its range, and the dadaists, in particular, had found it especially congenial, and in line with their preference for anti-art. In the hands of the post-war generation, collage now developed into the 'art of assemblage', a means of creating works of art almost entirely from preexistent elements, where the artist's contribution was to be found more in making the links between objects, putting them together, than in making objects ab initio.

119

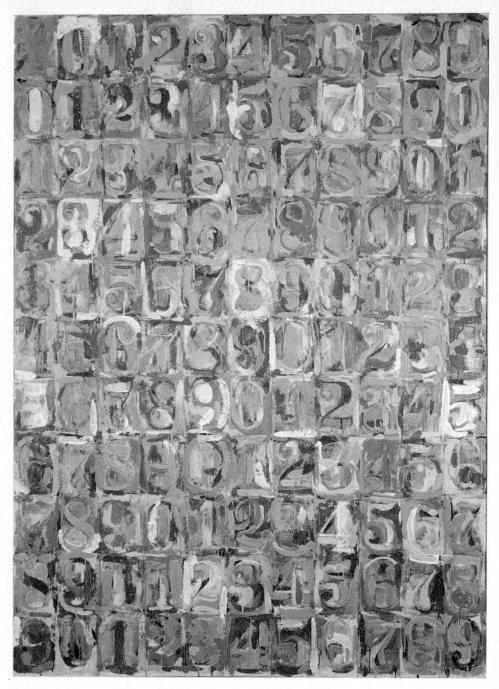

92 JASPER JOHNS Numbers in colour 1959

93 ARMAN Clic-Clac Rate 1960–6

94 JOSEPH CORNELL Eclipse series c. 1962

In 1961, the Museum of Modern Art in New York staged an important exhibition under the title 'The Art of Assemblage'. William C. Seitz remarked in his introduction to the catalogue:

The current wave of assemblage . . . marks a change from a subjective, fluidly abstract art towards a revised association with environment. The method of juxtaposition is an appropriate vehicle for feelings of disenchantment with the slick international idiom that loosely articulated abstraction has tended to become, and the social values that this situation reflects.¹

Assemblage was important for another reason too. It was not only that it provided a means of transition from abstract expressionism to the apparently very different preoccupations of pop art, but it brought about a radical reconsideration of the formats within which the visual arts could operate. For example, assemblage provided a jumping-off point for two concepts which were to be increasingly important to artists: the environment and the happening.

Of course, some practitioners of assemblage did not move very far beyond their original sources. The exquisite boxes made by Joseph Cornell, with their poetic juxtapositions of objects, and the witty collages of Enrico Baj, are things which explore the resources of a tradition, without seeking to enlarge them very radically. Other artists were not content with this. Most of them fall into the category which has now been rather slickly labelled 'neo-dada'. One would prefer to say, rather, that they are often artists who want to explore the idea of the minimal, the unstable, the ephemeral in what they do.

In America, the two most-discussed exponents of neo-dada have undoubtedly been Robert Rauschenberg and Jasper Johns. Of the two, Rauschenberg is the more various, and Johns the more elegant; elegance has a genuine, if rather uneasy, part to play in any discussion of what these two represent.

Ill. 96

Rauschenberg was born in Texas in 1925. In the late 1940s he studied at the Académie Julien in Paris, and then under Albers at Black Mountain College. In the early 1950s, Rauschenberg painted a series of all-white paintings where the only image was the spectator's own shadow. Later there was a series of allblack paintings. Neither of these developments was unique. The Italian painter Lucio Fontana did a series of all-white canvases in 1946; the Frenchman Yves Klein exhibited his first monochromesin 1950. After these experiments with minimality, Rauschenberg began to move towards 'combine painting', a mode of creation in which a painted surface is combined with various objects which are affixed to that surface. Sometimes the paintings develop into free-standing three-dimensional objects,

Ill. 94 Ill. 95

95 ENRICO BAJ Lady Fabricia Trolopp 1964

96 ROBERT RAUSCHENBERG Bed 1955

such as the famous stuffed goat which has appeared in so many exhibitions of contemporary American art. One painting makes use of a functioning wireless set, another of a clock. The artist has also used photographic images, which are silk-screened on to the canvas.

The aesthetic philosophy informing this is essentially that of the experimental composer John Cage, whom Rauschenberg met in North Carolina. One of Cage's basic ideas is that of 'unfocusing' the spectator's mind: the artist does not create something separate and closed, but instead does something to make the spectator more open, more aware of himself and his environment. Cage says:

New music; new listening. Not an attempt to understand something that is being said, for, if something were being said, the sounds would be given the shapes of words. Just an attention to the activity of sounds.²

Ill. 97

A characteristic painting of Rauschenberg's, such as the enormous *Barge* painted in 1962, is a kind of reverie which the spectators are invited to join; a flux of images which are not necessarily fixed and immutable. Cage remarks on 'the quality of encounter' between Rauschenberg and the materials he uses; one can compare this to the way in which Kurt Schwitters worked. But Rauschenberg is a Schwitters who has passed through the abstract expressionist experience.

So, for that matter, is Jasper Johns, though John's work gives one the impression of greater discipline. Johns is also more of an ironist. One work, entitled *The Critic Smiles*, is a toothbrush cast in sculpmetal, placed upon a plinth of the same material. Unlike Rauschenberg, Johns is chiefly known for his use of single, banal images: a set of numbers, a target, a map of the United States, the American flag. The point about these images is largely their lack of point – the spectator looks for a specific

Ill. 92

124

97 ROBERT RAUSCHENBERG Barge 1962

meaning, the artist is largely preoccupied with creating a surface. Where the manipulation of paint is concerned, Johns is a master technician. The way in which Johns operates also suggests links with other things besides pop art. Like Kenneth Noland, he is interested in pictorial inertia, for example. One of the reasons for choosing banal patterns is the fact that they no longer generate any energy. He is also interested in the idea of the painting as an object rather than as a representation. In some cases, he has used two canvases linked together, with a pair of wooden balls forced between them, so we see the wall behind at the point where they join. Other works have attachments: a ruler, a broom, a spoon.

It is clear from this description of the activities of these two artists that they represent a move away from 'pure' painting. Even to Johns, for all his virtuosity, painting is no more than a means of achieving a certain result, which might possibly be achieved some other way. Rauschenberg has for years been associated with the Merce Cunningham dance company: he performs with them as well as devising props and scenery, and clearly this forms as important and central a part of his activity as painting does.

98 EDWARD KIENHOLZ Roxy's 1961

One of the directions suggested by a painting like *Barge* is the move towards the tableau, the work of art which surrounds or nearly surrounds the spectator. The bulky and ferocious works of Edward Kienholz are an example.

Kienholz also represents one aspect of the tendency which is now often called 'funk', or 'funk art': the liking for the complex, the sick, the tatty, the bizarre, the shoddy, the viscous, the overtly or covertly sexual, as opposed to the impersonal purity of a great deal of contemporary art. Perhaps because if offers this kind of alternative, 'funk' art has proved more than a passing fashion, and has been responsible for some of the most alarming images of the 1960s – things such as Bruce Conner's *Couch* of 1963, which shows an apparently murdered and dismembered corpse lying on a crumbling Victorian sofa, or Paul Thek's *Death of a hippie*, or various tableaux by the Englishman, Colin Self. A characteristic one is another corpse, a figure entitled *Nuclear victim*.

Ill. 98

Ill. 99

Ill. 100

126

99 BRUCE CONNER Couch 1963

100 PAUL THEK Death of a hippie 1967

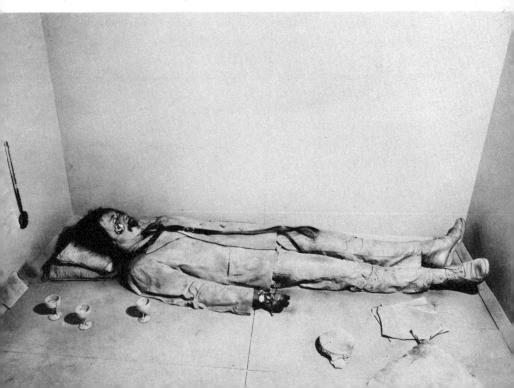

101 CHRISTO Packaged public building 1961

In Europe, an equivalent of the American neo-dadaists is supplied by what is sometimes called 'new realism', after the movement founded by the French critic Pierre Restany, in conjunction with Yves Klein and others. Restany claims that 'the new realism registers the sociological reality without any controversial intention'. What this means one may perhaps deduce from the work of Arman, who was one of the adherents of the group. Arman's most characteristic works consist of random accumulations of objects, but objects all of the same sort, encased in clear plastic. These accumulations can exist as panels, or be three-dimensional. For example, Arman has made a plastic torso of a woman, filled with writhing rubber gloves. Another artist attracted by the systematic is Christo, who is best known for his packages, mysterious lumpish objects which sometimes suggest and sometimes wholly conceal what is wrapped up in them.

The major personality among these European neo-dadaists was undoubtedly the late Yves Klein. Klein is an example of an artist who was important for what he did – the symbolic value of his actions – rather than for what he made. One sees in him an example of the increasing tendency for the personality of the artist to be his one true and complete creation.

128

Ill. 93

Klein was born in 1928. He was a jazz musician, a Rosicrucian, and a judo expert (he studied judo in Japan and wrote a book about it which is still a standard text). In judo, the opponents are regarded as collaborators, and it is this notion which seems to underlie a great deal of Klein's thinking about art. So does the wish to 'get away from the idea of art'. Klein said:

The essential of painting is that something, that 'ethereal glue', that intermediary product which the artist secretes with all his creative being and which he has the power to place, to encrust, to impregnate into the pictorial stuff of the painting.³

Besides creating the monochromes already mentioned, Klein adopted various unorthodox methods of producing works of art. For example, he used a flame-thrower, or the action of rain on a prepared canvas. (Paintings produced by the action of the

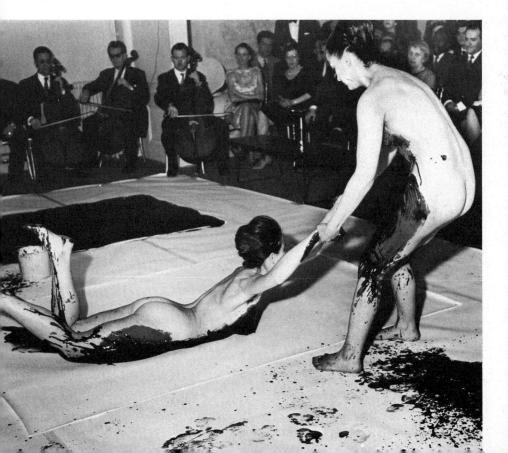

Ill. 102

elements he labelled Cosmogonies.) At his direction girls smeared with blue paint flung themselves on to canvas spread on the floor. The ceremony was conducted in public while twenty musicians played Klein's Monotone Symphony, a single note sustained for ten minutes which alternated with ten minutes silence. The making of these Imprints is recorded in the film Mondo Cane. On another occasion - in Paris in 1958 -Klein held an exhibition of emptiness: a gallery painted white, with all the furniture removed and a Garde Républicain stationed at the door. Albert Camus came, and wrote the words 'with the void, full powers' in the visitors' book. There were thousands of other visitors to the vernissage, so many as to cause a near-riot. Another of Klein's ideas was to offer for sale 'zones of immaterial pictorial sensitivity'. They were paid for in goldleaf, which the artist immediately threw in the Seine, while the purchaser burned his receipt.

These actions have a certain poetic rightness to them, a quality often absent from the clumsier and more elaborate happenings staged in New York. Klein, at the time of his death in 1962, seemed to stand at the meeting-point of a number of different tendencies. There is the obvious connection with the original dadaists, and also with certain contemporary artists

103 YVES KLEIN Feu F 45 1961

104 PIERO MANZONI Line 20 metres long 1959

105 LUCIO FONTANA Spatial Concept 1960

who stand on the fringes of dada, such as Lucio Fontana, whose own experiments with monochromes developed into the more familiar slashed canvases. Also reminiscent of Klein's work are the 'lines' of Piero Manzoni: single, unbroken brushstrokes which unroll on long strips of paper. All of these, in turn, are linked in a more general way with the tendency towards minimality in sculpture. On the other hand, Klein, as much as Johns and Rauschenberg, is one of the prophets of pop art. His use of monotony, of the undifferentiated, gives him something in common with Andy Warhol, for instance.

But only *something* in common. Neo-dada and pop art not identical, though neo-dada includes pop. The artists I have so far spoken of in this chapter are not, in my view, genuine practitioners of pop, though their work has been included in

Ill. 105

exhibitions and discussed in books under that label. The factors which created pop art were not universal, but had much to do with the urban culture of Britain and America in the years after the war. Only artists in close touch with that culture caught its special tone and idiom : of all the post-war styles, this is the one which most conspicuously has 'a local habitation and a name'.

After pop scored its initial success, it did, very naturally, exercise an influence elsewhere. Many of the artists connected with Pierre Restany's 'new realism' toyed with it. There are, for instance, Michelangelo Pistoletto's photographic figures fastened to mirror backgrounds in which the spectator sees himself reflected, thus completing the composition; and Martial Raysse's skilful parodies of painters such as Prud'hon. In a version of Prud'hon's *Cupid and Psyche* entitled *Tableau simple et doux*, Cupid holds a neon heart in his fingers. The young

106 MICHELANGELO PISTOLETTO Seated figure 1962 (with Pistoletto) 107 MARTIAL RAYSSE Tableau simple et doux 1965

Ill. 107

108 томіо мікі Ears (detail) 1968

Frenchman Alain Jacquet uses photographic images in a way which is reminiscent of both Warhol and Lichtenstein. The Japanese have been almost equally eager to catch up with pop. Tomio Miki has made almost as much a speciality of ears in cast aluminium as Warhol has of endlessly repeated images of Marilyn Monroe. In examining these works, however, one is aware that the involvement with the urban environment is not as immediate as it seems to be in the case of the leading British and American pop artists.

It now seems to be generally agreed that pop art, in its narrowest definition, began in England, and that it grew out of a series of discussions which were held at the Institute of Contemporary Arts in London by a group which called itself the Independent Group. It included artists, critics, and architects, among them Eduardo Paolozzi, Alison and Peter Smithson, Richard Hamilton, Peter Reyner Banham, and Lawrence Alloway. The group were fascinated by the new urban popular culture, and particularly by its manifestations in America. Partly this was a delayed effect of the war, when America, to those in England, had seemed an Eldorado of all good things,

109 RICHARD HAMILTON Just What is it that Makes Today's Homes so Different, so Appealing? 1956

from nylons to new motor-cars. Partly it was a reaction against the solemn romanticism, the atmosphere of high endeavour, which had prevailed in British art during the 1940s.

In 1956 the group was responsible for an exhibition at the Whitechapel Art Gallery which was called 'This Is Tomorrow'. Designed in twelve sections, the show was designed to draw the spectator into a series of environments. In his book on pop art, Mario Amaya points out that the environmental aspect probably owed something to Richard Buckle's exhibition of the Diaghilev Ballet, which was held in London in 1954, and which seized on the excuse of a theatrical subject to provide a brilliantly theatrical display.⁴ From the point of view of the future, however, probably the most significant part of 'This Is Tomorrow' was an entrance display provided by Richard Hamilton – a collage picture entitled *Just What is it that Makes Today's Homes so Different, so Appealing?* In the picture are a muscle-man from a physique magazine and a stripper with sequinned breasts. The muscle-man carries a gigantic lollipop, with the word POP on it in large letters. With this work, many of the conventions of pop art were created, including the use of borrowed imagery.

Hamilton already knew clearly what he thought a truly modern art should be. The qualities he was looking for were, so he said in 1957, popularity, transience, expendability, wit, sexiness, gimmickry, and glamour.⁵ It must be low-cost, mass produced, young, and Big Business. These were the qualities which British pop artists of the 1960s were afterwards to worship. But granted Hamilton's priority, and that of the Independent Group, it is still a little difficult to prove that pop art sprang directly from their activities. Of all the artists who belonged to the group, Hamilton himself is the only one who can be classified as a pop painter. In addition, there is the fact that he has always been a very slow worker, and that, at this period, little of his work was to be seen in England.

There were two other British painters who might be labelled 'transitional', both of them, as it happens, among the most interesting that Britain has produced in recent years. Both were students at the Royal College of Art in the mid 1950s. One is Peter Blake, who would classify himself unhesitatingly as a 'realist'. Blake's work represents a reversion to the tradition of the Pre-Raphaelites in the middle of the twentieth century. Like the Pre-Raphaelites, he is nostalgic, but not for the Middle Ages. What he looks back on is the popular culture of the 1930s and 1940s. Unlike other pop painters, Blake is always concerned to be a little out of date. His house is crammed with memorabilia –

Ill. 111

postcards, seaside souvenirs, toys, knick-knacks of every sort – and out of these is distilled a very personal poetry.

Ills 117, 118 Richard Smith represents an attitude which is almost the opposite to this. As a student, he painted in a figurative style which was influenced by the Euston Road School and the Kitchen Sink painters. He was still at the Royal College at the time of 'This Is Tomorrow', and on him, at least, the show had a demonstrable influence. During 1957–9 he shared a studio with Peter Blake, but in 1959 he left for America, and has divided his time between England and the United States ever since. Smith's earliest characteristic works were based on packaging. He was also influenced by colour photography, the kind of thing to be found in magazines such as *Vogue*.

112 DEREK BOSHIER England's Glory 1961

For men only starring MM and BB 1961

III PETER BLAKE Doktor K. Tortur 1965

His colour sensibility has remained unaltered through subsequent changes of style. He himself describes his colour as 'sweet and tender', and speaks of wanting to give 'a general sense of blossoming, ripening, and shimmering', but the paintings themselves have mostly shed any overt association with pop, though some canvases are stretched over threedimensional frames which may be a last, remote reminiscence of the shapes of packaging. What Smith has done is to pass through the experience of pop art in order to arrive at a position which approximates to that of the American colour painters. His change to acrylic paint in 1964 was an important step in this process. Smith, because he had successfully established himself in New York, meant a lot to his English colleagues, both as an example and as an influence. When he returned to England in 1961, he brought with him on-the-spot information about the activities of artists such as Jasper Johns which had an impact on artists such as Peter Phillips and Derek Boshier. Smith had already absorbed the American indifference to conventional limitations of format, and the American sense of scale, for example.

The key date in British pop was 1961, not so much because of Smith's resumption of contact with British artists, but because of the Young Contemporaries exhibition which was held in that year. This caused perhaps the greatest sensation of any student show held since the war. The reason was the presence of a group of young artists from the Royal College of Art: Phillips, Boshier, Allen Jones, and David Hockney. Exhibiting with them was a slightly older American student, R. B. Kitaj. Kitaj, like Smith, had a first-hand knowledge of American techniques, and he fostered the new obsession with popular imagery among his fellow students.

One of the weaknesses of British pop art was its easy and rapid success. England, so far as the visual arts were concerned, was at last moving out of its phase of insularity (in literature, insularity was to last much longer). The hedonism of the late 1950s had taken root, and the new artists seemed to offer precisely the gay, impudent, pleasure-centred art which fitted the mood of the times. But modern artists of any talent were still thin on the ground, and the young lions of pop did not meet with much competition.

It soon became clear that the artists who were grouped together after their spectacular début at the Young Contemporaries were temperamentally very different. Phillips was the most genuinely interested in popular imagery, but used it in a rigid and boringly dogmatic way. Boshier came under the influence of Richard Smith and veered away from figurative imagery in the direction of op art. More capricious and personal than either of these two were Hockney and Jones.

Ills 110, 112

113 DAVID HOCKNEY *Picture emphasizing stillness* 1962–3 (inscription: THEY ARE PERFECTLY SAFE, THIS IS A STILL)

Hockney is an artist who has had an interesting if slightly erratic development. He began as the *Wunderkind* of British art. His life-style was instantly famous; his dyed blond hair, owlish glasses, and gold lamé jacket created – or contributed to – a persona which appealed even to people who were not vitally interested in painting. In this sense, he forms part of the general development of British culture which was symbolized by the sudden and enormous fame of the Beatles. But it was also clear that Hockney was precociously gifted. In his early work, he adopted a cartooning, *faux-naïf* style which owed a lot to children's drawings. Often these early pictures have a delightful deadpan irony.

¹¹⁴ DAVID HOCKNEY A neat lawn 1967

Some of Hockney's most characteristic work at this time was to be found in his prints. The suite of etchings entitled *The Rake's Progress* chronicles his reactions to the dream-world of America, which he visited for the first time in 1961. They reflect profoundly ambiguous attitudes. The comment is often sharp – the *Bedlam scene*, for instance, shows a group of automata governed by the pocket transistor radios which have become part of their anatomy – but the overall tone of the series is one of avid enjoyment. Hockney has spent a great deal of his time in America ever since, and particularly likes southern California.

Soon, the precarious poise of these early works was threatened. Hockney's painting became increasingly dry, increasingly preoccupied with a kind of neoclassicism. Some middle period paintings of the Californian landscape – ranch-style houses with the sprinklers making great arcs on the lawns, swimming-pools with carefully stylized art-nouveau ripples – are disconcertingly dull when compared to his previous work. American critics have compared them to the realism of Edward Hopper. It is uncertain whether a more stringent irony is now intended, a satire on the *bourgeoisie* and the complacent life of the Los Angeles suburbs. On the whole, one suspects not.

Allen Jones, like Hockney, is an artist whose early work was captivating because it radiated an air of enjoyment not unspiced with satirical humour. The most 'painterly' of all the British pop painters, he seems to have learned a great deal from Matisse where colour is concerned. There is also a debt to the orphism of Robert Delaunay. Jones is a less narrative artist than Hockney: he is interested in metamorphoses, transformations, visual ambiguities. A series of *Hermaphrodite* (male/female images melting into one another on the same canvas) seem particularly characteristic of his work. Jones has shown a particularly deft and ingenious fancy with shaped canvases: a series of paintings of *Marriage medals*, done in 1963, is made up of tall vertical canvases to which octagonal canvases are attached.

Jones resembles Hockney rather less happily because he too seems to be having trouble in deepening and developing his work. It has had a tendency to grow increasingly harder and more strident; the colour seems to be leaving the comfortable 'fine art' tradition of the fauves. This shows up the extreme thinness of content. The artist insists that the subject-matter of his work has always been of secondary interest to him, but one becomes more and more aware of its insistent banality, a banality that does not seem to have been adopted with any doctrinaire purpose in mind.

No one could accuse R. B. Kitaj's work of lack of complexity. The term 'pop' has to be stretched rather far to cover his work. Kitaj is a hermetic artist; the best comparison is a literary one,

Ill. 122

141

115 PATRICK CAULFIELD Still-life with red and white pot 1966

in that his paintings are often rather like the *Cantos* of Ezra Pound. In them, one finds dense patterns of eclectic imagery. Often the painter requires that the spectator should try and match his own experience. The catalogue of one of Kitaj's infrequent exhibitions tends to pile footnote on footnote, in the endeavour to explain the complexity of his source material. These sources are more likely to be *The Journal of the Warburg Institute* than a favourite comic strip. One's approach to Kitaj's work must be intellectual. He is a competent but not overwhelmingly excellent draughtsman, and a rather dry colourist. Because his painting is so nearly a form of literature, it often seems that his prints are more successful than his paintings, and a good deal of his recent production has been graphics, mostly

142

silk-screen prints which use this flexible medium with great ingenuity.

There are one or two other artists in Britain who have also been associated by critics with the pop movement, though they stand a little apart from the rest. One is Anthony Donaldson, who uses pop imagery – nude or near-nude girls – as components in pictures which are closer to 'hard edge' abstract painting than they are to pop itself. This is because the girls are usually no more than silhouettes, and the silhouettes take their place among the other shapes in the composition. When the girls are omitted, as in Donaldson's more recent pictures, the effect is still much the same. Another is Patrick Caulfield, who is a little younger than the other members of the 'pop generation'. He did not leave the Royal College of Art until 1963. Caulfield is better described as a cliché painter than

Ill. 116

Ill. 115

116 ANTHONY DONALDSON Take away no. 2 1963

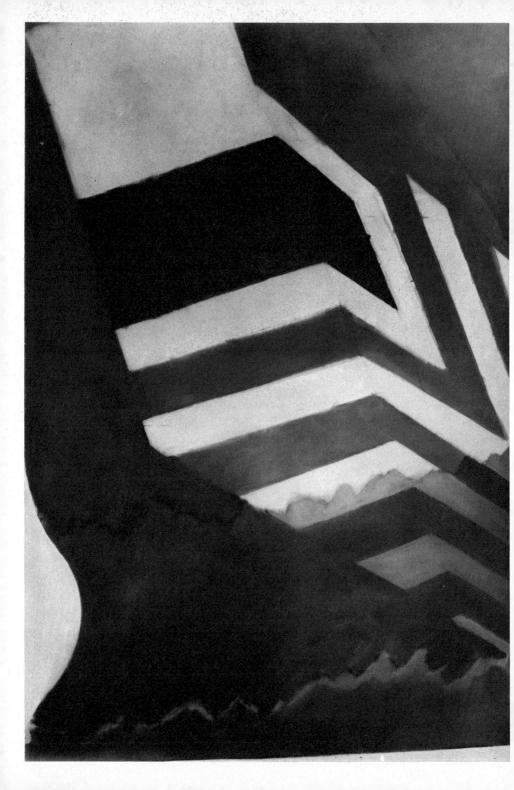

118 RICHARD SMITH Tailspan 1965

as a pop painter. His characteristic subject is the department store reproduction, the kind of image that commonly appears in cheap prints, on plastic trays, or in the kits which invite the amateur to 'paint by numbers'. Every shape he uses, every object he depicts, is described by a hard unvaried line, which looks as if it has been printed rather than painted. The colour is equally without modulation. Caulfield is intent on exploring the relationship between fine art and mass culture, and particularly the debased ways of seeing which mass culture seems to encourage. He is thus not fully committed to the pop ethos, but is, rather, a pitiless critic of it.

Before moving on to discuss the American pop artists, who are in some ways very different from their British counterparts, I must say something about a group of Australian artists who have a much greater relevance to the genesis of pop art than is generally admitted. The success of contemporary Australian art in London in the years after the war was one of the phenomena of art-dealing. The spearhead of this success was Sidney Nolan, and the pictures which created his reputation were a series devoted to the career of the Australian outlaw Ned Kelly.

The earliest Ned Kelly paintings date from the 1940s, and thus Ill. 119 antedate pop by some years. In them, Nolan, who had been an abstract painter, established a new, faux-naïf style as a vehicle for a fairly sophisticated Australian nationalism. If one compares the Ned Kelly pictures with Hockney's Rake's Progress, the resemblances are clear. The difference is that Nolan is still trying to find his roots in a nation, while Hockney commits himself to a culture: he is the nationalist of a style or taste. Both Hockney and Nolan are seductive artists, perhaps too much so. Nolan's work has faltered ever since he settled in England and began to leave behind his original subject-matter. Other Australian painters, such as the brothers Arthur and David Boyd, have Ill. 120 shown a similar inability to break away successfully from Australian imagery.

> The status of Australian painting as a kind of pre-pop is interesting in an American as well as in an English context, because it is clear that there is a goodish dose of nationalism in American pop art, or, rather, it is clear that nationalism contributed to its sudden and overwhelming success. The American pop artists were discovered and promoted by collectors and dealers. The critics and theorists lagged a long way behind these enthusiasts. Indeed, the American art establishment considered, and to some extent still seems to consider, the triumph of pop art as a rejection of itself and of the direction it had chosen to encourage. A leading advocate of abstract expressionism, Harold Rosenberg, had this to say about the new style:

Certainly, Pop Art earned the right to be called a movement through the number of its adherents, its imaginative pressure, the quantity of talk it generated. Yet if Abstract Expressionism had too much staying power, Pop was likely to have too little. Its congenital superficiality, while having the advantage of permitting the artist an almost limitless range of familiar subjects to exploit (anything from doilies to dining-club

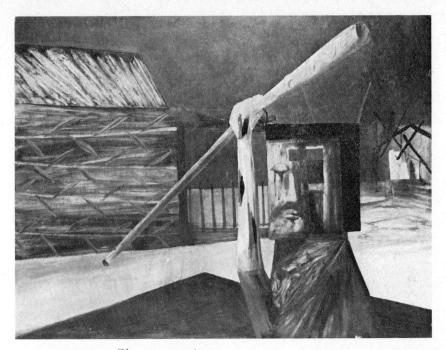

119 SIDNEY NOLAN Glenrowan 1956–7120 ARTHUR BOYD Shearers playing for a bride 1957

121 R. B. KITAJ Synchromy with F.B. – General of Hot Desire (diptych) 1968–9

cards), resulted in a qualitative monotony that could cause interest in still another gag of this kind to vanish overnight. ... Abstract Expressionism still excels in quality, significance and capacity to bring out new work; adding the production of its veterans to that of some of its younger artists it continues to be the front runner in the 'What next?' steeplechase.⁶

In effect, pop art challenged abstract expressionism – or seemed to challenge it – in three different ways. It was figurative, where abstract expressionism was mostly abstract; it was 'newer' than abstract expressionism; and it was 'more American'.

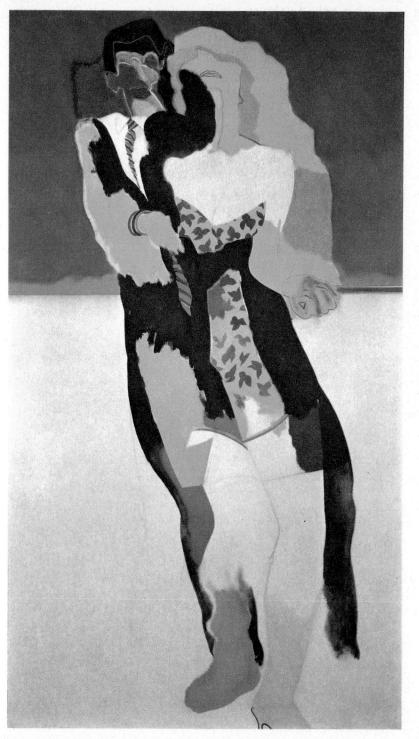

122 ALLEN JONES Hermaphrodite 1963

The principal American pop artists – Dine, Oldenburg, Rosenquist, Lichtenstein, and Warhol – differed fairly widely from one another. Jim Dine and Claes Oldenburg were the closest to the neo-dadaists whom I have already discussed. Dine, in particular, has two qualities which link him very closely to Rauschenberg and Johns: he is essentially a combine or assemblage painter, and his subject is the different varieties of reality. In a characteristic work by Dine, a 'ready-made' object or objects – an article of dress, a wash-basin, a shower, some tools – is fastened to canvas, and an environment is created for it with freely brushed paint. Often, whatever is presented is carefully labelled with its name.

Ill. 123

Ill. 124

Oldenburg, too, experiments with effects of displacement. His objects hover between the realms of sculpture and painting. These objects range from such things as giant hamburgers to squashy models of wash-basins and egg-beaters. Often these things are made of vinyl stuffed with kapok. Oldenburg says:

I use naïve imitation. This is not because I have no imagination or because I wish to say something about the everyday

123 CLAES OLDENBURG Study for Giant Chocolate 1966

124 JIM DINE Double red self-portrait (The Green Lines) 1964

world. I imitate 1. objects and 2. created objects, for example, signs, objects made without the intention of making 'art' and which naïvely contain a functional contemporary magic. I try to carry these even further through my own naïveté, which is not artificial. Further, i.e. charge them more intensely, elaborate their reference. I do not try to make 'art' of them. This must be understood. I imitate these because I want people to get accustomed to recognizing the power of objects, a didactic aim.⁷

Therefore he, too, is interested in reality, with an element of totemism added.

James Rosenquist and Roy Lichtenstein differ from Dine and Oldenburg because to a large extent they accept the limitations of the flat surface, and because they are formalists. At the

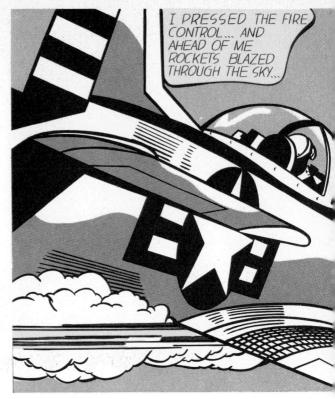

125 ROY LICHTENSTEIN Whaam! 1963

> moment, it seems to be Lichtenstein who has been elevated to a status above the others. He is not as hostile to the word 'art' as Oldenburg is. He says, for example, that 'organized perception is what art is all about'. He adds that the act of looking at a painting 'has nothing to do with any external form the painting takes, it has to do with a way of building a unified pattern of seeing'.

Ills 125,

Lichtenstein's earliest work was based on comic strips; eventhe dots which are part of the process of cheap colour printing are meticulously reproduced. The artist once said to an interviewer:

I think my work is different from comic strips – but I wouldn't call it transformation. . . . What I do is form,

whereas the comic strip is not formed in the sense I'm using the word; the comics have shapes, but there has been no effort to make them intensely unified. The purpose is different, one intends to depict and I intend to unify. And my work is actually different from comic strips in that every mark is really in a different place, however slight the difference seems to some.⁸

That is, the imagery is in part a strategy, a means of binding together the picture surface. Another aim can be seen most clearly in the series of *Brushstrokes*: meticulous, frozen versions (in comic-strip technique) of the marks which an abstract expressionist artist might have made with one sweep of the brush. The series is an experiment in 'removal': a word which

Ill. 126

crops up fairly often in Lichtenstein's discourse. It is also an attempt to make the audience question its own values.

This raises the question of the values put forward by the pop artists themselves. One of the most characteristic and disturbing aspects of pop art is the fact that, though figurative, it often seems unable to make use of the image observed at first hand. To be viable, its images must have been processed in some way. Rosenquist says: 'I treat the billboard image as it is. I paint it as a reproduction of other things. I try to get as far away from it as possible.'⁹ His bits and pieces of billboard imagery are jumbled together in such a way as to produce an effect which is abstract. Similarly, the nudes of Tom Wesselmann have

Ill. 129

Ill. 131

126 ROY LICHTENSTEIN Yellow and red brushstrokes 1966

127 ROY LICHTENSTEIN Hopeless 1963

become increasingly arbitrary, flat silhouettes from which the human presence fades.

There is a comparison to be made between Rosenquist and Larry Rivers, an artist who is best defined as 'near-pop'. Rivers is a seductive artist; he paints in a way which delights admirers

128 TOM WESSELMANN Still-life no. 34 1963

129 TOM WESSELMANN Great American Nude no. 44 1963

¹³⁰ LARRY RIVERS Parts of the face 1961

of the impressionists, and which, in particular, seems to owe a good deal to Manet. The imagery he deals with sometimes recalls pop, because Rivers is interested in subjects such as packaging, the design of banknotes, and so forth. But he is concerned always to make painterly variations upon these, rather than imitations. Rivers is also prepared to paint directly 1.31 JAMES ROSENQUIST Silver skies 1962

Ill. 130 from nature. He treats some of these pictures as a kind of vocabulary lesson – a female nude will be carefully labelled with all the names of the parts of the body, but in French, not in English. Other paintings are fragmented accounts of a particular experience, for example a street accident. The outstanding characteristic of all these paintings is a kind of glancing obliqueness, as if the artist were unable to focus on the actual subject for very long at a time.

George Segal shows much the same helplessness when confronted with an objective reality. His sculptures are made, not by a process of modelling, but by making life-casts of the subjects, almost as if the artist didn't trust his own vision of them.

The most controversial, as well as the most famous, of all the American pop artists is Andy Warhol. Warhol's activities go

far beyond the conventional boundaries of painting: he has made numerous films, he has directed a night-club entertainment, the Velvet Underground, and the kind of notoriety he enjoys is like that accorded to a famous actor or film star. When the first retrospective of Warhol's work was held, in Philadelphia in 1965, the crush at the private view was so great that some of the exhibits had to be removed, for fear of damage. It was clearly the artist himself, and not his products, whom the visitors wished to see.

Yet Warhol's attitudes towards the notion of 'personality' are ambiguous. On the one hand, he labels the performers in his films 'super-stars', on the other hand he declares that he himself wants to be a machine, something which makes, not paintings, but industrial products. Samuel Adams Green, in his

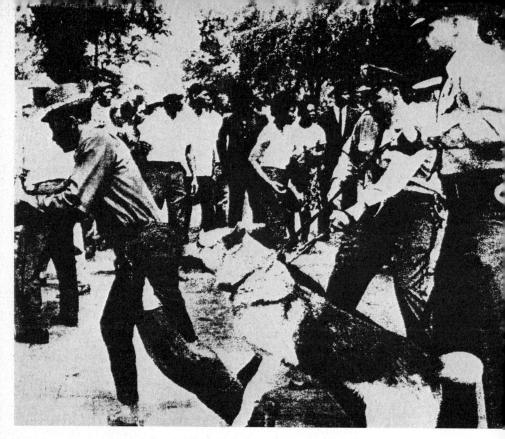

132 ANDY WARHOL Race riot 1964

introduction to the catalogue of the Philadelphia exhibition, remarks of Warhol:

Ill. 133

His pictorial language consists of stereotypes. Not until our time has a culture known so many commodities which are absolutely impersonal, machine-made, and untouched by human hands. Warhol's art uses the visual strength and vitality which are the time-tested skills of the world of advertising that cares more for the container than the thing contained. Warhol accepts rather than questions our popular habits and heroes. By accepting their inevitability they are easier to deal with than if they are opposed. . . . We accept

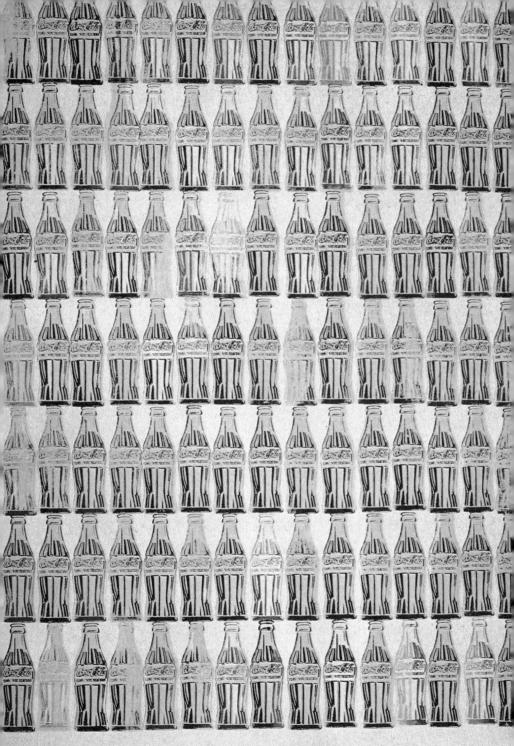

Coca Cola

the glorified legend in preference to the actuality of our immediate experiences, so much so that the legend becomes commonplace and, finally, devoid of the very qualities which first interested us.¹⁰

In fact, more than most pop artists, Warhol seems concerned to anaesthetize our reaction to what is put in front of us. Many of his pictures have morbid associations: Mrs Kennedy after the assassination of her husband, Marilyn Monroe after her suicide, 'mug shots' of criminals, automobile accidents, the electric chair, gangster funerals, race riots. The images are repeated over and over again in photographic enlargements which are silk-screened on to canvas. The only modification is an overlay of crudely applied synthetic colour. The repetition and the colour are the instruments of a moral and aesthetic blankness which has been deliberately contrived. We are aware of Warhol's narcissism when we look at his pictures, but even this scarcely touches us. Frank O'Hara, the poet and art critic, once remarked that much pop art was essentially a 'put on', a pokerfaced attempt to discover exactly how much the audience would swallow. Lichtenstein also said, speaking of the beginnings of pop in America, 'It was hard to get a painting which was despicable enough so no one would hang it - everyone was hanging everything.'11 Warhol carries this attitude to extremes, so that much of what he does is contemptuously private and aristocratic. This appears in his obsessive concern with boredom, for example. He has made a film of a man sleeping - that and nothing else - which lasts for more than six hours.

There is a clear connection between his activities and kinds of art which superficially look very different from what he produces. His silk-screen images are not far from 'minimal art', because, though figurative, they are also almost contentless.

The more closely one examines American pop art, the less it seems a celebration of mass culture, or even a reaction against it. Instead, popular imagery is used as a kind of stalking-horse, a means of creeping up on abstruse philosophical problems.

Ill. 132

The artists, when questioned, nearly always talk about the ways of looking at something, rather than about what is actually seen. The real attraction of advertisements, signs, comic strips, and the rest, so far as they are concerned, seems to be that the imagery is 'given', is gratuitously there, so that there is no need to confuse the issue by creating it afresh. They do not romanticize the material, as their British colleagues do.

One consequence of pop art in America has been an attempt to re-validate purely realistic painting. Often, as with the 'super realists' (Chapter Nine), the realism is at a remove – a reproduction of a reproduction (a photograph). Isolated painters, such as Philip Pearlstein, have returned to direct observation of the model. What links Pearlstein to 'super realism' is a programmatic neutrality of attitude, while his style, hovering on the edge of the banal, approaches 'minimal art' (Chapter Eight).

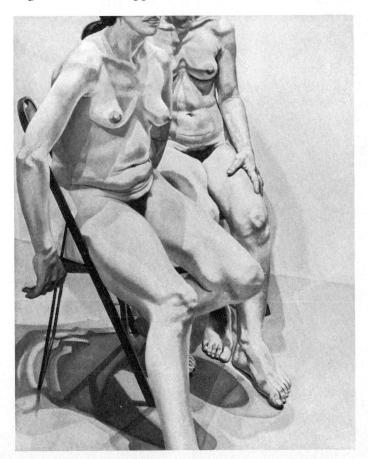

Ill. 134

134 PHILIP PEARLSTEIN *Two seated female nudes* 1968

CHAPTER SIX

Op and kinetic art

When pop art was succeeded, as a journalistic phenomenon, by 'op art', there was a natural tendency for journalists to seek out as many op artists as possible. Hence the inclusion in this category of artists whose interest in optical effects was in reality very marginal. A more serious distortion was the way in which op art was presented as something which had made a sudden appearance on the scene, rather as pop had done. In fact, optical painting, like 'hard edge' abstraction, had its roots deep in the Bauhaus tradition, and is the consequence of the kind of experiments which the Bauhaus encouraged.

If post-war optical painting is to be traced back to a single source, that source must unquestionably be Victor Vasarely. Vasarely is Hungarian by origin, and was born in 1908. He first studied medicine, then went to a conventional art school, and finally, in 1928–9, was a student at the Mühely academy of Alexander Bortnyik, the Budapest Bauhaus. He then settled in France. Characteristically, Vasarely remarks that it was during this period at the Budapest Bauhaus that 'the functional character of plasticity' was revealed to him. He began as a graphic artist, and it was not until 1943 that he turned to painting.

Vasarely is too rich and complex an artist to be thought of simply as an optical painter and nothing else. In fact, his large post-war *œuvre* embodies a whole complex of related ideas. One of the most important of these was the idea of 'work', of art as a practical activity. This made him hostile to the idea of free abstraction, as he noted in 1950:

The artist has become free. Anyone can assume the title of artist, or even of genius. Any spot of colour, sketch or outline is readily proclaimed a work, in the name of sacrosanct

Ills 135, 136

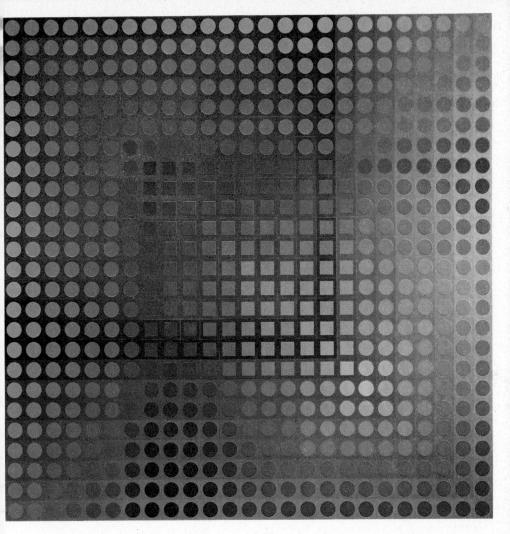

¹³⁵ VICTOR VASARELY Arny 1967-8

subjective sensitivity. Impulse prevails over know-how. Honest craftsman-like technique is bartered for fanciful and haphazard improvisation.¹

But Vasarely had been prepared to go further than most of those who condemned free abstraction, by proposing that we regard the artist simply as a man who makes prototypes which can then be reproduced at will: 'the value of the prototype does not consist in the rarity of the object, but the rarity of the quality it represents'. He feels that all the plastic arts form a unity, and that there is no need to split them into fixed categories, such as painting, sculpture, graphics, or even architecture:

Our time with the encroachment of technics, with its speed, with its new sciences, its theories, its discoveries, its novel materials, imposes its law upon us. Abstract painting, now, new in its conception, different in its approach, still has attachments to the former world, to the old painting, by a common technique and formal presentation that hold it back and cast a shadow of ambiguity over its conquests.²

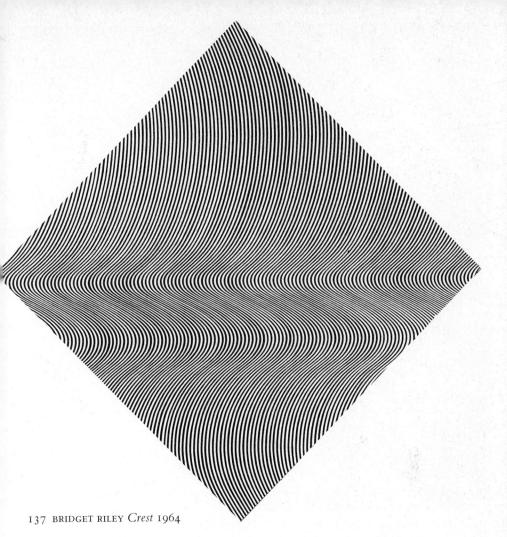

One reads this statement with respect, yet it must be said that Vasarely is in many ways a curiously divided artist, much less inventive formally than he is fertile in new ideas and concepts. His non-kinetic abstract paintings, for instance, owe a great deal to the work done some forty years ago by Auguste Herbin. Vasarely specifically acknowledges a debt to Herbin's vocabulary of 'colour-forms' (shapes related to colour, but without naturalistic references, which are used as units in more complex

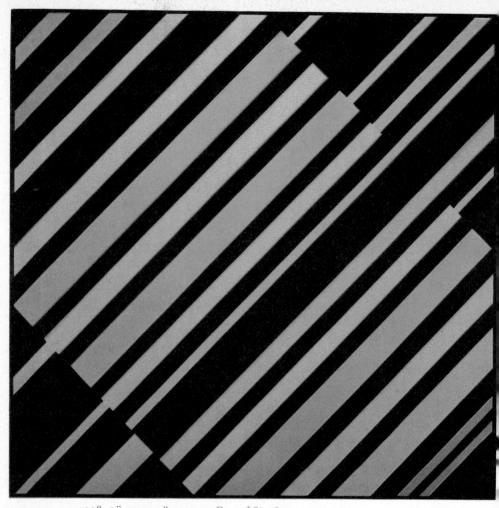

138 GÜNTER FRÜHTRUNK One of Six Screenprints 1967

groupings). He claims that this vocabulary is employed by him in new ways, which free themselves from Herbin's still traditional methods of composition. But the difference is not always as striking as he would have us suppose.

It is natural, therefore, to focus attention on his exploration of kinetic effects, the source of the most original things he has produced. It is easy to see the influence of such work on his 168 contemporaries, for example the German Günter Frühtrunk. Kineticism has been important to Vasarely for two reasons: one is personal, the fact that, as he tells us, 'the idea of movement has haunted me from my childhood'; and the other is the more general idea that a painting which lives by means of optical effects exists essentially in the eye and mind of the spectator, and not merely on the wall – it completes itself only when looked at.

I have already begun to use the words 'kinetic art' and 'optical art' almost interchangeably. In fact, the former seems to me the better term. Kinetic art can cover a good many categories of object.

There are, first of all, works of art which, though in fact static, appear to move or change. These can be in two or three dimensions. Vasarely, for instance, has concerned himself with paintings, with works composed in separate planes, and with screens and three-dimensional objects. Static works rely for their kineticism on the action of light and on well-known optical phenomena, such as the tendency of the eye to produce after-images when confronted with very brilliant contrasts of black and white, or the juxtaposition of certain hues.

Secondly, there are objects which move at random, without mechanical power, such as the mobiles of Alexander Calder.

Thirdly, there are the works which are mechanically powered, and which use lights, electromagnets, or even water.

The need for precision in works of the first category, and the fact that those of the second and third varieties are actually machines, of however simple a kind, gives kinetic art a mechanistic overtone. It seems to lie on the borders of an art which is actually produced by machines, rather than by men. This, however, is an oversimplification.

Bridget Riley, for instance, who is probably the most brilliant of all the kinetic artists who have worked in two dimensions, would certainly reject the suggestion that her paintings are not meant to express or to communicate feeling.³ Her work is often intricately programmed: the forms and their

Ill. 137

Ill. 138

relationship to one another conform to predetermined mathematical series, but the progressions are arrived at instinctively. Miss Riley once worked entirely in black and white, but now, having moved through a phase where muted colours were used, she has created a series of dazzlingly colourful pictures, which explore the way in which one colour can be made, by optical means, to bleed into another; or the way in which the whole picture surface can be made to move from warm to cool through the progression of hues. In contrast to the work of the colour painters, the surface does not remain inert, but ripples with muscular energy.

Few other optical artists have produced work as complex as this, though there are parallels in the painting of the American, Richard Anuszkiewicz, the Italian, Piero Dorazio, and the Englishman, Peter Sedgley. Sedgley supplies yet another

139 PETER SEDGLEY Action 1966

Ills 142, 140

140 PIERO DORAZIO Molto a punta 1965

variation on the theme of concentric circles, the ubiquitous target pattern. Here the pattern is used to produce powerful effects of recession or projection – some pictures draw the spectator inward, down an ever-receding tunnel, others seem to float towards him off the wall, in bursts of light. Sedgley's pictures, like Miss Riley's, suggest the notion that a good deal of optical and kinetic art aims at throwing the spectator into a hypnotic trance, thus achieving by another route the 'unfocusing' recommended by Cage.

The next stage in optical painting is represented by work which is in very slight relief. Often this extra dimension is used to provide planes of colour which move as the spectator shifts his position in relation to them. The 'physichromes' of the Venezuelan Carlos Cruz-Diez are works of this nature, and so are some of those of the Israeli artist Yaacov Agam. The Ill. 139

Ill. 141 Ill. 143

141 CARLOS CRUZ-DIEZ Physichromie no. 1 1959

principle employed is rather like that to be found in some of the 'trick pictures' made in Victorian times, where one image is suddenly replaced by another, according to the viewpoint one adopts.

Ill. 144

A more important artist who sometimes makes use of effects of somewhat the same kind is another Venezuelan, J. R. Soto. Soto's original influences were Mondrian and Malevich. In the early 1950s he made paintings which created their effect by repetition of units. The units were so disposed that the rhythm which linked them came to seem more important to the eye than any individual part, and the painting was therefore, by implication at any rate, not something complete in itself, but a part taken from an infinitely large fabric which the spectator was asked to imagine. Soto then became interested in effects of superimposition, just as Vasarely did. Two patterns painted on

142 RICHARD ANUSZKIEWICZ Division of intensity 1964

144 JESÚS RAFAEL SOTO Petite Double Face 1967

▲ 145 LUIGI TOMASELLO Atmosphère ébromo-plastique no. 180 1967

> 146 SERGIO DE CAMARGO Large split white relief no. 34/74 1965

perspex sheets were mounted very slightly apart, and seemed to blend together in a new space which hovered between the front and back planes supplied by the sheets. Later, Soto began a series of experiments with lined screens. These have metal plaques which project in front of them, or else metal rods or wires are freely suspended before this vibrating ground. The vibration tends, from the optical point of view, to swallow up and dissolve the projecting or suspended solids. Each instant, as the spectator moves his eyes, a new wave of optical activity is set up. The most intense of all Soto's works are large screens of hanging rods. Hung along the length of a wall, these layers of rods seem to dissolve the whole side of a room, calling into question all the spectator's instinctive reactions to an enclosed space.

Related to Soto's work, but using a slightly different principle, are the reliefs made by the Argentinian, Luigi Tomasello. Tomasello attaches a series of hollow cubes at an angle to a white surface. The cubes themselves are also white on the outside, but brightly coloured within, and one of the surfaces invisible to the spectator is left open. By reflection, this produces effects of soft, shimmering coloured light on the ground to which the cubes are fastened.

On the borderline of kinetic art, but certainly quite close to Tomasello's work, are the reliefs and sculptures of the Brazilian.

Ill. 146

Ill. 145

Tomasello's work, are the reliefs and sculptures of the Brazilian, Sergio de Camargo. Camargo uses small cylindrical units, set at random angles so that the plane at the end of the cylinder is never square to the viewer, to cover the surfaces of his work. The work itself is usually painted white, so that each piece becomes an intricate play of reflections and shadows. Here, too, as in the work of all the South American artists I have just discussed, there seems to be a desire to dissolve everything solid, everything weighty, in favour of an ethereal play of light and colour. Distances, planes, and forms become ambiguous. However physically massive it may be in fact, the work seems weightless and floating. A similar effect can be observed in the work of the German artist Günther Uecker, who uses spikes or

147 GÜNTHER UECKER *Light-disc* 1960

nails to break up his surfaces, thus producing a diaphanous look Ill. 147 – a surface which is not truly a surface.

Weightlessness, as part of the kinetic tradition, might be thought to go back to Alexander Calder. Calder is an artist who, while appearing to be lightweight in almost every sense, turns out to have had a powerful influence on the art of his time. Calder first exhibited his mobiles in the 1930s – the original idea came from a delicate and amusing toy circus he had made, but the mobiles themselves, with their brightly painted flanges connected by pivots and wires, seem to have taken a number of ideas from the paintings of Miró, a hypothesis which the Miró-like nature of Calder's drawings con-

Ill. 149

firms. But there was an important difference - the arrangement of shapes in a Calder mobile is of course always provisional, as one flange swings into a new relationship with the others. The possibilities of the object are, of course, governed by such things as the various points of balance, the length of the wires, and the weight of the flanges. The organized capriciousness which this system produces is a quality which is extremely characteristic of post-war kinetic art. Besides making mobiles, Calder also constructs what he calls stabiles, some of the largest of which do not incorporate any moving parts at all. They provide an unexpected link between Calder's work and that of sculptors such as David Smith and Anthony Caro, whom I shall discuss in Chapter Eight. Meanwhile Calder, even in the mobiles, remains consistently more inventive than other artists who make sculpture which employs the same principles. One has only to compare Calder's mobiles with the far more cumbersome pieces of George Rickey, for instance.

Ill. 148

148 GEORGE RICKEY Summer III 1962-3

149 ALEXANDER CALDER Antennae with red and blue dots 1960

Where most people are concerned, it is the machine-powered objects which seem the newest and the most fascinating. In fact, works of art powered by machines are not as novel as they seem to be. Even if it is unnecessary to bring such things as the fountains of Versailles into the discussion, mechanically powered sculpture is something which can be traced back at least to the early 1920s. It is both constructivist and dadaist in ancestry. As early as 1920, Naum Gabo made a sculpture which consisted of a single vibrating rod. Duchamp and Man Ray, in the same year, produced the 'rotorelief', a circular glass plate which seemed, as it revolved, to present an illusory design.

Post-war kinetic art has tended to reflect this double ancestry. Jean Tinguely's ramshackle mechanisms clearly owe a great deal to the 'mechanical compositions' made by Picabia at the

height of the dada period, in 1917–19. Picabia's drawings were elegantly sardonic parodies of conventional blueprints, designs for machines which could never possibly work. One is slyly dedicated 'to the memory of Leonardo da Vinci'.

Tinguely's machines work, but only just. They groan and judder, and one suspects that they often develop both functions and malfunctions which were not anticipated by their author when he originally planned them. In fact, they have been labelled 'pseudomachines', because they move without function. Or sometimes they have functions which imply a satirical comment. Tinguely has made machines which produce abstract expressionist drawings, for instance. And perhaps the most famous of all his creations was the self-destructive machine which he made for the Museum of Modern Art in New York in March 1960. This created a famous scandal.

150 JEAN TINGUELY Metamachine 4 1958–9

Ill. 150

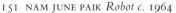

152 BRUCE LACEY Baby versus man 1962

From Tinguely's machines, some of which do actually move about the floor, it is only a short step to such things as the deliberately ramshackle robots created by Bruce Lacey and Nam June Paik. Lacey, for example, states that he means his robots to symbolize the human predicament in the midst of the modern technological environment.⁴

Quite different from Tinguely, though often associated with him, is the Greek artist Takis. Where Tinguely mocks the clumsiness of machines, and the clumsiness of men in dealing

Ills 151, 152

Ills 153, 154

153 TAKIS Signal 1966

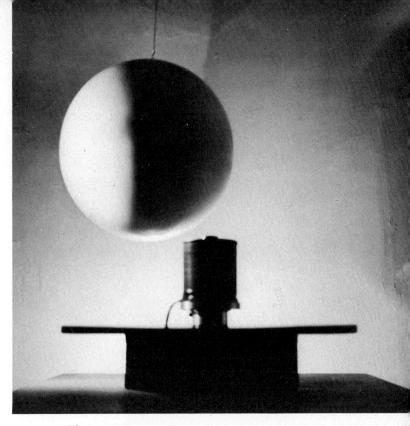

154 TAKIS Electro magnetic 1960–7

with them, Takis tries to exploit new technological possibilities. Some of his most interesting works are those which employ the principles of magnetism. In the *Magnetic ballets*, for instance, two magnets are suspended on threads from the ceiling. An electromagnet on a base switches itself on and off in a regular rhythm. When it is on, it attracts the positive pole of one magnet and repels the negative pole of the other. When it is off the two magnets seek each other. Alternatively, Takis will use a magnet to hold a needle suspended, quivering, in the air. What is new about these works is that they do not exist as form, but as an almost immaterial energy. The function of the visible parts is not to be interesting in themselves, but to demonstrate the operations of that energy. The point is perhaps made clearer if one contrasts the work of Takis with that of the Belgian, Pol Bury. Pol Bury belongs as firmly in the surrealist tradition as Tinguely belongs in the tradition of dada. His machines have their working parts hidden out of view. One critic has remarked on the fact that Bury's work is 'deliberately mystifying'.⁵ His machines stir, stealthily, rather than moving in any very decisive or positive fashion. A set of little balls on a sloping plane click together, move upward with almost imperceptible jerks, instead of rolling down as one might expect. Clusters of needles, or waving feelers, rustle together. Fascinating as all this is, however, the movement is only part of what the work has to say. The slowest ones have a formal presence which strikes us even before we realize that they are in fact moving. The same is not true of any of Takis's inventions when deactivated.

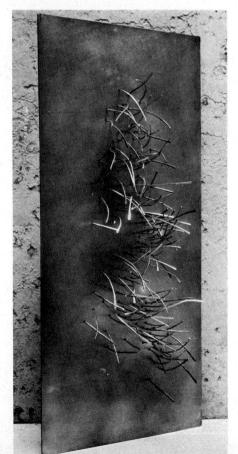

Ill. 155

155 POL BURY The Erectile Entities

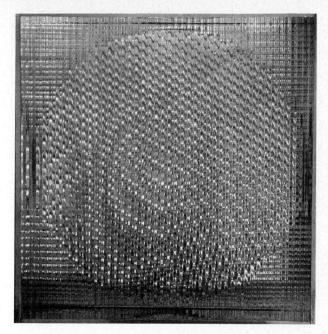

156 HEINZ MACK Light dynamo 1963

Given this penchant for the immaterial, it seems inevitable that Takis should have experimented with light. His celebrated *Signals* are flashing lights held at the ends of long flexible rods – another means of expressing the force of the energy which moves the universe.

In general, light has been the favourite medium of many kinetic artists. The way in which it is used differs widely from artist to artist. The German, Heinz Mack, for instance, uses a mechanization of the *moiré* principle. A disc rotating beneath a transparent, uniformly rippled glass surface makes the surface itself ambiguous. It is not the motion itself which holds our attention so much as the slow disturbance of the light rays which are reflected back at us – these seem drawn into a vortex, then spilled out again. On the other hand, the American, Frank Malina, makes light boxes, where constantly changing coloured patterns are projected on to a plexiglass screen. The result is merely an extension of free abstraction: a picture which never arrives at its final state, but which is constantly undergoing a process of metamorphosis.

More imaginative and more radical is the work offered by artists such as Liliane Lijn and Nicolas Schöffer, though these two are in sharp contrast to one another. Miss Lijn is a purist. She traps drops of liquid under the clear perspex face of a turntable. On the turntable, moving in counter-motion to its rotation, is a perspex ball or group of balls. The liquid trapped in the disc is affected by the movement of these solids, and breaks up into patterns which are reminiscent of the patterns which iron filings form under the action of a magnet. One can observe these patterns closely, as the work is brilliantly lit.

Ill. 158

Schöffer is a baroque artist. His work turns and flashes, sending out beams of light and flickering reflections. He combines the movement of a piece of kinetic sculpture with light projections which extend the movement deep into space. The whole volume of air that surrounds the sculpture becomes an ambiguous entity. Schöffer has, on occasion, gone even

157 LILIANE LIJN Liquid reflections 1966–7

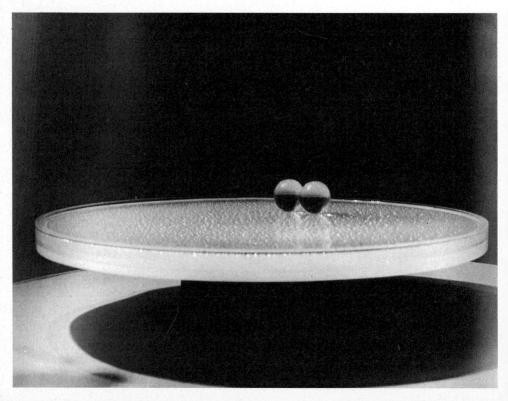

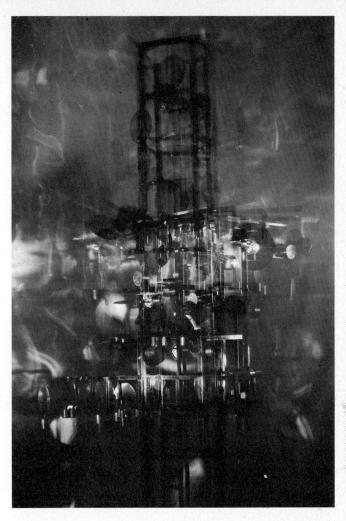

158 NICOLAS SCHÖFFER Chronos 8 1968

further than this, by producing work which reacts to the intensity of light, and to sounds. He has also experimented with combinations of light, kinetic movement, and music, notably in the light-and-sound tower which he constructed at Liège in 1961. Work of this kind seems to translate the experiments of the seventeenth century into contemporary terms – some of Schöffer's enterprises are the equivalent of the masques contrived by Ben Jonson and Inigo Jones for the Stuart court.

159 FRANÇOIS MORELLET Sphère-trames 1962

In fact, kinetic art seems to have two tendencies which both oppose and reinforce one another. One is the tradition of showmanship. Much kinetic art is 'exhibition art'. Its ambitions are environmental. It aims to bombard the spectator with new experiences. The greatest triumphs scored by kinetic artists have been in large, collective exhibitions, such as the 'Lumière et Mouvement' show held at the Musée d'Art Moderne in Paris in the summer and autumn of 1967. Here the sheer number of artists, and the spectacular nature of some of the works on view, tended to disguise the extreme narrowness of many of the individual contributions.

160 JULIO LE PARC Continuel-mobile, Continuel-lumière 1963

The other tradition is that of scientific or pseudo-scientific research, which is typified by the Groupe de Recherche d'art visuel, founded in Paris in 1959, as a gesture of defiance towards the then triumphant fashion for informal abstraction. The group was much under the influence of Vasarely, and particularly affected by his tenet that the artist should as far as possible be anonymous, that the work and not the individual should speak. Vasarely's son Yvaral was a member, but the two bestknown associates of the group were probably the Argentinian Julio Le Parc, winner of the major prize at the Venice Biennale in 1966, and the Frenchman François Morellet. Ill. 160 Le Parc creates devices which belong partly to the laboratory, partly to the funfair. They are experiments with mechanisms, and also experiments upon the psychology of the spectator. Mirrors, distorting spectacles, balls which run through complicated labyrinths – he has made use of all these things. Le Parc is a minimalist in the sense that nothing he makes is ever too heavy, or too serious. The spectator becomes a collaborator; he is not invited to read a meaning into what he sees, but merely to react. In this sense Le Parc is the equivalent of Johns or Cage in America.

Ill. 159

Morellet is more severe. His best-known work is the *Sphère-trames* ('Sphere-webs') – a sphere made up of rods laid at right angles to one another to form a cellular structure which, through its multiple perspectives, has strange effects on light. A related work is a lattice of fluorescent tubes, which seems to dissolve the wall behind it. Morellet, too, is an artist whose work is related to that of the minimalists in America.

The visual and psychological subtlety of kinetic art so far stands in marked contrast to the simplicity and even crudity of many of the mechanisms used. Some artists, notably Tinguely, even make this mechanical crudity a contributing element in their work. A few others have reached a very respectable level of technological complexity by working in conjunction with industrial organizations. Schöffer created the Liège tower in collaboration with the firm of Philips NV. Usually, however, kinetic art has aped technology from a distance. The reasons are twofold. Firstly, the limited financial resources available to the artist, or, more exactly, the fact that the kinetic artist is a maker of the 'one-off' in a field geared to volume production. Secondly, there is the fact that most kinetic artists have a very limited scientific background, the exception being Frank Malina, who was responsible for the first high-altitude rocket launched by the Americans in 1945, and who has been President of the International Academy of Astronautics. Even so, the mechanical principles employed in his work are not complex.

Whatever the reasons for this lack of technical sophistication,

the claims made by kinetic artists that they were producing 'art for the technological age' must be taken with a pinch of salt. It would, indeed, be fairer to say that the sudden upthrust of kinetic art in the 1950s and early 1960s represented a kind of nostalgia for technology, rather than the presence of technology itself. A real technological involvement has followed, but slowly and with difficulty.

There have been one or two other developments in the arts which can be taken in conjunction with kineticism, though they do not add up to precisely the same thing. One is the tendency to compare scientific models, high-magnification photographs, and other by-products of scientific research, with the work of contemporary artists, and to claim that the frequent resemblances to be found there argue for a kinship between the new arts and the new sciences.

The trouble is that the resemblance is more often to the products of the free abstractionists than to those of any artist with an avowed commitment to science. What one sees is not the influence of science upon art, but of artists upon scientists. The most beautiful high-magnification photographs are often almost meaningless from the strictly scientific point of view, and the reason for taking them is aesthetic. Art has taught the photographer to look at his subject in a certain way, has made its appearance meaningful to him. It is one of the most prominent characteristics of the history of photography: the tendency for the man behind the camera to be influenced by whatever style of painting is dominant at the time. Thus, photographs taken by photographers in the Pre-Raphaelite circle tend to look like the paintings of Rossetti or Millais.

Another aspect of the relationship between art and science has been represented by 'computer art' – experiments made to discover what computers could be programmed to produce, and also what they could be persuaded to do if certain random elements were introduced into the programming. The extent to which a computer can actually make art is a matter of dispute. One authority says: 'the computer is used as a tool for the spectator and artist, it does not produce art, but is used to manipulate thoughts and ideas which could be called art'.⁶ What it produces at present, certainly in the field of the visual arts as opposed to that of music, tends to be uninteresting. Dr Johnson's remark about a woman preaching seems applicable: it is not that the computer does it well, but it is surprising that it can do it at all.

There is, however, the chance that interest in computers will eventually extend the capabilities of the visual artist, by forcing him to think in new ways. In analyzing ideas so that they can be fed to the machine, the artist is undertaking a more rigorous process of thought than perhaps he is accustomed to. Once programmed, the computer carries out the processes which it has been asked to carry out with unfaltering logic. It can be made to present as many different alternatives as the user desires, and analyses of the finished product can be stored for future use. As a labour-saving tool, the computer opens up a vastly broader range of chance operations, simply because it works both more surely and more rapidly than the artist can hope to do himself. In this sense, the computer can be said to extend the idea of freedom, which is to be found in the work of artists such as Pollock and Louis, into the intellectual as well as the physical sphere. But its full potentialities are unlikely to be realized until

Ills 14, 15, 78, 80

sphere. But its full potentialities are unlikely to be realized until the operator can treat it as being as much an extension of his own mind as Pollock treated paint and canvas, rags and brushes as extensions of his own body.

Sculpture : as it was

So far I have said little about sculpture. The reason for this is that sculpture was much slower in responding to the post-war situation. Partly, this was due to the fact that the situation itself seemed to reject what the sculptor had to offer. Though a number of sculptors in America adopted the attitudes of abstract expressionist painting (just as, at an earlier date, a number of sculptors responded to the discoveries of cubism) it was difficult for any artist to produce a satisfactory threedimensional equivalent for the work of Jackson Pollock.

In Europe, however, there were a number of dominant figures among the sculptors. The chief of these were the Swiss Alberto Giacometti and the Englishman Henry Moore. It is convenient to speak first of Giacometti, as he stands conspicuously alone. He began as a surrealist, and by force of talent made himself very much a leading figure in the movement during the 1930s. Such works as *The Palace at 4 a.m.* and *Woman with her throat cut* still retain all their original force as works of art. In 1935, however, he felt the urge to work again from the model, and his 'reactionary' activity led to his being excluded from the surrealist group. He made no attempt to exhibit his work again until 1948.

The second phase of Giacometti's career really begins in 1940, when he ceased working from the model and began to work from memory, making heads and female figures. The sculptor has left a famous description of what occurred:

To my terror the sculptures became smaller and smaller. Only when small were they like, and all the same these dimensions revolted me, and tirelessly I began again, only to end up, a few months later, at the same point. A big figure

seemed to me to be false and a small one just as intolerable, and then they became so minuscule that often with a final stroke of the knife they disappeared into dust.¹

In fact, Giacometti's new work was a dialogue with appearances, and he was obsessed with their provisional nature, the impossibility of ever really seizing them. Even when he learned to work again on a somewhat larger scale, his repertoire of images was very restricted; the most famous is a very attenuated, stick-like figure, whose very thinness makes it seem to recede, to slip away from us and evade the touch.

In exploring these images, Giacometti was acting out, through the medium of sculpture, some of the leading ideas of existentialist doctrine, a fact of which the artist was well aware, since he and Jean-Paul Sartre were close friends. One way of looking at existentialism is to regard it as both a continuation of surrealism and a rejection of it. What it has in common with surrealism is the emphasis which it places upon subjectivity; where it differs is in the fact that it puts stress upon the notion, not only of reality, but of responsibility to reality, however ungraspable this may prove to be.

161 ALBERTO GIACOMETTI Woman with her throat cut 1932

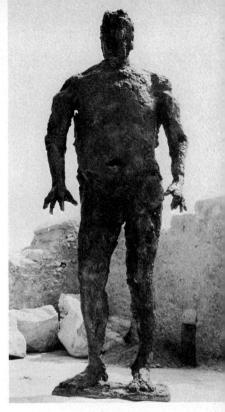

162 ALBERTO GIACOMETTI Man walking III 1960

163 GERMAINE RICHIER The Hurricane 1948–9

Yet, though existentialism itself enjoyed an immense intellectual influence, Giacometti was almost the only artist to echo it so precisely in his work. He is almost as isolated as a sculptor as his own figures are in space. Perhaps the artist who comes nearest to him is the Frenchwoman Germaine Richier, the proportions of whose figures often seem to owe something to Giacometti. But there is an important difference. Richier was interested not so much in the problem of reality, and the effort to seize reality, as in the presentation of visual metaphors. In *The Hurricane*, for example, a male figure becomes a threatening storm; the form dissolves before our eyes. Essentially, this is a modern variant of baroque allegory.

Giacometti's importance lies, not in his influence over other artists, but in his impact upon the public. In his later work, he created one of the truly recognizable stereotypes of post-war art. This stereotype could be linked to the new appreciation of certain ancient or primitive cultures fostered by André Malraux's *Les Voix du silence*. The sculptor's tall thin figures were seen to have an affinity with certain exaggeratedly thin Etruscan bronzes. All of this helped to give Giacometti's work a helpful aesthetic and intellectual context. He became a 'critic's artist' in much the same manner as Nicolas de Staël became a 'critic's painter', and for similar reasons.

It will be seen that I am inclined to think that Giacometti's reputation has been inflated. If one looks at his paintings (admittedly a minor part of his work) they are surprisingly conventional, though the characteristic imagery persists. If one looks at the sculptures after studying the paintings, it becomes clear how many conventional and even academic elements they too contain. The artist of the immediately previous generation who should be compared to Giacometti is Aristide Maillol. Maillol, too, tried to reconcile the great traditions of academic sculpture with modernism. To his immediate contemporaries, his work seemed to combine the best features of the old art and the new; to us, now, there is something insipid about it. Just as honourably, Giacometti strives to reconcile the old humanism with the new subjectivity. The drama of his work springs from the attempt; what slips from the sculptor's grasp is not, finally, the reality of nature, but the reality of conventional representations, and (to split hairs) of conventions of representation.

Besides Giacometti, the other major sculptor of the immediately post-war years was Henry Moore. It was surprising that an Englishman should find himself in such a commanding position. Since the end of the Middle Ages, the English sculptural tradition has been a feeble and intermittent one. The last English sculptor to achieve much influence abroad, before Moore's arrival on the scene, was the neoclassicist.John Flaxman, and even so it was Flaxman's drawings (his illustrations to the

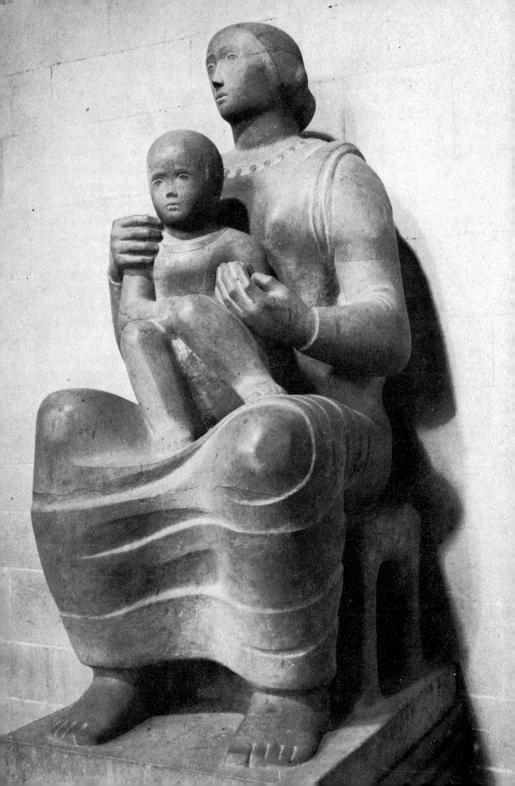

Iliad and the *Odyssey*) which won him the respect of his European contemporaries.

Moore has been an important figure in English art ever since the 1930s. During that decade, he was connected with both the major art movements then active in England, surrealism and constructivism. He did not, however, commit himself fully to either of these, but evolved, instead, a personal manner which used elements taken from both, and which also showed the influence of primitive cultures (such as ancient Mexican art) and of the English romantic tradition. The principal themes of Moore's work were soon established: the reclining female figures, the groups of a mother and a child, the more abstract stringed forms. Moore is essentially a biomorphic sculptor, and thus more a surrealist than a constructivist. Two ideas which much influenced him were those of 'truth to materials', and of revealing the full potential of the sculptural form. It was the latter which led him to pierce the forms which he used, to explore the effect of placing one form within another. He also had a keen sense of sculptural metaphor; as the English critic David Svlvester, one of Moore's keenest admirers, has commented ·

Moore's metamorphic forms reveal marvellous and unsuspected likenesses between disparate things, but the revelation is like that of some elemental truth: once recognized, it seems inevitable; it may not lose its mystery, but it does lose its surprise; it seems right and natural, reasonable, not outlandish and questionable.²

When the war came, Moore, like a number of other leading British modernists, such as Graham Sutherland, felt the impulse to bring his art closer to the expectations of the mass audience. The result was the creation of works such as the *Northampton Madonna* and the series of 'shelter drawings', a tribute to the stoic endurance of Londoners under the Blitz. The work he did at this period confirmed Moore's stature in the public mind. In 1946, a retrospective exhibition of his work was held at the

Ill. 164

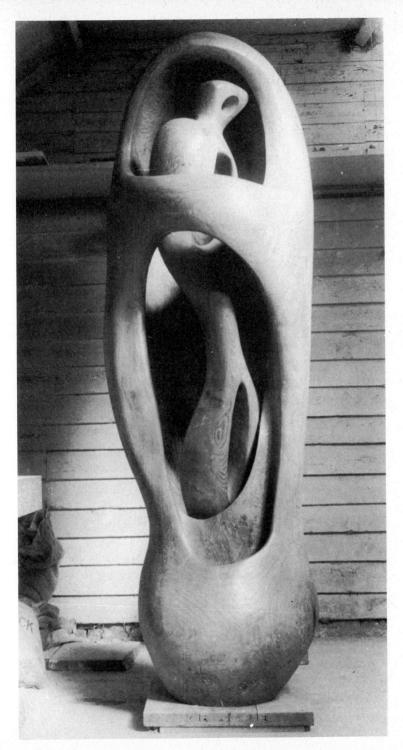

165 HENRY MOORE Internal and external forms 1953-4

Museum of Modern Art in New York, the first of over a hundred such retrospectives to be held abroad. The show made a deep impression, and when, in 1948, Moore won the major prize at the Venice Biennale, his international reputation was assured.

Since 1946, Moore has continued to develop the themes which interested him in the 1930s, and some new ones have been added – the sculptures derived from the forms of bones, for example. But in some respects his later career has been a disappointment. He has moved away from materials such as stone and wood, and has made increasing numbers of works in bronze, many of them enlarged, with the help of assistants and by traditional methods, from smaller models. It is true that this reflects, not so much a radical break with his previous practice, but the increased scope of the opportunities now being offered to him – the chance to create large-scale public monuments in particular. But too often this later work has seemed flaccid and insensitive compared with what he did earlier.

There is also a sense in which the whole development of post-war sculpture has been a criticism of the things which Moore has always stood for. Naturally, as his work has become more familiar, so it has come to seem less radical. The reclining figures can now be seen to have a clear relationship with the reclining figures of classical art - those of the Parthenon pediments, for instance, and those on Michelangelo's Medici tombs. They are often closer to these predecessors than to anything which has succeeded them. Even Moore's most abstract works, such as the big Locking-piece of 1963-4, have a deliberately monumental quality - and the sense of the monumental is one of the things which younger sculptors have most reacted against. The American art critic Clement Greenberg caused a mild uproar in the English art world when, in a published interview with me, he criticized what he felt to be Moore's wish to produce 'masterpieces'.3 The concept of the 'masterpiece' has also played a somewhat controversial role in recent sculpture, because it seems to imply that the spectator is being

Ill. 165

Ill. 166

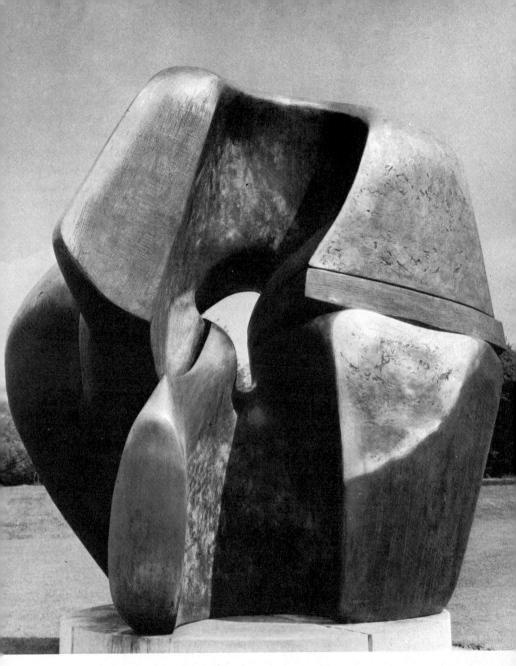

166 HENRY MOORE Locking-piece 1963-4

courted in some way, and, in addition, that he is being asked to focus on the personality of the artist and not on the work.

Ills 167, 168 Next to Moore, the most respected British sculptor of the older generation is Barbara Hepworth. Essentially, Hepworth's art springs from the same intellectual and cultural ethos as Moore's, and she uses some of the same formal devices, notably piercing and stringing. But she is a cooler artist, a superb craftsman in wood and stone whose best work has an aloofness and purity which have not been among Moore's aims. More clearly even than Moore, Hepworth belongs to a previous age. One finds the best comparisons for her work among the pioneer modernists, sculptors such as Arp and Brancusi, and few links with sculptors who are younger than she is. Hepworth provides a striking demonstration of the fact that there are now two modernisms rather than one, and that the two often have little to say to one another.

Moore, however, is not as isolated as Hepworth or Giacometti. There is a whole 'middle generation' of sculptors who owe a great deal, both to his influence and to his example.

167 BARBARA HEPWORTH *Two figures* 1947–8

168 BARBARA HEPWORTH *Hollow form (Penwith*) 1955 (Collection The Museum of Modern Art, New York)

169 BERNARD MEADOWS Standing armed figure 1962

170 KENNETH ARMITAGE Figure lying on its side (version 5) 1958–9

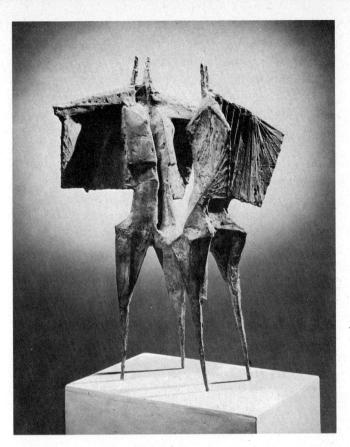

171 LYNN CHADWICK Winged figures 1955

Among them are artists such as Kenneth Armitage, Lynn Chadwick, Reg Butler, and Bernard Meadows. During the 1950s these sculptors enjoyed a very considerable success.

In varying degrees, their work was figurative. It kept to the human scale, perhaps for the reason that Reg Butler once gave to an interviewer, that it was no longer possible to imagine men with the stature of gods.⁴ Certainly Butler's female nudes are not heroic. They have a keen and rather wry eroticism. Even Armitage, when eventually he moved away from figuration to become the most abstract of the group, made a kind of sculpture which was still to the measure of mankind.

Ills 169–71, 173 All of these are things which divide the 'middle generation' sculptors from their younger colleagues. But there is often a vast difference in technique as well, for the artists I have just mentioned are modellers; they work in plaster and then in bronze. Compare their work to that of sculptors such as Anthony Caro or Phillip King, who are scarcely, if at all, younger, and they seem the inhabitants of a different universe.

But British sculptors were not the only ones who, in this immediately post-war period, seemed to be seeking a compromise between modernism and what people had traditionally expected of sculpture. In Italy, for instance, there were a number of sculptors who strove to come to terms with the Italian past, among them Marino Marini, Emilio Greco, and Giacomo Manzù. Marini's bronze horsemen and Greco's

172 MARINO MARINI Horse and rider 1947

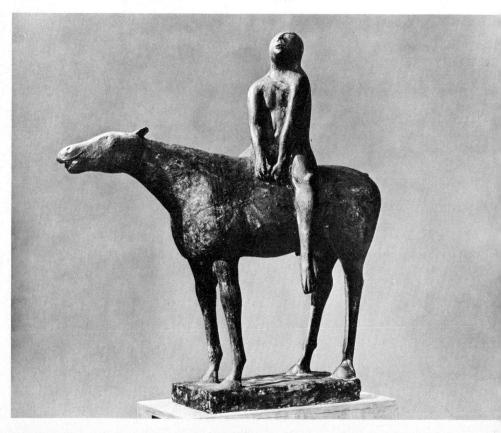

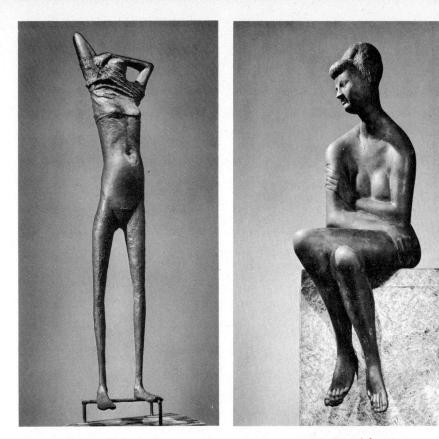

173 REG BUTLER Girl 1953-4

174 EMILIO GRECO Seated figure 1951

female nudes are seductive images which seem, ultimately, to fail because of their superficiality. In Marini's horsemen, for instance, one catches echoes both of Etruscan art (as with Giacometti) and of the lively polo-players modelled by Chinese potters in the T'ang dynasty. Greco, too, seems to allude to Etruscan sculpture, especially that of the later period. Indeed, for all their apparent simplicity and straightforwardness, these are two very sophisticated artists, and they require from their audience the kind of response which summons up memories of the art of earlier ages. Perhaps for this reason, disillusionment follows swiftly upon the heels of pleasure when one looks at

Ill. 172

their work. For what is being alluded to, or hinted at, is more powerful than the sculpture which is the object of contemplation.

Ill. 175

Ill. 176

Ill. 177

Of these three sculptors, Giacomo Manzù is in many ways the most interesting. In works such as his Fruit and vegetables on a chair, a poker-faced reproduction of reality, he seems to anticipate some of the ideas of pop art; and in the bronze doors which he designed for St Peter's in Rome, he attempts the traditional role of the sculptor who subordinates his work to a religious or commemorative purpose. In ways, the panels for these doors are an impressive feat. The technique of very low relief, which derives from Donatello, is handled with extreme sensitivity and skill. The imagery, with its fierce condemnation of cruelty and injustice, exerts a genuine popular appeal. Manzù comes closer, in these panels, to being a genuine 'populist' than does his compatriot Renato Guttuso. And when the sculptor chooses, in one of the panels, to show the death of Pope John XXIII, we are convinced that he has been genuinely moved by a contemporary event, and has tried to communicate his emotion.

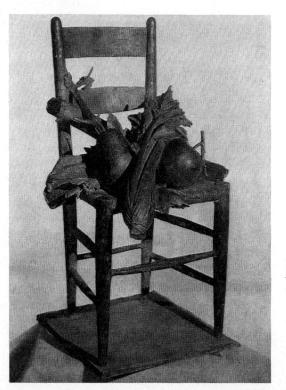

175 GIACOMO MANZÙ Fruit and vegetables on a chair 1960

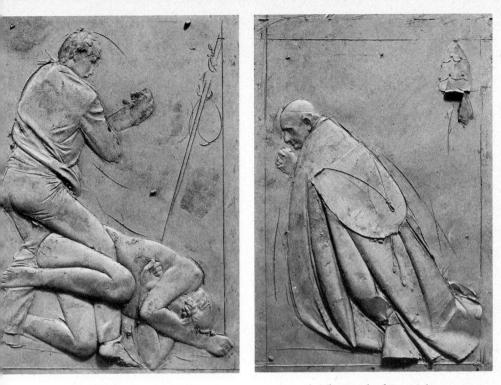

6 GIACOMO MANZÙ The Death of Abel 1964 177 MANZÙ The Death of Pope John 1964

The trouble is that the very virtuosity of the workmanship emphasizes the lack of true inventiveness. These illustrations – sacred strip cartoons, one might almost call them – are an anthology of other men's ideas. Not only Donatello but Bernini, not only Bernini but Medardo Rosso has been laid under contribution. The hints and borrowings have not been fully assimilated, as Picasso, for example, has usually been able to assimilate his countless borrowings. The great ghosts of Italian art haunt Manzù's work and will not be exorcized.

A more recent, less ambitious, and perhaps more hopeful tendency in Italian sculpture is represented by the work of Arnaldo Pomodoro. Pomodoro began his career as a stage designer, and then began to make jewellery. His first exhibition of sculpture was not held until 1955.

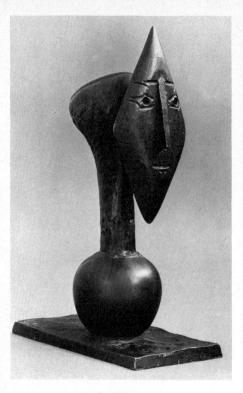

179 ANDREA CASCELLA The White Bride 1962

His work, though often executed on a very large scale, has something of the jeweller about it still. Smoothly polished metal surfaces split open to reveal roughened interiors full of complex forms. Pomodoro is a brilliantly skilful craftsman in metal, whose work always reveals a keen eye for the nature and possibilities of his material. But, like Antonio Tapiés, he seems essentially a maker of luxury objects, which titillate the senses without offering any kind of intellectual challenge.

Ill. 179

Much the same criticism might be made of Andrea Cascella's finely finished work in marble, though Cascella straddles two worlds. In one sense he resembles Barbara Hepworth: he is a carver who gives us beautiful materials, beautifully used. But

his interest in the constructive aspect – the way in which the sculptures are made in separate parts, which lock intricately together – hints at the concerns of an apparently quite different kind of art, exemplified in the metal constructions of Chillida, which are discussed in the next chapter.

Though, as I noted at the beginning of this chapter, American sculpture found it difficult to respond to the challenge of abstract expressionism, there were a number of sculptors in the United States who strove to learn from the new style. The most important of these is David Smith, whose work eventually moved so far outside the original abstract expressionist orbit that it will be more useful to discuss it later. Among the others

180 ARNALDO POMODORO Sphere no. 1 1963 (Collection The Museum of Modern Art, New York)

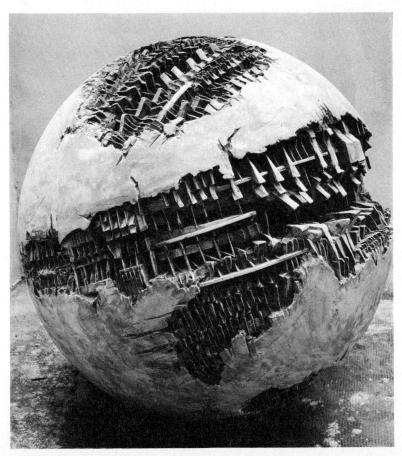

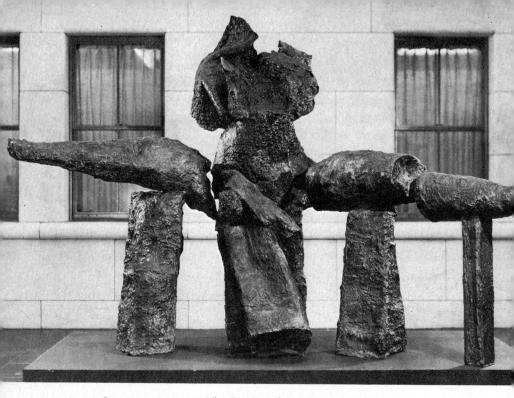

181 REUBEN NAKIAN The Goddess of the Golden Thighs 1964–5

who were touched by abstract expressionist concepts were
185 Ibram Lassaw, Herbert Ferber, Theodore Roszak, and Reuben
183 Nakian. Lassaw's open, rather calligraphic work in metal is like
the strokes of abstract expressionist brushwork, transferred to a
182 different medium. Ferber experimented with direct welding,
perhaps because this seemed to provide an equivalent for the
spontaneity with which an artist like Pollock used paint. It
is perhaps significant that there is something of a time-lag
between the establishment of the new style in painting and its
impact in sculpture (this was also true of the sculpture which
181, cubism inspired). Nakian, for instance, who is perhaps the freest

186 and most direct of all the artists I have just listed, embarked on his most abstract expressionist phase only at the beginning of the 1960s. The forms he then used also seem to owe something

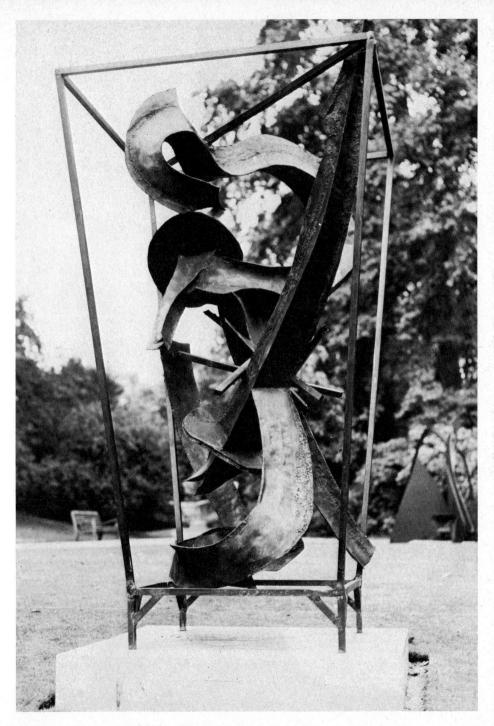

182 HERBERT FERBER Homage to Piranesi 1962-3

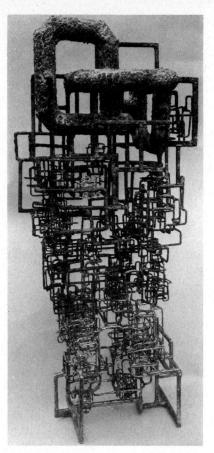

183 IBRAM LASSAW Space densities 1967

184 ALEXANDER CALDER The Red Crab 1962

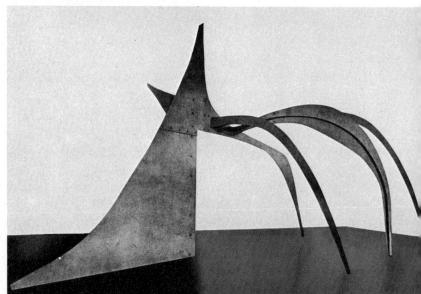

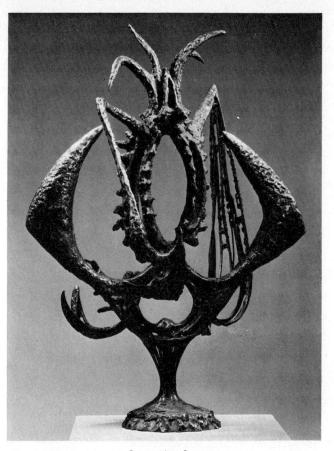

185 THEODORE ROSZAK Invocation I 1947

to the billowing veils of paint with which Morris Louis had been experimenting.

There is a very marked break, however, between the sculpture which I have been discussing in this chapter, and that which I shall deal with in the next. One is tempted to describe them as two different art forms, so radical is the difference in attitudes and techniques. The work I have described is work by artists who have been content with the traditional categories: they have tried to participate in the modernist revolution, but they have also had a bond with the great sculptors of the past. What they make – the imagery – might seem strange to a man of the Renaissance. But he would find their techniques familiar: the casting of metal, the carving of wood and stone. What is more, the man of the Renaissance would agree, very largely, with these successors on the subject of how a work of sculpture *functions*. A monumental piece by Henry Moore, and one by Giovanni da Bologna, are things which belong to the same intellectual ordering. Many of the objects I shall now describe spring from wholly different premisses, which Giovanni da Bologna would not have understood.

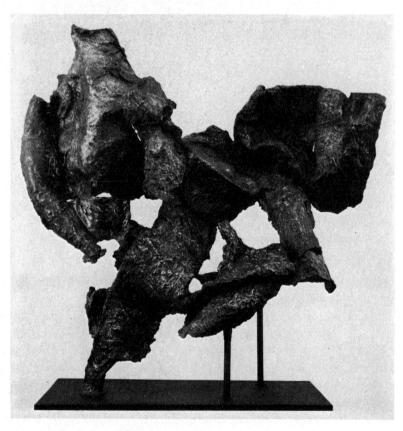

186 REUBEN NAKIAN Olympia 1960-2

CHAPTER EIGHT

The new sculpture

Pinpointing how the new sculpture began is a difficult matter. Certain developments and certain ideas seem important in the light of hindsight, but one cannot say that they led inevitably to the situation as it exists today. Some of these developments belong to the early part of the post-war period, others took place earlier. Calder's mobiles, and the welded metal sculptures of Julio González, are important progenitors of some of the most interesting work we see being done today. The webs of glittering wires created by the American sculptor Richard Lippold in the 1940s foreshadow a more recent feeling for a seemingly weightless sculpture which engulfs and embraces space. The texturing of tiny cog-wheels and small machineparts which the British sculptor Eduardo Paolozzi applied to the surface of his early bronzes predicts the much bolder use of ready-made components which was to come into fashion some years later. And of course the whole concept of the 'ready-made' was the brainchild of Marcel Duchamp.

It was the new interest in assemblage, following on the heels of abstract expressionism, which brought with it the first stirrings of the new sculpture. An extremely personal example was set by Jean Dubuffet. His work in three dimensions includes figures made of clinker, sponge, charcoal, and vineshoots. The irrepressible Yves Klein made three-dimensional works from blue-dyed sponges at the end of long stalks. What creations like these seemed to indicate was the desire to question the role of the role of the more traditional sculptor, imagining forms and then imposing them on the surrounding universe.

One consequence of this interest was an apparent revival of the surrealist 'object', an extension into three dimensions of the collage. Rauschenberg's stuffed goat, already described, had

Ill. 188

Ill. 187

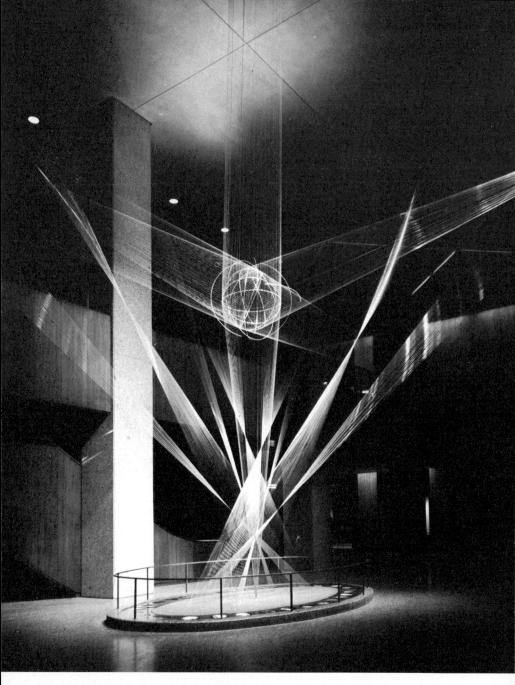

187 RICHARD LIPPOLD Flight 1962

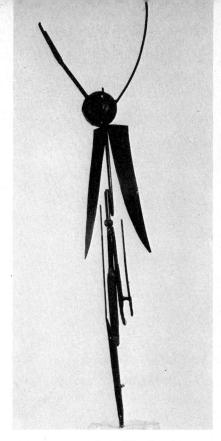

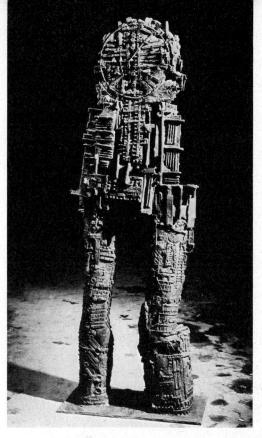

188 JULIO GONZÁLEZ The Angel 1933

189 EDUARDO PAOLOZZI Japanese War God 1958

already been anticipated by such things as Miró's *Poetic object* of 1936, which is crowned by a stuffed parrot; by Brauner's *Wolf-table* of 1939, which features the head and tail of a stuffed wolf; and even by Meret Oppenheim's celebrated fur teacup. But it was the more strictly sculptural uses of the collage idea which were to have large consequences for the future.

For instance, the American sculptor Louise Nevelson began by using smooth abstract shapes, in a way that was almost comparable to Hepworth. Then she moved towards assemblage: the fitting together of ready-made wooden shapes, such as the splats and backs of chairs, knobs and banisters from

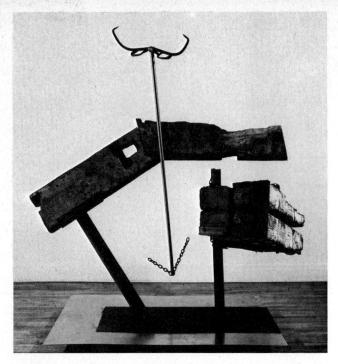

190 MARK DI SUVERO New York Dawn (for Lorca) 1965

demolished houses, scrolls and bits of moulding. These fragments are associated within compartments and boxes, and the boxes themselves are often assembled to form large screens or walls. The fact that these intricate sculptures are painted a uniform colour – white, black, or gold – stresses what would in any case be clear. Nevelson uses her wide range of wooden shapes as a grammar of form, and it is the relationship between them which interests her, rather than each shape in isolation. The triumph of relationship over form is one of the themes of the new sculpture.

Ill. 190

Ill. 191

But despite Nevelson's work, and that of certain other artists, such as Mark di Suvero, it was metal, not wood, which was the favoured material of the first wave of the new sculptors. One reason for this was the 'junk ethos' which had much to do with the popularity of assemblage techniques among painters

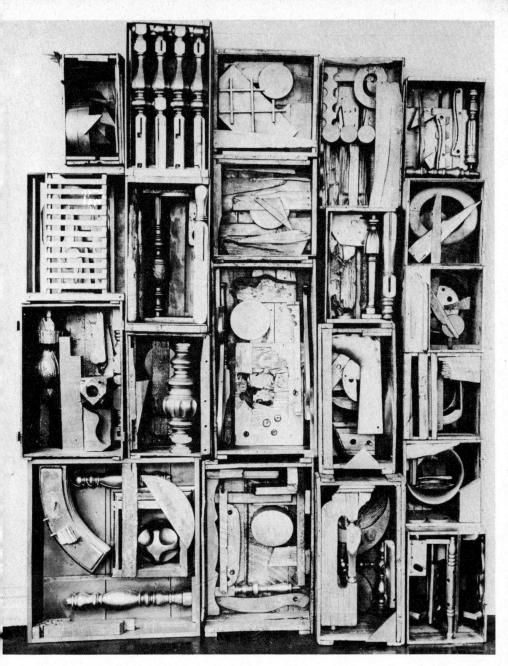

191 LOUISE NEVELSON Royal Tide V 1960

192 JOHN CHAMBERLAIN Untitled 1960

Ill. 192

Ill. 193

and sculptors alike. Junk, in a technological society, is apt to be the fragments of wrecked machines. John Chamberlain's sculptures made from parts of wrecked automobiles, and Richard Stankiewicz's, created from scrap steel parts welded together, were comments on consumer culture. The artists I have just mentioned are American, but Europeans worked on the same lines, notably César, who arrived at his *Compressions*

dirigées, objects made with the help of the giant machines which *II* are used for baling old automobiles and other metal scrap into packages of convenient size.

More important than any of these, however, was the late David Smith, who occupies almost the same position in the history of post-war sculpture as Pollock does in that of post-war painting. Indeed, there are reasons for regarding Smith as the more important figure. Pollock's work was an assertion of the rights of the individual: the interior world of dream was opposed to the exterior world of fact; the paintings themselves were a rejection of the mechanistic. But it is one of the distinctive things about Smith's work that it could only be the product

193 RICHARD STANKIEWICZ Kabuki Dancer 1956

194 CÉSAR Dauphine 1961

of a highly developed technological civilization. He was a Mid-Westerner, and not only worked in an automobile plant as a young man, but returned to heavy industry during the Second World War. These facts are as crucial to an understanding of his work as the knowledge that he was influenced by Picasso and Julio González.

Smith was born in 1906, and it was in the mid 1920s that he moved to New York and turned painter: among his early associates were Arshile Gorky and Willem de Kooning. When he abandoned painting for sculpture (this happened in the early 1930s) Smith did not think of this as marking a sharp break in his career, or a radical change of interest. As he said later, 'I never recognized any separation except one element of dimension.' At this period, his mind ranged freely over what European artists were doing, though he knew their work for the most part only from reproductions in books and art magazines. He noted: 'While my technical liberation came from Picasso's friend and countryman González, my aesthetics were more influenced by Kandinsky, Mondrian and cubism.'¹

Even at this period, Smith was doing some important and original work. There are sculptures made in the 1930s from steel and ready-made or 'found' steel parts, which come remarkably close to what Stankiewicz was to produce at a much later epoch. Already, industrial techniques provided Smith with a personal language. Frank O'Hara said of him:

From the start, Smith took the cue from the Spaniards to lead him toward the full utilization of his factory-skills as an American metal-worker, especially in the aesthetic use of steel glorifying rather than disguising its practicality and durability as a material for heavy industry.²

When the war ended, Smith was already a respected artist in mid-career. The Museum of Modern Art had acquired a sculpture by him in 1943. In 1944, he was able to return full time to sculpture, and in January 1946 there was a large-scale retrospective of his work in two New York art galleries. It was

195 DAVID SMITH Hudson River landscape 1951

the succeeding years which established him as a key figure, however. First, he went through a linear phase, where the sculptures were like drawings in metal. It is significant that some of the work of this phase is concerned with ideas about landscape: a piece like the well-known Hudson River landscape of Ill. 195 1951 is almost 'anti-sculptural', both in aims and in effect. The openness of this work, and of others like it, was a portent for the future.

Later in the 1950s, Smith's work became even more unconventional, and larger and larger in scale. Smith was a prodigious worker, and the techniques he adopted enabled him to work very rapidly and freely. In 1962, for example, he was invited by the organizers of the Spoleto Festival to spend a month in Italy, and was offered an old factory as a workshop.

196 DAVID SMITH Voltri VII 1962

Ill. 196 He made twenty-six sculptures in thirty days, many of them gigantic. In fact, the series rather than the individual piece had now become Smith's chosen means of expression: a single idea would be put through a great many permutations, until the artist felt that it had been taken far enough.

These ideas were themselves highly original. In the early series, *Agricola* and *Tank totem*, Smith is still interested in the figurative, and, more specifically, in the human figure. Later he moved towards a more abstract style, in the series he labelled *Zig* and *Cubi*. The *Cubi* series, in particular, has an unstable, dynamic quality which seems very typical of Smith's work.

Smith was a revolutionary artist in a number of ways. The first, and perhaps the most important, of these is the fact that, though he worked on a monumental scale, especially towards the end of his life (he was killed in a car crash in 1965), he is not

Ill. 197

¹⁹⁷ DAVID SMITH Cubi XVIII 1964

a monumental sculptor in the strict sense. There often seems to be a deliberate avoidance of the massive; there is a lack of sculptural density which can seem disconcerting. No image which Smith produced remains in the mind in the way that Moore's or Brancusi's images do. The shapes are ready-made and their arrangement seems provisional. One sculpture, seen in isolation, is usually much less effective than several from the same series, viewed together or in sequence. The fact that Smith sometimes painted his work, or at other times gave it a rough polish, the raw glitter of metal which is only part of the way through some process of manufacture, reinforces these reactions. Like the post-painterly abstractionists, Smith tended to eschew associations; in this he is very different from a sculptor such as Moore, who seems to want to summon up the powers of nature - rocks, water, and wind - to help him in his task. All of these procedures and preferences were to be influential upon younger men.

The only other sculptor to enjoy anything like the prestige which Smith has had during the past decade is an Englishman, Anthony Caro. Caro, too, makes use of ready-made steel parts – I-beams, sheet-steel, pieces of coarse metal mesh – which are assembled in sprawling compositions. He said, in an interview with Andrew Forge in 1966:

I would really rather make my sculpture out of 'stuff' – out of something really anonymous, just sheets maybe, which you cut a bit off. . . . Much of the sculpture that I'm doing is about extent, and might even get to be about fluidity or something of this sort, and I think one has to hold it from becoming just amorphous.³

In fact, Caro has been widely recognized as David Smith's heir – paradoxical because he is not only English, but was once (like so many British sculptors) one of Henry Moore's assistants.

But it would be wrong to suggest that Smith and Caro have exactly the same sculptural preoccupations. To take the most obvious difference first: Caro's work usually has a horizontal

Ills 198, 209

198 ANTHONY CARO Homage to David Smith 1966

emphasis, as opposed to the verticality of most of Smith's late sculpture. Caro's sculptures could be described as being both space-devouring and ground-devouring. The base has been abolished, and each piece takes possession of a certain territory, and modifies the spectator's reactions to the space in which it is put. Smith, like Moore, preferred to have his work shown in the open air; Caro, on the contrary, seems to like an enclosed space, which the piece can occupy and activate. Most of his sculptures are painted a single, unifying colour, which often seems chosen for its ambiguity, its quality of making us feel uncertain whether the object we are looking at is heavy or light. A number of his small sculptures, often made to balance on the edge of a table, with some of the mass below the level of the table-top, have a shiny chromium finish which captures the surrounding space in a series of distorted reflections.

It has been customary, especially among American critics, to suggest that this is entirely an abstract, gestural art. Certainly, in Caro's hands, rigid materials acquire a surprising suppleness. But the English eye is apt to find his work at least remotely figurative, whether or not this is intentional. From some angles Caro's sprawling sculptures can seem like Moore's giantesses stripped to their skeletons.

This affinity with Moore, in spite of an apparently firm renunciation of everything Moore stands for, is not the least of the reasons why Caro occupies a pivotal position in recent sculpture. It is right to mention the work of other artists: that of David Smith, and the sculpture of men who derive more or less directly from Smith such as the German Erich Hauser;

199 ERICH HAUSER Space column 7/68 1968

200 EDUARDO CHILLIDA Modulation of space 1963

Calder's stabiles, which anticipate Caro's rejection of the customary base or plinth; the wrought iron sculptures of the Spaniard Eduardo Chillida which both cleave to the tradition of González and parallel some of Caro's experiments. Caro does not stand completely alone even in the English tradition. The 'screw mobiles' of Kenneth Martin, for instance, where the parts can often be assembled in almost any order on a central armature, provide a more extreme example of the industrial approach; while much of the more recent work of Eduardo Paolozzi belongs to the same category as Caro's, though with an influence from pop art which Caro never seems to have felt. But none of these artists stands precisely upon the cusp, and looks both forward and back, as Caro seems to do.

When it comes to giving explanations of this, Chillida and Paolozzi provide the best comparisons. On the whole, European sculpture has not progressed in the direction taken by British Ill. 200

Ill. 202

and American art during the late 1960s. The difference is like that between American post-painterly abstraction and the op art of Vasarely and his followers. Those European artists who work in three dimensions – or at least those of them who are in the vanguard of experiment – have mostly turned towards kinetic art, and have been discussed under that heading in an earlier chapter. Chillida, however, belongs to the Spanish tradition of craftsmanship in wrought iron just as Smith and Caro, in their various ways, belong to the Anglo-American tradition of heavy

201 EDUARDO PAOLOZZI Etsso 1967

202 KENNETH MARTIN Rotary rings 1967

industry. However similar Chillida's ideas are to those of his American and British contemporaries, we are conscious, when we look at his work, that he belongs to a tradition of the 'handmade' object, which they are rejecting. His intellectual affinities are with them; his sensibility is closer to that of Spanish painters such as Tapiés.

Paolozzi presents an even more interesting case. He is an artist who has gone through a remarkable number of stylistic transformations, but the guiding thread in his work seems alwavs to have been an interest in machines, or, to put it more accurately, in the mechanistic. I have already spoken of his early figurative sculptures, textured with cog-wheels and other small machine-parts. In later work, he has made use of readymade metal parts and sections, but in a different spirit from Caro and David Smith. Paolozzi, unlike Smith or Caro, has mostly tended to assemble these shapes into pseudomachines, or at least into objects which look as if they have some kind of mechanical function, even though there are no moving parts. Paolozzi has also made a series of sculptures which look as if they derive, not directly from machinery, but from the machine-influenced decoration and architecture of the Jazz Age. Characteristic are boxy chromium-plated objects, the horizontal planes flat, the vertical ones crimped and rippled like the mouldings in a 1930s movie-palace. These look like the remote cousins of things found in amusement arcades. The point of the contrast between Caro and Paolozzi is that Caro is neutral in the attitudes he adopts towards his materials. To him they are, as he says, just 'stuff'; the technological side of his activity is not romanticized, but exists in its own right.

The work of David Smith and of Anthony Caro marks a moment of transition in a general sense as well as in a particular one. After the war, painting was the dominant art. It was in painting that the major experiments were tried. But recently, and particularly in American and in British art, there has been a change of attitude. It has been work in three dimensions which has come to seem a natural vehicle of *avant-garde* expression. Ill. 189

It is true, as I have noted, that the boundaries between sculpture and painting have, at the same time, tended to dissolve. Despite this, one is conscious that the emphasis has shifted towards the three-dimensional object, something which governs our reactions to the environment in which we move.

One of the best examples of this is the work of the British sculptor Phillip King. When King's sculpture was exhibited at the Venice Biennale in 1968, Bryan Robertson summed up its effect as follows:

The enigmatic character of King's work springs from a built-in, subliminal effect of paradox. Each sculpture is so very much more remarkable than its bare, factual existence as a physical object in space. An essential *logos*, or personal system of clear rules, is so charged by imagination that wholly unexpected conclusions are revealed: each sculpture will shift suddenly into a different identity whilst its structure is examined. The disclosure has the impact of a dramatic event. It is as if two plus two were made to yield five, incontrovertibly and with splendid finality.⁴

Ill. 210 His *Span* is made up of a double box, two leaning slabs, and two square columns, the capitals and bases of which are truncated pyramids. These are placed so that the spectator is free to move between them; he does not merely walk *round* the sculpture, he walks *in* it.

King does not work in metal, like Caro, but in brightly coloured fibreglass. The colour is often used to emphasize the movement of the shapes, to impart something dynamic to otherwise static forms. The shift from metal to fibreglass and other kinds of plastic is something which King has in common with younger sculptors, and the implications are interesting. Plastic is man-made; any character can be given to it; it can be tinted any colour. This makes it something quite different from the wood and stone of the days of 'truth to materials'. It also carries none of the industrial overtones of sheet-steel and I-beams. In fact, if it has any implications at all, they are those of a

Ills 203, 210

²⁰³ PHILLIP KING Genghis Khan 1963

culture where everything is disposable, a culture aligned towards exhibitions and events rather than permanent objects.

In Britain, most of these sculptors were introduced to the public through the medium of the second 'New Generation' show at the Whitechapel Art Gallery in 1965. Among the sculptors represented in this exhibition, besides King himself, were David Annesley, Tim Scott, and William Tucker. The exhibition had an immense impact. The favoured material, besides various forms of plastic, was brightly painted sheet metal, but the material itself was never stressed; it was simply the vehicle for the formal idea. It was clear that the young artists concerned had learned a good deal from the American

Ills 204-6

colour painters, and from the sculptural experiments of men who were primarily painters, such as Barnett Newman and Ellsworth Kelly. There was a lack of bulk and volume about most of the pieces which reflected these influences. The sculptures sprawled and twisted. They made play with repeated forms. Tucker, in particular, has experimented with a principle of extension which also appears in some of Frank Stella's linked canvases, and, earlier still, in the various versions of Brancusi's *Endless column*. It was noticeable then, and has remained noticeable, how much of the new work not only shunned a base but seemed to hug the floor. A great deal of recent sculpture is well below eye-level. Some of the most extreme experiments in this direction have been made by David Hall, a sculptor who, though not included in the 'New Generation' exhibition, has much in common with those who were.

204 DAVID ANNESLEY Orinoco 1965

205 TIM SCOTT Trireme 1968

206 WILLIAM TUCKER Memphis 1965–6

Ill. 208 Hall, for example, has made sculptures of metal plates, which float horizontally at ankle height, suggesting the existence of another floor surface hovering just above the true one. The shapes suggest perspectives that conflict with the true perspectives of the room. The whole work acts as a mechanism for bending and distorting space, and has little physical presence of its own. One notices, not the piece itself, but its alteration of the area which it occupies.

British sculpture of the 'new generation' has remained a tightly coherent movement, or school, of a rather insular kind. Though these sculptors are usually spoken of as being related to developments in America, they have had their most clearly marked impact on certain German artists, notably Kaspar Thomas Lenk, whose recent work closely parallels theirs, while what he did earlier was in a totally different style, influenced by surrealism.

American sculpture, post-David Smith, makes a less coherent impression than British sculpture, post-Caro. One artist stands out as having played an important role: the ex-architect Tony

207 TONY SMITH Playground 1962

208 DAVID HALL Nine 1967

Smith. Smith's career is an example of the suddenness with which even a mature artist can burst upon the scene in current conditions. The first single piece of his to be shown was exhibited in 1963.

Tony Smith was born in 1912, six years later than David Smith, and served his architectural apprenticeship as clerk of the works on several of the houses built by Frank Lloyd Wright. For twenty years, from 1940 to 1960, he had an architectural practice of his own. He gave up architecture because he felt that buildings were too impermanent, and too vulnerable to alterations which would wreck the creator's intention.

His sculptures have been described as 'minimal art', or as examples of the 'single-unit Gestalt', but this is to oversimplify matters. The artist himself speaks of some of them as

part of a continuous space grid. In the latter, voids are made up of the same components as the masses. In this light, they may be seen as interruptions in an otherwise unbroken flow of space. If you think of space as solid, they are voids in that space. While I hope they have form and presence, I don't think of them as being objects among other objects; I think of them as being isolated in their own environments.⁵

Much of Smith's work seems to reflect his experience of architecture. He says of one piece, called *Playground*: 'I like

shapes of this kind; they remind me of the plans of ancient buildings made with mudbrick walls.' Characteristically, the sculptures consist of rectangular boxes fitted together; sometimes this is varied by using tetrahedrons. Smith describes one as having come from the accidental conjunction of three Alka-Seltzer boxes; another, called *Black Box*, was suggested by a box for index cards which the artist saw on a friend's desk. Seen one night, the shape became an obsession, so Smith telephoned his friend the next morning and asked for the dimensions.

I asked him to take his ruler and measure the box. He was so out of it that he didn't even enquire about why I wanted to know the size. I multiplied the dimensions by five, made a drawing, took it to the Industrial Welding Co. in Newark, and asked them to make it up.⁶

Obviously, art of this kind marks a radical break from the sculptural preoccupations of the past. In a way, it could be said to stem from dada, and in particular from the cult of the 'found object'. It could also be said to have something to do with John Cage's notion of unfocusing the spectator's mind. But neither of these goes so far as to imply a concentration on the deliberately inexpressive, and that is what the new American sculpture has more and more tended to do.

Minimal art is not simply a question of the activity of one artist, but of a whole school of artists, among them Carl André, Dan Flavin, Robert Morris, Sol Lewitt, and John McCracken. One of the most articulate of these artists is Donald Judd, who speaks of his practice thus:

Three dimensions are real space. That gets rid of the problem of illusionism and of literal space, space in and around marks and colours – which is riddance of one of the most salient and most objectionable relics of European art. The several limits of painting are no longer present. A work can be as powerful as it can be thought to be. Actual space is intrinsically more powerful and specific than paint on a flat surface.⁷

209 ANTHONY CARO Sun-feast 1969-70

210 PHILLIP KING Span 1967

211 ROBERT MORRIS Untitled (circular light piece) 1966

Ill. 212

His interpretation of this credo is less liberal than the words themselves might lead one to suppose: a string of galvanized iron boxes strung out at regular intervals across the wall.

Judd's colleague, Robert Morris, defends minimality in equally emphatic terms:

Simplicity of shape does not necessarily equate with simplicity of experience. Unitary forms do not reduce relationships. They order them. If the predominant, hieratic nature of the unitary form functions as a constant, all those particularizing relations of scale, proportion, etc., are not thereby cancelled. Rather they are bound more cohesively and indivisibly together. The magnification of this single most important sculptural value, shape, together with greater unification and integration of every other essential sculptural value, makes, on the one hand, the multipart, inflected formats of past

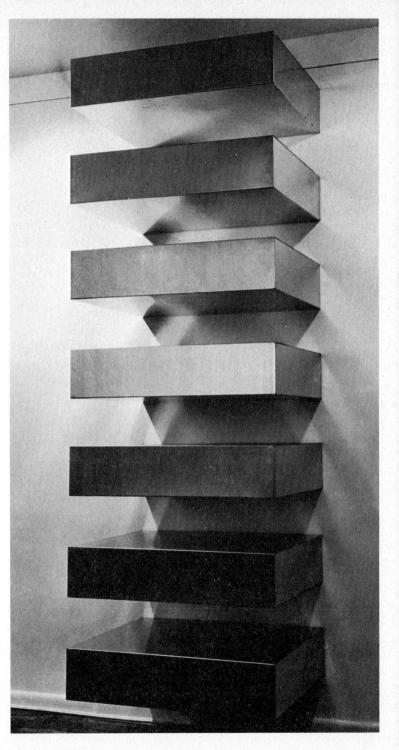

212 DONALD JUDD Untitled 1965

213 KASPAR THOMAS LENK Schichtung 22a 1966

sculpture extraneous; and on the other, establishes both a new limit and a new freedom for sculpture.⁸

These justifications are in some ways beside the point, because it seems to become increasingly clear that the minimal artist does not really wish to express himself, or express some meaning, in the old sense. There is, it is true, a sense of *ordering*, which often takes the form proposed by Tony Smith: the artist provides a partial image of a complete order throughout all the space which can be imagined, and leaves the spectator to fill the rest in.

This is exactly what happens, for instance, in much of the work of Sol Lewitt. In April 1968 Lewitt had an exhibition in New York which consisted of a single sculpture, descriptively entitled 46 Three-part variations on three different kinds of cubes. The cubes were boxes of standard size. Some were closed, some open on one side only, some open on two facing sides. These were piled together in groups of three. The cubes were regularly aligned in their stacks, and the stacks regularly aligned with one another. Each of the eight rows set out the possible solutions in a fixed order of permutation, beginning with a row which established all the possible permutations when each stack contained only one example of each of the three kinds of cubes.

Ill. 215

Some minimal art is less dour – and less naïve. Dan Flavin's work, for instance, makes use of straight lengths of fluorescent tubing, and is the point at which minimal art meets kinetic art. Flavin regards not only light, but space, as his material. 'I knew', he says, 'that the actual space of a room could be broken down and played with by planting illusions of real light [electric light] at crucial junctures in the room's composition.'⁹

Flavin, therefore, is aiming at a kind of dematerialization of art, and much the same might be said about the Californian artist Larry Bell, who makes use of plates of coated glass which are placed at right angles. These both reflect the spectator and allow him to see what lies on the other side of the plate. The art object is not the cube itself, but these fleeting effects of reflection and transparency.

Ill. 214

John McCracken, another Californian, also seems concerned that the play of light should be regarded as part of the effect of the work. He makes long plywood and fibreglass boards, which lean casually against a wall. These boards are lacquered in gleaming colours. The artist says: 'I think of colour as being the structural material I use to build the forms I am interested in.'¹⁰

Colour, light, transparency – these are the materials of much of the new sculpture in America. There is also a tension between extremes of formality and formlessness. Robert Morris says:

215 DAN FLAVIN Untitled (to the 'innovator' wheeling beachblow) 1968

217 ROBERT SMITHSON Broken circle 1971

In recent object-type art the invention of new forms is not an issue. A morphology of geometric, predominantly rectangular forms has been acceptable as a given premise.... Because of the flexibility as well as the passive, unemphasized object-type shape it is a useful means.¹¹

He proceeded to try to prove his point by showing works, still minimal in intent, which consisted of loosely piled pieces of grey felt. These, as he pointed out, co-opted both Pollock and Oldenburg as forerunners of his own tradition.

Since Morris showed these deliberately soft, formless works, minimal artists have gone still further in the direction of antiart. Specimens of rock and earth gathered in a particular place and piled in boxes have been shown in New York galleries as 'sculpture', and so have photographs of diggings

made by the artists: trenches in the desert, piles of sand on the beach, gigantic earth-sculptures, meant to be viewed from the air. The concept of the 'art object' is thus discarded in favour of that of the 'art idea'.

Ills 217, 218

218 RICHARD LONG A line in Ireland 1974

Super realism

It might seem that pop art's successor 'super realism' is in direct contradiction to what has just been said about the replacement of the 'art object' by the 'art idea'. On the face of it, we are here confronted with a reaction towards the most conservative kind of representational painting and sculpture. Even more than pop art, super realism's reputation was made by an alliance between dealers and collectors, in the teeth of hostile critical response. Yet one can also see that art of this kind owes much of its character to its dependence upon conceptual thinking. The painter, at.least, does not approach reality directly, but tries to reproduce what a camera would see.

The transition from pop to what is recognizably super realism, at least where painting is concerned, appears in the work of the English-born but American-domiciled Malcolm Morley. In common with many pop artists, from Lichtenstein to David Hockney, Morley is fascinated, not so much by what the painting shows, as by the method used to show it – in other words, by the convention of representation. The main difference between his work and that of, say, Lichtenstein, is that he allows himself much less freedom to manœuvre.

Morley began by painting pictures which were based on the kind of illustration one would find in a travel brochure – an ocean liner upon an improbably blue sea, for example. But there was no aping of the distortions imposed by cheap processes of colour reproduction. Rather, the artist seemed to want to get the effect of a good-quality four-colour separation. The pictures were painted area by area, and often upside down, so that the artist did not see how close he had managed to come to his model until the task of copying it was completed. An

219 MALCOLM MORLEY St John's Yellow Pages 1971

apparently realistic painting was therefore produced in an intensely abstract way.

Even so, Morley seems to have found that the perfection of finish worked against the alienation effect intended; and in later paintings, such as *St John's Yellow Pages*, he has been careful to introduce devices which make it plain that the painting is in fact a reproduction of a reproduction.

Painters who are more thoroughly identified with the super realist movement, such as Richard Estes and Ralph Goings,

220 RICHARD ESTES Paris street-scene 1973

Ill. 220

have tempered this strictness of approach. The fascination of Estes's work lies in the extreme precision with which it seems to reproduce appearances. The New York street scenes which form the subject-matter of nearly all his paintings and prints are depicted with a meticulous care which recalls the Dutch masters of the seventeenth century. Indeed, the likeness between some of his pictures and paintings such as Vermeer's *View of Delft* and the church interiors of Saenredam seems to suggest that Estes departs from super realist principles in the degree of covert organization which he imposes on his compositions. The more one looks at his work, the more clearly one sees that it depends on carefully plotted geometric structures of a kind that the camera can seldom discover for itself.

Goings differs from Estes in several important respects, despite an apparently identical smoothness of finish. It is clear

221 DUANE HANSON Florida shopper 1973 enough, for instance, that in his work, as also in that of an artist such as Robert Bechtle, the subject-matter does count for something. The aggressive banality seems designed to make a comment on the quality of the life which is lived in these desolate surroundings. But this is secondary to his desire to create a dialogue with the monocular vision of the camera. The neutrality of finish (the result of using an air-brush) is meant to match the neutrality of a good colour-slide.

Super realist sculpture, unlike super realist painting, involves no act of translation from three dimensions into two. The sculpture is therefore even more literal in its representation of reality. Or so it might seem when we first look at these mostly life-size figures. If we look at the work of Duane Hanson, for example, we are struck by its extraordinary quality of lifelikeness. For a moment it seems as if the person represented stands living and breathing before us. Certainly every care is taken to give us this feeling: the figure not only wears real clothes, but is equipped with carefully selected accessories. The face

222 GEORGE SEGAL Girl on red wicker couch 1973

Ill. 223

²²³ RALPH GOINGS Airstream 1970

and other flesh-areas are painted to imitate life. Yet Hanson's work has a quality which is not to be found in the fairground waxworks that try to trick us in the same way. There is an element of subtle intensification – one might almost call it caricature – which makes these figures more memorable than their models.

Hanson's technique, and that of other super realist sculptors such as John de Andrea, has its roots in procedures which were first used (at least in the period under review) by the pop sculptor George Segal. Hanson and de Andrea, like Segal, base their work on the use of life-casts. In their hands these serve as the equivalent of the camera-lens in super realist painting, a way of reproducing reality more exactly than the eye itself can see it. This is a method which is also employed by the young British sculptor John Davies. It is interesting to note what

Ill. 222

255

very different results these artists get. In Segal's case, the rough, white surface of the figures serves to distance them into the realm of what is recognizably 'art'. Hanson and de Andrea, on

Ills 221. 227

the other hand, seem to want to thrust their work into direct competition with the living figures we see moving around us.

Davies, in his Head of William Jeffrey, adopts a compromise Ill. 225 solution. The power of the head reminds us of certain Roman Republican portrait busts, which were also based on life-masks. The 'device' that surrounds it (a blue wire cage with pendant pearls) serves to put it firmly in a different domain from the one we ourselves inhabit

To help us to grasp the character of super realist art, and the different aims of the painters and sculptors, comparison between the head by Davies and the portrait illustrated by Chuck Close is useful. Close is perhaps the 'purest' of all the painters who have been classified as belonging to this school. The artist says categorically: 'My main objective is to translate photographic information into paint information.' He says, too, that he wants to bring about a different mode of seeing:

My large scale forces the viewer to focus on one area at a time. In that way he is made aware of the blurred areas that are seen with peripheral vision. Normally we never take those peripheral areas into account. . . . In my work the blurred areas don't come into focus, but they are too large to be ignored.1

Sculpture, which cannot control our actual method of seeing in this way, is naturally forced to seek other ways of making its effect. Davies, for example, by his use of 'devices' of various kinds, seems to try to externalize the inner psychological strangeness of the characters he depicts. Duane Hanson uses tricks which are derived from the stage. His figures, like certain actors, have expressions and poses which pinpoint the essence of the character. A flow of motion has been stopped at its most expressive point. Even John de Andrea, at first sight the blandest and most non-committal of super realist sculpturs, has ways

224 CHUCK CLOSE Nat 1972

225 JOHN DAVIES Head of William Jeffrey

of eliciting a particular planned reaction to what he puts before us.

We can better understand the character of a de Andrea nude by comparing it with a similar nude by Reg Butler. There are a number of superficial resemblances. Butler, though the figure is made of bronze, paints it flesh-colour, and gives it 'real' hair and 'real' eyes. We are keenly conscious, none the less, that this is a personal vision of female sexuality, expressed by means of deliberate adjustments of what is objectively seen. De Andrea, on the other hand, while apparently content with literal reproduction, has chosen and posed a model to project her personality, and even her social class. This girl has the confidence of someone who has never been hungry. The more one looks at super realist art, the more one is impressed by the element of social comment which emerges from its apparent neutrality.

This is an art which, in one sense, seems to appeal to entirely trivial responses – to the shock of delight at seeing something

exactly imitated, no matter what that thing is – yet at a deeper level speaks to its audience because it expresses, without rhetoric, the nullity and despair to be found in large areas of urban society. Although we see this particularly clearly in the sculpture of Duane Hanson, who so often seems to concentrate exclusively on the ugliness of his fellow Americans, we can detect it, too, in the apparently fresh and innocent co-eds of de Andrea, whose milk-fed mindlessness and complacency is tellingly portrayed, despite the physical beauty the sculptor depicts. In more than one sense, super realism is the representative art of the Western democracies in the later twentieth century.

226 REG BUTLER Girl on a long base 1968-72

227 JOHN DE ANDREA Freckled woman 1974

²²⁸ TOM PHILLIPS Conjectured picture No. 3

Conceptual art, Environments and Happenings

What do people mean when they use the phrase 'conceptual art'? Two main meanings emerge. First, the examination of what we mean by the concept 'art'. Secondly, the concept itself as art – intellectual patterns separate from any concern with embodiment. The answer therefore is less precise than one would like, but the direction indicated is plain: there has been a shift of attention from the physical embodiment to the art 'idea'. Often it has been assumed that the embodiment itself is no longer of great importance: a few statements on a piece of paper will serve just as well as a work produced by traditional methods, and in traditionally accepted materials.

Even those artists who have continued to make sculpture, or paint on canvas, have been affected by the new way of thinking. For the work of art can be seen as essentially the map of a thought process, a visible summary of all the steps which have been necessary for a particular end result to be achieved. Hence the frequent use of labels such as 'process' and 'system'.

Perhaps the most interesting painter to turn traditional methods to a new purpose is Tom Phillips. Phillips's work is difficult to define in terms of style, because he tries to find a style suitable to the solution of each problem as it presents itself. His best-known work is a vast series of prints and drawings in the 'cut up' technique derived from William Burroughs, known collectively as *A Humument*. This work is borrowed from a little-known Victorian novel, *A Human Monument*, by W.H. Mallock. In his notes on the project, he remarks: 'I have so far extracted from it over six hundred texts, and have yet to find a situation, statement or thought which its words cannot comprehend or its phrases be adapted to cover.'1

229 PANAMARENKO Airship

230 CLAUS RINKE Water-circulation 1969-70

But Phillips's preferred tool is conjecture, and especially the conjectural reconstruction of something partly effaced or destroyed. He is fascinated, for example, by the changes wrought by cheap colour reproduction, especially in postcards, and has created many pictures based on postcard imagery. A whole series is derived from a single card showing the interior of an art gallery (the Mappin Art Gallery, Sheffield), from which he painstakingly reconstructs each of the paintings shown on the gallery walls. What interests him, here, is the way in which the commonplace images of Victorian art have become 'either obscure, cryptic or boldly and prophetically abstract'.²

The mainstream of conceptual art, however, tries to get as far away as possible from the established idea of what a work of art should look like. A full-sized silver airship, the work of Panamarenko, filled one large hall at the Kassel Documenta of 1972. Panamarenko is obsessed with flying machines, but chiefly with those of the earliest days of aviation technology. He invents new variations of these, but not, apparently, with any expectation of seeing them take to the air. He is content that they should be presented to the spectator as a source of aesthetic experience. Often, he seems to feel that drawings or blueprints will serve as well as the actual object.

A recirculatory water-system at the same exhibition consisted of a tank, a coil of plastic hose, a pump, and a nozzle which produced a powerful jet. It was the flow of the liquid, rather than the mechanism used to produce it, which was the point of the demonstration. The art object was therefore ungraspable, in the most literal sense, and what it had to offer was simply the experience of coming for a moment into its presence.

It might be suggested that this demonstration was intended as some kind of statement about the energy of natural forces; an interpretation equally applicable to a well-known piece of 'body art' by Dennis Oppenheim, in which two photographs record the effects of sunburn. But the most obvious fact is that art, in both cases, has become a rather simple-minded demonIll. 228

Ill. 229

Ill. 230

stration of physical laws, with no special physical identity of its own.

Curiously enough, one of the routes by which artists have arrived at activity of this kind is through an *exaggeration* of the physical size and presence of the work. Not content that the spectator should survey what they do as a whole, and from his own chosen distance, they have created the all-embracing environment. The environment, in its simplest and most basic

231 DENNIS OPPENHEIM Reading position 1970

²³² RICHARD SERRA Circuit 1972

form, is represented by Richard Serra's four steel plates, set on their edges so as to divide the space in a large room. (The overall view illustrated cannot be seen by anyone standing in the room.) What they did was to modify the space, so that there was no longer any position from which it could be experienced as a totality.

The concept of the environment goes back much further than the 1970s. Perhaps the most celebrated examples in the early history of modern art are the successive *Merzbauten* created by the German dadaist Kurt Schwitters, the first of which was made at his house in Hanover from 1920 onwards.

With the rise of pop art, the environment took on a new and special importance. There were several reasons for this. One

was that pop specialized in the 'given'; this led artists to experiment with the literal reproduction of reality. Edward Kienholz's more ambitious works fall into this category. There was, too, the consuming interest taken by pop artists in the phenomena of popular culture, among them such enfolding experiences as amusement arcades and side-shows in circuses: the 'Tunnel of Love', for example. But most important of all was the growing insistence that all the spectator's senses should be engaged, that the work of art should be regarded not so much as an object to be grasped and held, but as a mechanism for producing a particular sensation, or series of sensations.

The question was no longer 'what is it?', but 'how do I react to it?'. The emphasis had shifted even further from the objective towards the subjective.

The process was accelerated when environments were joined by what were called 'Happenings'. The cult of the Happening grew up suddenly in the American art world of the late 1950s and early 1960s. But it, too, had roots in the past. Schwitters, in addition to *Merzbauten*, had envisaged a Merz theatre. And the dadaists, like the Russian and Italian futurists who immediately preceded them, had channelled a lot of their creative energy into theatrical presentations.

The Happening really involved the extension of an 'art' sensibility – or, more precisely, a 'collage-environment' sensibility – into a situation composed also of sounds, timedurations, gestures, sensations, even smells. Its roots remained in the artist's studio and not in the theatre. The spectator was not supplied with a matrix of plot and character; instead, he was bombarded with sensations which he had to order on his own responsibility. This was the essence of a work such as Allan Kaprow's *The Courtyard*. Here one of the performers was a man who rode a bicycle slowly in circles round the performance space. What you made of this, if you happened to be there, was up to you.

Many pop artists including Jim Dine and Claes Oldenburg were involved with Happenings. Perhaps the best-remembered 266

Ills 234-5

of the New York events of this period was Jim Dine's *The Car Crash*, staged at the Reuben Gallery in November 1960. The successive phases (which lasted for about twenty minutes in all) were an allegorization of the words of the title.

In the United States the fashion for Happenings died down, not only because the events themselves lost their novelty, but because their role was gradually stolen by the experimental or off-Broadway theatre. This took over not only many of the techniques, but the new ethos which Happenings helped to

234, 235 JIM DINE The Car Crash 1960

236 STUART BRISLEY And For Today – Nothing 1972

create. In general, since the early 1960s, narrative has played a smaller and smaller part in the *avant-garde* theatre, and so too has the creation of character. These changes stem from contemporary art.

It may well have been the greater conservatism of cultural attitudes in Europe which ensured that, though Happenings were suddenly less in vogue in America, there was an upsurge of enthusiasm for them across the Atlantic, where they were generally described as 'events'. The countries where there has been perhaps the highest level of activity are Britain, Germany

237 RUDOLF SCHWARZKOGLER Action Vienna, May 1965

and Austria. Outside Europe, spectacular events have been created in Japan.

The events put on by Europeans differed from the American Happenings which preceded them in several ways. They were more abstract, less specific even than their predecessors. Much of their energy went into the exploration of extreme situations. Sometimes, indeed, the artists who took part in them seemed to concentrate on a desperate search for the unacceptable, for something which would restore to them a position as rebels and enemies of society. At the same time, these European events were markedly more intellectual than what had been done in the United States. There was less disposition to regard this form of activity as a kind of art-world romp.

In England, Stuart Brisley's work is typical in combining images of isolation with others that seem designed to provoke revulsion or nausea. At the same time, the artist is at grips with various physical constraints. The performance becomes something which the maker must force himself to endure, and the spectator is naturally aware of this. For one event, Brisley spent many hours almost motionless in a bath full of water and animal entrails.

Even more extreme, violent and terrifying is the work done by various members of the Vienna Group in Austria - among them Hermann Nitsch. Otto Muehl, Günter Brus and Rudolf Schwarzkogler. Many of their events and actions are unbridled expressions of sado-masochistic fantasy. Nitsch has claimed that he takes upon himself 'the apparent negative, unsavoury, perverse, obscene, the passion and the hysteria of the act of sacrifice so that YOU are spared the sullying, shaming descent into the extreme'.³ This, valid or not, is an example of an aspiring towards intellectuality unknown to American makers of Happenings in the early 1960s.

The opposite pole from work of this kind was represented by Nice Style, the pose band, and the 'performances' of the Englishmen Gilbert and George. The latter made a tremendous cult reputation with a piece called Singing Sculptures, which

Ill. 236

Ill. 237

Ill. 238

270

has been many times repeated in different locations. The presentation was simple in the extreme. The two performers, with hands and faces gilded, stood on a plinth and mimed to a recording of the music-hall song 'Underneath the Arches'. The point, in so far as there was one, was the concern with the idea of style and stylishness. Style was plucked from its context, and examined as a separate entity. The notion of banality was also scrutinized. And, finally, the question of the division, or the lack of it, between the creator and what he creates was brought up. Gilbert and George describe themselves as 'living sculptures', and there is more than an implication that everything they do is to be looked upon as art.

238 GILBERT AND GEORGE Singing Sculpture 1970

An artist who seems to make a very similar claim, though in other respects very different from these two Englishmen, is the German Joseph Beuys. Of all the makers of events and actions, Beuys has been perhaps the most avidly discussed. After service in the Second World War as a Stuka pilot, he became a student of natural sciences before turning to art. His activity has covered a wide range, but has gradually homed in upon the personality of the artist himself. From emblematic works, such as the *Fetteke*, or fat-corners, where the amorphous plastic energy of fat was symbolically married to the geometry of angles, he progressed to the creation of events which involved even more extraordinary feats of endurance than those undertaken by Brisley. In one, the artist stood on a box for twentyfour hours at a stretch, performing various complex actions at arms' length, having fasted for several days beforehand.

Ill. 239

Yet Beuys was not satisfied with the remoteness which this kind of activity imposed upon him. In 1967, therefore, he

239 JOSEPH BEUYS *Twenty-four Hours* Action 1965

240 JOSEPH BEUYS Action in 7 Exhibitions 1972

founded a radical but non-aligned political organization, the German Student Party. Gradually, his chief form of artistic activity came to be the exposition of his political views, but often, still, in a museum setting. In 1972, when invited to take part in an exhibition at the Tate Gallery, he spent a day explaining his political views to a large and attentive audience. At Kassel, in the same year, he had a special office, open to all visitors, on the ground floor of one of the exhibition buildings, and engaged in dialogue with any visitor who cared to argue with or question him.

In his recent contacts with the public, Beuys seems to suggest that art, and the intention to make art, are irrelevances, obstructions rather than enhancements to the communication of ideas.

The flight from the object to the idea has sometimes been justified on technological grounds. It has been argued, for instance, that video is the art-medium of the future, and that the translation of art into electronic terms imposes its own

You are the product of t.v.

You are delivered to the advertiser who is the customer.

brand of dematerialization. In fact, experimentation in this field has gone in three different directions. In the first place, there is what we may describe as the video of boredom – a continuation of the experiments made by Andy Warhol in some of his films. A piece by Gilbert and George, *Gordon's Makes Us Drunk*, with the words of the title endlessly repeated on the soundtrack, may be taken as an example. Secondly, there are the tapes which show distortion and transformation of imagery. These tend to look like the next step forward from kinetic art, and, in particular, from the light boxes of Frank Malina. Lastly, there is the kind of video which evades all aesthetic issues, and puts itself forward as an alternative to the

274

²⁴¹ RICHARD SERRA Television Delivers People 1975

242 JACQUES GUYONNET and GENEVIEVE CALAME Le Chant Remémoré 1975

programmes which are available on 'official' television – a platform for radical spokesmen and minority groups. One wonders why video of this third kind, whose real commitment is to polemic and to information, should wish to label itself 'art', and why art galleries are an appropriate place to show it. But then one wonders, too, why Beuys thinks an art gallery is an appropriate, much less an efficient, mechanism for disseminating a new political philosophy.

'Pure' conceptual art – an art of statements only, or an art in which the audience is asked to find its satisfaction by following the creator step by step in his thought processes, without asking that these should take a form more concrete than words

275

or diagrams on paper, also seems to suffer from this kind of inappropriateness, and to an even stronger degree. Indeed the public nature of an art exhibition too often seems hostile to what is being done by the conceptual artist. From the use of deliberately 'inappropriate' materials and techniques, as with Dubuffet, twentieth-century art has progressed to a deliberate mismatching of the means of expression and the framework within which it exists.

In part, at least, this seems an inevitable consequence of the transference of interest from the art object to the artist. More and more, the modern artist wishes to stand forth as his own best and most authentic creation. The wit that flickers in I'm a Real Artist, by the British conceptualist Keith Arnatt, seems exercised at the expense of the profession he has chosen. While it raises the question of a valid definition of reality – as it is meant to do – it more dangerously raises the question of a valid definition a valid definition of a valid definition of a

If all value resides in the personality of the artist, who achieves a moment of self-recognition, and who is then entitled to make any demand he pleases upon the public, are we then unable to protect ourselves against charlatanism? This is a fear which has been expressed thousands of times since the inauguration of the modern movement, but one which has never seemed more valid than now. There are, of course, cultures which recognize that certain individuals have a quality of *mana*, and demand no more of them than that. The Buddhist sages often seem to have been in just this kind of relationship to those who surrounded them. But on the whole, such cultures have little time for 'professionalism' as we understand it in the West.

It is the artist's new view of himself, and the public's view of him, which are now in conflict, and the struggle is made more acute by the fact that art of the extreme *avant-garde* is now noted for its almost total dependence upon public subsidy. It has escaped from the market-place to cast itself upon the mercy of the cultural bureaucracy. Such public appeal as it has is an appeal to curiosity. Radical in politics it may be, but

Ill. 243

276

²⁴³ KEITH ARNATT I'm a Real Artist

it is deeply élitist in its attitudes to the public. Yet granted these defects, one must recognize that the modern artist goes on exploring his own humanity and the possibilities of man's imagination with admirable, even heroic persistence. Some artists are inclined to bring in a completely negative verdict on man's future, but the majority still seem to see art as an expression of faith in what may become of mankind.

Text References

Chapter One

¹ Hans Richter, *Dada – Art and Anti-Art*, London, Thames and Hudson, and New York, McGraw-Hill, 1966, pp. 207–8.

 Clement Greenberg, 'Recentness of Sculpture', in American Sculpture of the Sixties, catalogue of an exhibition held at the Los Angeles County Museum of Art, 28 April–25 June 1967, and at the Philadelphia Museum of Art, 19 September–29 October 1967, p. 27.

3 Pierre Restany, catalogue of *Superlund* exhibition, Lund, Sweden, 1967.

Chapter Two

1 André Breton, *Manifestes du Surréalisme*, Paris, J.-J. Pauvert, 1962, p. 40.

2 Maurice Nadeau, *The History of Surrealism*, New York, Collier Books, 1967, and London, Jonathan Cape, 1968, p. 202.

3 Barbara Rose, *American Art Since 1900*, New York, Frederick A. Praeger, and London, Thames and Hudson, 1967, pp. 127 et seq.

4 Harold Rosenberg, 'Arshile Gorky: the Man, the Time, the Idea', *Horizon*, New York, 1962, p. 106.

5 Arshile Gorky: Paintings, Drawings, Studies, catalogue of an exhibition held at the Museum of Modern Art, New York, in collaboration with the Washington Gallery of Modern Art, 1962, p. 45.

6 Talcott B. Clapp, 'A painter in a glass, house', quoted in *Arshile Gorky: Painting, Studies, Studies, catalogue of an exhibition* held at the Museum of Modern Art, New York, in collaboration with the Washington Gallery of Modern Art, 1963, p. 43.

7 Jackson Pollock, 'My Painting', *Possibilities* 1, New York, George Wittenborn, winter 1947–8.

8 André Breton, op. cit., p. 44.

9 Harold Rosenberg, *The Tradition of the New*, London, Thames and Hudson, 1962, p. 31.

10 Ibid., p. 30.

11 Frank O'Hara, Jackson Pollock, New York, George Braziller, 1959, p. 116.

12 Patrick Heron, 'The Ascendancy of London', *Studio International*, London, December 1966.

Chapter Three

1 From interviews with Francis Bacon by David Sylvester, recorded and filmed in Lon-

don for BBC Television, May 1968, in *Francis Bacon : Recent Paintings*, catalogue of an exhibition at the Marlborough New London Gallery, March–April 1967, p. 26.

2 Peter Selz and Jean Dubuffet, *The Work of Jean Dubuffet*, New York, The Museum of Modern Art, 1962, pp. 81–2.

3 Jean Dubuffet, *Prospectus et tous écrits suivants II*, Paris, Gallimard, 1967, p. 74.

Chapter Four

I Barbara Rose, op. cit., p. 234.

2 Max Kozloff, 'The New American Painting' in Richard Kostelanetz ed., The New American Arts, New York, Collier Books, 1967, p. 102.

3 Clement Greenberg, 'Louis and Noland', Art International, vol. 4, No. 5, Zurich 1960.

4 Michael Fried, introduction to *Morris Louis* 1912–1962, Boston, Museum of Fine Arts, 1967, p. 21.

5 Michael Fried, catalogue of *Three American Artists*, an exhibition at the Fogg Art Museum, Harvard University, 1965, p. 27.

Chapter Five

1 William C. Seitz, *The Art of Assemblage*, New York, The Museum of Modern Art, 1961, p. 87.

2 John Cage, Silence, Middletown, Conn., Wesleyan University Press, 1961, p. 10.

3 Quoted by Pierre Descargues in Yves Klein, catalogue of an exhibition at the Jewish Museum, New York, 1967, p. 18.

4 Mario Amaya, *Pop as Art*, London, Studio Vista, 1965, p. 33.

5 Ibid., p. 33.

6 Harold Rosenberg. *The Anxious Object*, London, Thames and Hudson, 1964, pp. 27–8.

7 Quoted by Gene Baro in 'Claes Oldenburg, or the things of this world', *Art International*, New York, November 1966.

8 From replies to questions put by G.R. Swenson, *Art News*, New York, November 1963.

9 Quoted by Mario Amaya, op. cit., p. 95.

10 Andy Warhol, catalogue of an exhibition at the Institute of Contemporary Art, University of Pennsylvania, 8 October–21 November 1965.

Chapter Six

1 Vasarely in *Vasarely*, Neuchâtel, Editions du Griffon, 1965, pp. 10–12.

2 Ibid., p. 14.

3 Bridget Riley, 'Notes on Some Paintings', Art and Artists, III, No. 3, London, June 1968.

4 Statement by Bruce Lacey in 'Cybernetic Serendipity', a special issue of *Studio International*, London 1968, p. 38.

5 Guy Brett, Kinetic Art, London, Studio Vista, 1968, p. 53.

6 Statement by Johan Severtson in 'Cybernetic Serendipity', a special issue of *Studio International*, London 1968, p. 32.

Chapter Seven

I Quoted by David Sylvester, catalogue of Alberto Giacometti, Sculpture, Paintings, Drawings, an exhibition at the Tate Gallery, London 1965.

2 David Sylvester, catalogue of the retrospective exhibition *Henry Moore* at the Tate Gallery, London 1968, p. 36.

3 In Studio International, London January 1968.

4 Statement by Reg Butler on the gramophone record *Five British Sculptors Talk*, London, Caedmon TC 1181.

Chapter Eight

I Quoted by Frank O'Hara in the catalogue of *David Smith 1906–1965*, an exhibition at the Tate Gallery, London, 1966, p. 7.

2 Ibid., pp. 9-10.

3 'Anthony Caro Interviewed by Andrew Forge', London, *Studio International*, 1968.

4 Bryan Robertson, catalogue of the British Pavilion, Venice Biennale, 1968.

5 Statement in the catalogue of Tony Smith: Two Exhibitions of Sculpture, Wadsworth Atheneum, Hartford, Conn., and The Institute of Contemporary Art, University of Pennsylvania, 1966–7.

6 Ibid., note on Black Box.

7 Donald Judd, 'Specific Objects', Contemporary Sculpture, New York, The Art Digest (Arts Yearbook 8), 1965, p. 79.

8 Robert Morris, 'Notes on Sculpture', Artforum, New York, February 1966, p. 44.

9 Dan Flavin '. . . In Daylight or Cool White', Artforum, New York, December 1965, p. 24.

10 Robert Morris, 'New Talent USA', Art in America, New York, July-August 1966, p. 66.

11 Robert Morris, 'Anti-Form', Artforum, New York, April 1968, p. 33.

Chapter Nine

1 Interview in Artforum, New York, January 1970.

Chapter Ten

I Tom Phillips, Works. Texts. To 1974,

Edition Hansjörg Meyer, Stuttgart, London Reykjavik, 1975, p. 215.

2 Ibid., p. 173.

3 Quoted by Adrian Henri, Environments and Happenings, London, Thames and Hudson, 1974, p. 168.

Further Reading

The best sources of information on the development of contemporary art are the files of the following magazines:

- In the United States: Art News; Art in America; Artforum; Arts Magazine; Show (no longer published).
- In Great Britain: Studio International; Art and Artists; Arts Review; Ark (journal of the Royal College of Art).
- In France: L'Oeil; Connaissance des Arts; Cimaise
- In Germany: Das Kunstwerk; Syn.
- In Holland: Sigma.
- In Italy: Domus; Critica d' Arte; L' Arte Moderna.
- In Sweden: Konstrevy. In Switzerland: Art International; Du.
- In Spain: Goya.
- In Canada: Arts Canada.

Another principal source of information consists in the catalogues issued in connection with important exhibitions, notably those at the Museum of Modern Art, New York, and the successive Documenta exhibitions at Kassel.

Some books of interest (besides those mentioned in the notes) are:

Painting in General

- WERNER HAFTMANN, Painting in the 20th Century, London, Lund Humphries, 1961, new ed. 1965 (a particularly good source of information for painting in the 1950s).
- ALDO PELLEGRINI, New Tendencies in Art, New York, Crown Publishers Inc., 1966, and London, Elek Books, 1967 (unreliable critically, covers a wide range of artists).
- UDO KULTERMANN, The New Painting, London, Pall Mall Press, 1969.

Sculpture in General

- A Dictionary of Modern Sculpture, ed. Robert Maillard, Paris, Hazan, 1960, and London, Methuen, 1962 (a source of information for the sculpture of the 1950s).
- JACK BURNHAM, Beyond Modern Sculpture, London, Allen Lane, the Penguin Press, 1968.
- UDO KULTERMANN, The New Sculpture, London, Thames and Hudson, and New York, Frederick A. Praeger, 1968.

Pop Art

LUCY R. LIPPARD, Pop Art, New York, Frederick

A. Praeger, and London, Thames and Hudson, 1966.

- JOHN RUSSELL and SUZI GABLIK, Pop Art Redefined, London, Thames and Hudson, and New York, Frederick A. Praeger, 1969.
- CHRISTOPHER FINCH, Pop Art Object and Image, London, Studio Vista, and New York, E.P. Dutton, 1968.

Kinetic Art

- FRANK POPPER, Naissance des arts cinétiques, Paris, Gauthier-Villars, 1967.
- STEPHEN BANN, REG GADNEY, FRANK POPPER and PHILIP STEADMAN, Four Essays on Kinetic Art, London, Motion Books, 1966.

Later Developments

- DOUGLAS DAVIS, Art and the Future, London, Thames and Hudson, 1973.
- ADRIAN HENRI, Environments and Happenings, London, Thames and Hudson, 1974. Published in the US as Total Art, New York, Frederick A. Praeger, 1974.
- UDO KULTERMANN, New Realism, Greenwich, Conn., New York Graphic Society, 1972.
- JOHN A. WALKER, Art since Pop, London, Thames and Hudson, 1975.

List of Illustrations

Dimensions are given in inches, height preceding width

AGAM, Yaacov (b. 1928) 143 Appearance 1965–6. Freestanding metapolymorphic painting, oil on corrugated aluminium painted on both sides 19³ × 30. Collection the Marlborough-Gerson Gallery, New York.

ALBERS, Josef (b. 1888) 69 Homage to the Square 'Curious' 1963. Oil on canvas 30 × 30. Collection R. Alistair McAlpine, London.

ALECHINSKY, Pierre (b. 1927) 62 The Green Being Born 1960. Oil on canvas $72\frac{1}{2} \times 80\frac{3}{4}$. Musée Royal d'Art Moderne, Brussels.

ANDRÉ, Carl (b. 1935) 4 144 pieces of aluminium 1967. Aluminium 44×144×144. Dwan Gallery, New York.

ANNESLEY, David (b. 1936) 204 Orinoco 1965. Painted metal $50\frac{3}{4} \times 80 \times 68\frac{1}{2}$. The Tate Gallery, London.

ANUSZKIEWICZ, Richard (b. 1930) 142 Division of intensity 1964. Liquitex on canvas 48×48 . Courtesy of the Martha Jackson Gallery, Inc., New York.

APPEL, Karel (b. 1921) 61 Women and birds 1958. Oil on canvas $63\frac{3}{4} \times 51\frac{1}{4}$. Private Collection.

ARMAN (Fernandez Arman, b. 1928) 93 Clic-Clac Rate 1960–6. Accumulation of photographic apparatus $23\frac{5}{8} \times$ $39\frac{3}{8}$. Galleria Schwarz, Milan.

ARMITAGE, Kenneth (b. 1916) 170 Figure lying on its side (version 5) 1958–9. Bronze 32 long. Collection The British Council, London.

ARNATT, Keith (b. 1930) 243 I'm a Real Artist.

AUERBACH, Frank (b. 1931) 38 Head of Helen Gillespie III 1962–4. Oil on board $29\frac{1}{2} \times 24$. Courtesy Marlborough Fine Art Ltd, London.

AVEDISIAN, Edward (b. 1936) 86 At Seven Brothers 1964. Liquitex on canvas 36×36. Kasmin Gallery, London.

BACON, Francis (b. 1910) 41 Study after Velázquez: Pope Innocent X 1953. Oil on canvas $60\frac{1}{8} \times 46\frac{1}{2}$. Collection Carter Burden, New York.

45 One of three studies for a Crucifixion 1962. Oil on canvas (centre panel) 78 × 57 1962. Courtesy Marlborough Fine Art Ltd, London. BAJ, Enrico

95 Lady Fabricia Trolopp 1964. Collage $39\frac{3}{8} \times 31\frac{7}{8}$. Galleria Schwarz, Milan.

BALTHUS (Balthazar Klossowski de Rola, b. 1908)

44 The Bedroom 1954. Oil on canvas $106\frac{1}{4} \times 129\frac{7}{8}$. Private Collection.

BAZAINE, Jean (b. 1904) 48 Shadows on the hill 1961. Oil on canvas. Galerie Maeght, Paris.

BAZIOTES, William (1912–63) 17 Congo 1954. Oil on canvas $71\frac{1}{4} \times 59\frac{3}{4}$. Los Angeles County Museum of Art. Gift of Mrs Leonard Sperry.

BELL, Larry (b. 1939) 216 Untitled 1971. Coated glass, nine units. Each unit $72 \times 60 \times \frac{1}{4}$. Tate Gallery, London.

BEUYS, Joseph (b. 1921) 239 Twenty-four Hours 1965. Action, Wuppertal. Photo Edward Lucie-Smith.

240 Action in 7 Exhibitions 1972. Tate Gallery, London. Photo Lucie-Smith.

BILL, Max (b. 1908) 68 Concentration to brightness 1964. Oil on canvas $41\frac{1}{2} \times 41\frac{1}{2}$.

BLAKE, Peter (b. 1932) 111 Doktor K. Tortur 1965. Cryla, collage on hardboard 24×10 . Robert Fraser Gallery, London.

BOMBERG, David (1890–1957) 37 Monastery of Ay Chrisostomos, Cyprus 1948. Oil on canvas 36×36. Courtesy Marlborough Fine Art Ltd, London.

BOSHIER, Derek (b. 1937) 112 England's Glory 1961. Oil on canvas $40 \times 50\frac{1}{4}$. Grabowski Gallery, London.

BRAQUE, Georges (1882–1963) 34 Studio IX 1952–6. Oil on canvas $57\frac{1}{4} \times 57\frac{1}{2}$. Galerie Maeght, Paris.

BOYD, Arthur (b. 1920) 120 Shearers playing for a bride 1957. Oil and tempera on board 59×69§. National Gallery of Victoria, Melbourne.

BRATBY, John (b. 1928) 33 Window, self-portrait, Jean and hands 1957. Oil on board 48×144. The Tate Gallery, London.

BRISLEY, Stuart (b. 1933) 236 And For Today – Nothing 1972. Action, Gallery House, London. BUFFET, Bernard (b. 1928) 66 Self-portrait 1954. Oil on canvas $57\frac{5}{8} \times 44\frac{7}{8}$. The Tate Gallery, London.

BURRI, Alberto (b. 1915) 56 Sacco 4 1954. Burlap, cotton, rinavil glue, silk and paint on cotton canvas 45 × 30. Collection Anthony Denney, London.

BURY, Pol (b. 1922) 155 *The Erectile Entities.* Copper. Collection Günther Sachs, Lausanne.

BUTLER, Reg (b. 1913) 173 Girl 1953–4. Bronze $70 \times 16 \times 9\frac{1}{2}$. The Tate Gallery, London.

226 Girl on long base 1968-72. Painted bronze h. 58. Courtesy of the artist.

CALDER, Alexander (b. 1898) 149 Antennae with red and blue dots 1960. Kinetic metal sculpture. $43\frac{3}{4} \times$ $50\frac{1}{2} \times 50\frac{1}{2}$ (range). The Tate Gallery, London.

184 The Red Crab 1962. Stabile, steel plates $120 \times 240 \times 120$. Museum of Fine Arts, Houston, Tex.

CAMARGO, Sergio de (b. 1930) 146 Large split white relief no. 34/741965. Assembled relief $84\frac{3}{4} \times 36\frac{1}{4} \times 10\frac{3}{4}$. The Tate Gallery, London.

CARO, Anthony (b. 1924) 148 Homage to David Smith 1966. Painted steel $54 \times 120 \times 64$. Collection Mary Swift, Washington DC.

209 Sun-feast 1969–70. Painted steel $71\frac{1}{2} \times 164 \times 86$. Private Collection.

CASCELLA, Andrea (b. 1920) 179 The White Bride 1962. White marble, 3 parts $24 \times 14\frac{1}{2}$. Grosvenor Gallery, London.

CAULFIELD, Patrick (b. 1936) 115 Still-life with red and white pot 1966. Oil on board 63×84 . Harry N. Abrams Family Collection, New York.

CÉSAR (César Baldaccini, b. 1921) 194 *Dauphine* 1961. Bronze 63. Galerie Claude Bernard, Paris.

CHADWICK, Lynn (b. 1914) 171 Winged Figures 1955. Bronze 22. The Tate Gallery, London.

CHAMBERLAIN, John (b. 1927) 192 Untitled 1960. Welded metal 20× 16×12. Joseph H. Hirshhorn Collection.

CHILLIDA, Eduardo (b. 1924) 200 Modulation of space 1963. Metal $21\frac{1}{4} \times 27\frac{1}{2} \times 15\frac{3}{4}$. The Tate Gallery, London.

CHRISTO (Christo Jaracheff, b. 1935) 101 Packaged public building 1961. Photomontage $13 \times 35\frac{7}{8}$. Collection the artist.

CLOSE, Chuck (b. 1940) 224 Nat 1972. Watercolour on paper $68\frac{1}{8} \times 65\frac{7}{8}$. Ludwig Collection, Neue Galerie, Aachen.

CONNER, Bruce (b. 1933) 99 Couch 1963. Assemblage $31\frac{1}{2} \times 264 \times 721$. Pasadena Art Museum.

CORNEILLE (Cornelis van Beverloo, b. 1922)

63 Souvenir of Amsterdam 1956. Oil on canvas $47\frac{1}{4} \times 47\frac{1}{4}$. Private Collection, Paris.

CORNELL, Joseph (b. 1903) 94 *Eclipse series c.* 1962. Construction $120 \times 192 \times 60$. Collection of Allan Stone, New York.

CRUZ-DIEZ, Carlos (b. 1923) 141 Physichromie no. 1 1959. Plastic and wood $19\frac{5}{8} \times 19\frac{5}{8}$. Collection the artist.

DALI, Salvador (b. 1904) 8 Christ of St John of the Cross 1951. Oil on canvas $80\frac{3}{4} \times 45\frac{3}{4}$. Glasgow Art Gallery and Museum.

DAVIE, Alan (b. 1920) 60 The Martyrdom of St Catherine 1956. Oil on canvas 72 × 96. Collection Mrs Alan Davie.

DAVIES, John (b. 1946) 225 Head of William Jeffrey. Painted polyester resin, fibreglass and inert fillers $12 \times 8 \times 15\frac{1}{2}$. The Tate Gallery, London. Photo John Webb.

DE ANDREA, John (b. 1941) 227 Freckled woman 1974. Polyester and fibreglass polychromed. Life size. Courtesy of O. K. Harris Gallery, New York.

DENNY, Robyn (b. 1930) 90 *Growing* 1967. Oil on canvas 96 × 78. Collection The Peter Stuyvesant Foundation.

DINE, Jim (b. 1935) 124 Double red self-portrait (The Green Lines) 1964. Oil and collage on canvas 120 × 84. Courtesy Sidney Janis Gallery, New York.

234, 235 The Car Crash 1960 (Happening). Photo Robert McElroy, New York.

DONALDSON, Anthony (b. 1939) 116 Take Away no. 2 1963. Oil on canvas 60×60. Collection R. Alistair McAlpine, London. DORAZIO, Piero (b. 1927) 140 Molto a Punta 1965. Oil on canvas $61\frac{1}{4} \times 92\frac{1}{2}$. The Tate Gallery, London.

DUBUFFET, Jean (b. 1901) 65 Corps de Dame 1950. Watercolour $12\frac{1}{4} \times 9\frac{1}{4}$. Collection Peter Cochrane, London.

DUCHAMP, Marcel (1887–1968) 3 Bottle rack 1914. Readymade 25¼. Now lost.

ERNST, Max (b. 1891) 35 Cry of the seagull 1953. Oil on canvas $37\frac{1}{4} \times 51\frac{1}{4}$. Collection François de Menil, Houston, Tex.

ESTES, Richard (b. 1936) 220 Paris street-scene 1972. Oil on canvas $41\frac{3}{8} \times 59\frac{7}{8}$. Collection Sydney and Frances Lewis.

ESTEVE, Maurice (b. 1904) 47 Composition 166 1957. Oil on wood $19\frac{7}{8} \times 25\frac{1}{8}$. The Tate Gallery, London.

FAUTRIER, Jean (1897–1964) 49 Hostage 1945. Oil on canvas $10\frac{3}{4} \times 8\frac{1}{2}$. Private Collection, London.

FERBER, Herbert (b. 1906) 182 Homage to Piranesi 1962–3. Copper 92×49 . Collection the artist.

FLAVIN, Dan (b. 1933) 215 Untitled (to the 'innovator' wheeling beachblow) 1968. Fluorescent light (pink, gold and 'daylight') 96×96. Dwan Gallery, New York.

FONTANA, Lucio (1899–1968) 105 Spatial Conceot 1960. Oil on canvas $38\frac{1}{4} \times 23\frac{1}{2}$. McRoberts and Tunnard Gallery, London.

FRANCIS, Sam (b. 1923) 25 Blue on a point 1958. Oil on canvas 72×96. Private Collection.

FRANKENTHALER, Helen (b. 1928) 77 *Mountains and sea* 1952. Oil on canvas $86\frac{3}{8} \times 117\frac{1}{4}$. Collection the artist.

FRÜHTRUNK, Günter (b. 1923) 138 One of Six Screenprints 1967. $24\frac{3}{8} \times 24\frac{3}{8}$. Galerie Der Spiegel, Cologne.

GIACOMETTI, Alberto (1901–66) 40 Portrait of Jean Genet 1959. Oil on canvas $25\frac{1}{2} \times 21\frac{1}{2}$. Private Collection.

161 Woman with her throat cut 1932. Bronze $34\frac{5}{8}$ long. Collection Mr and Mrs Pierre Matisse, New York.

162 Man walking III 1960. Bronze. Galerie Maeght, Paris.

GILBERT AND GEORGE (both b. 1942)

238 Singing Sculpture November 1970. Photo courtesy of Nigel Greenwood Inc. GOINGS, Ralph (b. 1928) 223 Airstream 1970. Oil on canvas $59\frac{7}{8} \times 84\frac{1}{4}$. Ludwig Collection, Neue Galerie, Aachen.

GONZÁLEZ, Julio (1876–1942) 188 The Angel 1933. Iron 63. Musée National d'Art Moderne, Paris.

GORKY, Arshile (1904–48) 11 The Betrothal II 1947. Oil on canvas $50\frac{3}{4} \times 38$. Collection Whitney Museum of American Art, New York.

GOTTLIEB, Adolph (1903–74) 19 The Frozen Sounds Number 1 1951. Oil on canvas 36 × 48. Collection Whitney Museum of American Art, New York. Gift of Mr and Mrs Samuel Kootz.

GRECO, Emilio (b. 1913) 174 Seated figure 1951. Bronze 52¹/₈. The Tate Gallery, London.

GUSTON, Philip (b. 1913) 24 The Clock 1956–7. Oil on canvas $76 \times 64\frac{1}{8}$. Collection The Museum of Modern Art, New York. Gift of Mrs Bliss Parkinson.

GUTTUSO, Renato (b. 1912) 42 The Discussion 1959–60. Tempera, oil and collage on canvas $86\frac{5}{8} \times 97\frac{5}{8}$. The Tate Gallery, London.

GUYONNET, Jacques, and Geneviève Calame

242 *Le Chant Remémoré* 1975. Videotape, 15 minutes duration. *Photo Daniel Vittet.*

HALL, David (b. 1937) 208 Nine 1967. Lamin board and polyurethane paint, sprayed pale blue/ grey 228 × 204 × 3. Collection the artist.

HAMILTON, Richard (b. 1922) 109 Just What is it that Makes To-day's Homes so Different, so Appealing? 1956. Collage to $24 \times 9\frac{3}{2}$. Collection E. Janss, Los Angeles.

HANSON, Duane (b. 1928) 221 Florida shapper 1973. Mixed media. Life size. Collection Mr and Mrs Charles Saatchi, London. Photo Courtesy of DM Gallery, London.

HARTUNG, Hans (b. 1904) 51 Painting T 54–16 1954. Oil on canvas 51 $\frac{1}{8}$ × 38 $\frac{1}{8}$. Musée National d'Art Moderne, Paris.

HAUSER, Erich (b. 1930) 199 Space column 7/68 1968. Steel $129^{\frac{1}{2}} \times 338^{\frac{3}{4}} \times 98^{\frac{1}{2}}$. Galerie Müller, Stuttgart.

HELD, Al (b. 1928)

72 Echo 1966. Acrylic on canvas 84× 72. André Emmerich Gallery, New York. HEPWORTH, Barbara (1903–75) 167 *Two figures* 1947–8. Elm, painted white 48. Collection of the University Gallery, University of Minnesota.

168 Hollow form (Penwith) 1955. Lagos wood 36. Collection The Museum of Modern Art, New York.

HERON, Patrick (b. 1920) 26 Manganese in Deep Violet: January 1967. Oil on canvas 40 × 60. Collection J. Walter Thompson Company, London.

HIRSCHFELD-MACK, Ludwig (1893-1965) 7 Crossplay c. 1923. Variations of reflected coloured lights.

HOCKNEY, David (b. 1937) 113 Picture emphasizing stillness 1962– 3. Oil on canvas 72×60. Collection Mark Glazebrook, London.

114 A neat lawn 1967. Acrylic on canvas 96×96 . Kasmin Gallery, London.

HOFFMEISTER, Adolph 2 Jean-Paul Sartre 1962. In drawing $16\frac{1}{2} \times 11\frac{1}{2}$. Courtesy of Jennifer Adams.

HOFMANN, Hans (1880–1966) 16 Rising Moon 1964. Oil on canvas 84×78. André Emmerich Gallery, New York.

HOYLAND, John (b. 1934) 87 28.5.66 1966. Acrylic on canvas 78 \times 144. The Tate Gallery, London.

HUNDERTWASSER (Fritz Stowasser, b. 1928)

64 The Hokkaido Steamer 1961. Watercolour on rice-paper, with a chalk ground $18\frac{7}{8} \times 26$. Collection S. and G. Poppe, Hamburg.

JARAY, Tess (b. 1939) 88 Garden of Allah 1966. Oil on canvas 72 × 96. Collection the artist.

JOHNS, Jasper (b. 1930) 92 Numbers in Colour 1959. Encaustic and collage on canvas $66\frac{1}{2} \times 49\frac{1}{2}$. Albright-Knox Art Gallery, Buffalo, N.Y. Gift of Seymour H. Knox.

JONES, Allen (b. 1937) 122 Hermaphrodite 1963. Oil on canvas 72×24 . Walker Art Gallery, Liverpool.

JORN, Asger (1914–73) 59 You never know 1966. Oil on canvas $25\frac{1}{2} \times 32$. Arthur Tooth & Sons, Ltd, London.

JUDD, Donald (b. 1928) 212 Untitled 1965. Galvanized iron and aluminium 33 × 141 × 30. Leo Castelli Gallery, New York. KAPROW, Allan (b. 1927) 233 The Courtyard 1962 (Happening). Photo Harry N. Abrams, New York.

KELLY, Ellsworth (b. 1923) 71 White – Dark Blue 1962. Oil on canvas $58\frac{1}{4} \times 33$. Arthur Tooth & Sons, Ltd, London.

KIENHOLZ, Edward (b. 1927) 98 Roxy's 1961. Mixed media $94\frac{1}{2} \times 212\frac{5}{8} \times 263\frac{3}{4}$. Collection the artist. Photo Dwan Gallery, New York.

KING, Phillip (b. 1934) 203 Genghis Khan 1963. Purple plastic 84×144 . Collection The Peter Stuyvesant Foundation.

210 Span 1967. Metal 96×186×210. National Gallery of Victoria, Melbourne. Photo Hugh Gordon.

KITAJ, R. B. (b. 1932) 121 Synchromy with F.B. – General of Hot Desire (diptych) 1968–9. Oil on canvas 60×36 each panel. Courtesy Marlborough Fine Art Ltd, London.

KLEIN, Yves (1928–62) 102 Painting ceremony (the creation of Imprints). Photo Shunk-Kender, Paris.

103 Feu F 45 1961. Oil on paper $31\frac{1}{4} \times 40\frac{1}{2}$. Private Collection, Paris.

KLINE, Franz (1910–62) 21 Chief 1950. Oil on canvas $58\frac{3}{8} \times 73\frac{1}{2}$. Collection The Museum of Modern Art, New York. Gift of Mr and Mrs David M. Solinger.

KOONING, Willem de (b. 1904) 23 Woman and bicycle 1952–3. Oil on canvas 76 $\frac{1}{2}$ ×49. Collection Whitney Museum of American Art, New York.

KOSSOF, Leon (b. 1926) 39 Profile of Rachel 1965. Oil on board 34×24 . Courtesy Marlborough Fine Art Ltd, London.

LACEY, Bruce (b. 1927) 152 Baby versus man 1962. Assemblage $72 \times 24 \times 24$. Collection the artist. Photo Patrick Thurston.

LASSAW, Ibram (b. 1913) 183 *Space densities* 1967. Steel, brass, phosphor bronze 53 × 25 × 17. Wichita Art Museum, Wichita, Kans.

LÉGER, Fernand (1881–1955) 29 The Constructors 1950. Oil on canvas 119×85. Musée Fernand Léger, Biot.

LENK, Kaspar Thomas (b. 1933) 213 Schichtung 22a 1966. Coloured wood $43\frac{1}{4} \times 43\frac{1}{4} \times 15\frac{3}{4}$. Galerie Müller, Stuttgart. LE PARC, Julio (b. 1928) 160 Continuel-mobile, Continuellumière 1963. Assembled relief 63×63 \times 9. The Tate Gallery, London.

LEWITT, Sol (b. 1923) 5 A7 1967. Painted metal sculpture $13\frac{3}{4} \times 13\frac{1}{2} \times 13\frac{1}{2}$. Dwan Gallery, New York.

LICHTENSTEIN, Roy (b. 1923) 125 Whaam! 1963. Acrylic on canvas 68×160 . The Tate Gallery, London.

126 Yellow and red brushstrokes 1966. Oil on canvas $80\frac{3}{4} \times 68\frac{1}{2}$. Collection Philippe Durand-Ruel.

Hopeless 1963. Oil on canvas 44×
44. Collection Mr and Mrs Michael Sonnabend, Paris–New York.

LIJN, Liliane (b. 1939) 157 Liquid reflections 1966–7. Perspex disc filled with water and oil, light source separate 22" wide 8" high including balls. Axiom Gallery, London.

LIPPOLD, Richard (b. 1915) 187 Flight 1962. Gold, stainless steel 360×960×480. Vanderbilt Avenue Lobby of the Pan American Building, New York.

LOHSE, Richard (b. 1902) 70 Fifteen systematic colour scales merging vertically 1950–67. Oil on canvas $47\frac{1}{4} \times 47\frac{1}{4}$. Kunsthaus, Zurich.

LONG, Richard (b. 1945) 218 *A line in Ireland* 1974. Courtesy of the artist.

LOUIS, Morris (1912–62) 78 Untilled 1959. Magna acrylic on canvas 104×76. Photo Kasmin Gallery, London.

80 *Omicron* 1961. Synthetic polymer paint on canvas $103\frac{1}{4} \times 162\frac{1}{4}$. Waddington Gallery, London.

McCRACKEN, John (b. 1934) 214 There's No Reason Not To 1967. Wood, fibreglass $120 \times 18 \times 3\frac{1}{2}$. Nicholas Wilder Gallery, Los Angeles.

MACK, Heinz (b. 1931) 156 Light dynamo 1963. Kinetic sculpture $22\frac{1}{2} \times 22\frac{1}{2} \times 12\frac{1}{4}$. The Tate Gallery, London.

MAGRITTE, René (1898–1967) 13 Exhibition of painting 1965. Oil on canvas $31\frac{1}{2} \times 25\frac{5}{8}$. Collection Alexander Iolas, New York, Paris, Milan, Madrid, Rome, Geneva.

MANZONI, Piero (1933–63) 104 Line 20 metres long 1959. Ink on paper. Collection Edward Lucie-Smith, London. MANZU, Giacomo (b. 1908) 175 Fruit and vegetables on a chair 1960. Gilded bronze $39\frac{3}{8}$.

176 The Death of Abel 1964. Bronze $36\frac{1}{4} \times 24\frac{3}{4}$. St Peter's, Rome.

177 The Death of Pope John 1964. Bronze $36\frac{1}{4} \times 24\frac{3}{8}$. St Peter's, Rome.

MARINI, Marino (b. 1901) 172 Horse and rider 1947. Bronze 64. The Tate Gallery, London.

MARTIN, Kenneth (b. 1905) 202 Rotary rings 1967. Brass 21¹/₄ high 7 at broadest. Axiom Gallery, London.

MASSON, André (b. 1896) 9 Landscape with precipices 1948. Oil 0n canvas 81×100 . Galerie Louise Leiris, Paris.

MATHIEU, Georges (b. 1922) 58 Battle of Bouvines 1954. Oil on canvas $98\frac{1}{2} \times 236\frac{1}{4}$. Collection the artist.

MATISSE, Henri (1869–1954) 30 Zulma 1950. Gouache cut-out 238 × 133 cm. Statens Museum for Kunst, Copenhagen.

31 The Snail 1953. Gouache cut-out 286 × 387. The Tate Gallery, London.

MATTA, Roberto (b. 1911) 10 Being With 1945–6. Oil on canvas $179\frac{1}{8} \times 87\frac{3}{8}$. Pierre Matisse Gallery, New York.

MEADOWS, Bernard (b. 1915) 169 Standing armed figure 1962. Bronze 64. Gimpel Fils Gallery, London.

MICHAUX, Henri (b. 1899) 55 Painting in india ink 1960–7 $29\frac{1}{2} \times 41\frac{3}{8}$. Galerie Le Point Cardinal, Paris.

MIDDLEDITCH, Edward (b. 1923) 43 Dead chicken in a stream 1955. Oil on board $53\frac{3}{4} \times 43$. The Tate Gallery, London.

MIKI, Tomio (b. 1938) 108 *Ears (detail)* 1968. Plated aluminium $6\frac{3}{4} \times 6\frac{1}{4} \times 2\frac{3}{4}$. Minami Gallery, Tokyo.

MIRÓ, Joan (b. 1893) 36 Blue II 1961. Oil on canvas 106× 140. Pierre Matisse Gallery, New York.

MOON, Jeremy (1934–73) 91 Blue Rose 1967. Oil on canvas 86×99 . The Tate Gallery, London.

MOORE, Henry (b. 1898) 164 Northampton Madonna 1943-4. Hornton stone 59. Church of St Matthew, Northampton. 165 Internal and external forms 1953–4. Elmwood 103. Albright-Knox Art Gallery, Buffalo, N.Y.

166 (Lambert) Locking-piece 1963-4. Bronze 115. Collection Banque Lambert, Brussels.

MORELLET, François (b. 1926) 159 Sphère-trames 1962. Aluminium 85½ diameter. Indica Gallery, London.

MORLEY, Malcolm (b. 1931) 219 St John's Yellow Pages 1971. Oil on canvas 159×137. Ludwig Collection, Wallraf-Richartz Museum, Cologne.

MORRIS, Robert (b. 1931) 211 Untitled (circular light piece) 1966. Plexiglass 24 × 96 diameter. Dwan Gallery, New York.

MOTHERWELL, Robert (b. 1915) 18 Elegy to the Spanish Republic no. LV 1955–60. Oil on canvas $70 \times 76\frac{1}{8}$. Contemporary Collection of the Cleveland Museum of Art.

NAKIAN, Reuben (b. 1897) 181 The Goddess of the Golden Thighs 1964–5. Bronze 152. Courtesy of the Detroit Institute of Arts.

186 Olympia 1960–2. Bronze 72×72 . Whitney Museum of American Art, New York. Gift of the Friends of the Whitney Museum.

NEVELSON, Louise (b. 1900) 191 Royal Tide V 1960. Wood, painted gold (21 compartments) $80\frac{3}{4} \times$ 102. Private Collection.

NEWMAN, Barnett (1905–70) 74 *Tundra* 1950. Oil on canvas 72× 89. Collection Mr and Mrs Robert A. Rowan.

NOLAN, Sidney (b. 1917) 119 *Glenrowan* 1956–7. Ripolin on hardboard 36×48. The Tate Gallery, London.

NOLAND, Kenneth (b. 1924) 79 Cantabile 1962. Plastic paint on canvas $66\frac{1}{2} \times 64\frac{1}{4}$. Collection Walker Art Center, Minneapolis.

81 Grave Light 1965. Plastic paint on canvas 102×90. Collection Mr and Mrs Robert A. Rowan.

OLDENBURG, Claes (b. 1929) 123 Study for Giant Chocolate 1966. Enamel and plaster $10\frac{1}{2} \times 4\frac{1}{4} \times 4\frac{1}{4}$. Robert Fraser Gallery, London.

OLITSKI, Jules (b. 1922) 85 Feast 1965. Magna acrylic on canvas 93 × 26. Collection Catherine Zimmerman. Brookline, Mass. OPPENHEIM, Dennis (b. 1938) 231 Reading position 1970. Photo courtesy of the artist.

PAIK, Nam June (b. 1932) 151 Robot c. 1964. Assemblage $68 \times$ 30. Collection the artist.

PANAMARENKO (b. 1940) 229 *Airship.* Mixed media. Kassel Documenta, 1972.

PAOLOZZI, Eduardo (b. 1924) 189 *Japanese War God* 1958. Bronze 60. Albright Knox Art Gallery, Buffalo, N.Y.

201 Etsso 1967. Aluminium $55 \times 48 \times$ 31. Hanover Gallery, London.

PEARLSTEIN, Philip (b. 1924) 134 Two seated female nudes 1968. Oil on canvas 60×48 . Courtesy of Allan Frumkin Gallery, New York. Collection Mr and Mrs Gilbert F. Carpenter.

PHILLIPS, Peter (b. 1939) 110 For men only starring MM and BB 1961. Oil on canvas 108×60 . The Calouste Gulbenkian Foundation, London.

PHILLIPS, Tom (b. 1937) 228 Conjectured picture No. 3 (Mappin Art Gallery). Acrylic on canvas 85×63. Courtesy of the artist.

PICASSO, Pablo (1881–1973) 28 Massacre in Korea 1951. Oil $43\frac{1}{4} \times 66\frac{3}{4}$. Collection the artist.

178 Head of a woman 1951. Bronze $21\frac{1}{2}$. The Solomon R. Guggenheim Museum. The Joseph H. Hirshhorn Collection.

6 The Women of Algiers 1955. Oil on canvas $44\frac{7}{8} \times 57\frac{1}{2}$. Collection Mr and Mrs Victor W. Ganz.

PIGNON, Edouard (b. 1905) 46 The Miner 1949. Oil on canvas $36\frac{1}{4} \times 28\frac{3}{4}$. The Tate Gallery, London.

PISTOLETTO, Michelangelo (b. 1933)

106 Seated figure 1962. Collage on polished steel $49\frac{1}{4} \times 49\frac{1}{4}$. Kaiser-Wilhelm-Museum, Krefeld.

POLLOCK, Jackson (1912-56) 14 Uumber 2 1949. Oil, Duco and aluminium paint on canvas 38½×189½. Munson-Williams-Proctor Institute, Utica, N.Y.

15 Jackson Pollock at work. Photo Hans Namuth, New York.

POMODORO, Arnaldo (b. 1926) 180 Sphere no. 1 1963. Bronze 474 diameter. Collection The Museum of Modern Art, New York. POONS, Larry (b. 1937)

84 Night Journey 1968. Acrylic on canvas 108×124. Collection Carter Burden, New York.

RAUSCHENBERG, Robert (b. 1925) 96 Bed 1955. Combine painting 74× 3. Collection Mr and Mrs Leo Castelli.

97 Barge 1962. Oil on canvas 80 × 389. Leo Castelli Gallery, New York.

RAYSSE, Martial (b. 1936) 107 Tableau simple et doux 1965. Assemblage with neon light $76\frac{3}{4} \times 51\frac{1}{4}$. Collection André Mourgues, Paris.

REINHARDT, Ad (1913–67) 75 *Red painting* 1952. Oil on canvas 144×76. The Metropolitan Museum of Art, New York. Arthur H. Hearn Fund, 1968.

RICHIER, Germaine (1904–59) 163 The Hurricane 1948 \pm 9. Bronze $60\frac{1}{2} \times 76\frac{3}{8}$. Musée National d'Art Moderne, Paris.

RICKEY, George (b. 1907) 148 Six squares, one rectangle 1967. Stainless steel 32×16×13. Staempfli Gallery, New York.

RILEY, Bridget (b. 1931) 137 Crest 1964. Emulsion on board $65\frac{1}{2} \times 65\frac{1}{2}$. Rowan Gallery, London.

RINKE, Klaus (b. 1939) 230 Water-circulation 1969–70. Pump, plastic hose and polyester tank. Photo Edward Lucie-Smith.

RIOPELLE, Jean-Paul (b. 1924) 52 Encounter 1956. Oil on canvas $39\frac{1}{4} \times 32$. Wallraf-Richartz Museum, Cologne.

RIVERS, Larry (b. 1923) 130 Parts of the face 1961. Oil on canvas $29\frac{1}{2} \times 29\frac{1}{2}$. The Tate Gallery, London.

ROSENQUIST, James (b. 1933) 131 Silver skies 1962. Oil on canvas $78 \times 16\frac{1}{2}$. Collection Mr and Mrs Robert C. Scull.

ROSZAK, Theodore (b. 1907) 185 *Invocation I* 1947. Steel 29³/₄. The Solomon R. Guggenheim Museum, New York. The Joseph H. Hirshhorn Collection.

ROTHKO, Mark (1903–70) 20 Orange Yellow Orange 1969. Oil on paper mounted on linen 48½×40½. Collection of the Marlborough-Gerson Gallery, New York.

SCHÖFFER, Nicolas (b. 1912) 158 Chronos 8 1968. 118 $\frac{1}{8}$. Collection the artist. SCHWARZKOGLER, Rudolf (1941-

237 Action May 1965, Vienna.

60)

SCOTT, Tim (b. 1937) 205 Trireme 1968. Steel tube, acrylic sheet, painted 180×156×66. Waddington Gallery, London. Photo John Goldblatt.

SEDGLEY, Peter (b. 1930) 139 Action 1966. PVA on canvas 48× 48. Redfern Gallery, London.

SEGAL, George (b. 1924) 222 Girl on a red wicker couch 1973. Mixed media. Photo Sidney Janis Gallery, New York.

SERRA, Richard (b. 1939) 232 *Circuit* 1972. Steel plates, each plate 665 × 243 × 22. Kassel Documenta, 1972.

241 Television Delivers People. Videotape, 6 minutes duration. Photo Castelli-Sonnabend Tapes and Films, New York.

SMITH, David (1906–65) 195 Hudson River landscape 1951. Steel 900 long. Collection Whitney Museum of American Art, New York.

196 Voltri VII 1962. Steel 120 wide. Collection of the Marlborough-Gerson Gallery, New York.

197 *Cubi XVIII* 1964. Stainless steel 1153. Courtesy. Marlborough-Gerson Gallery, New York.

SMITH, Richard (b. 1931) 117 Soft Pack 1963. Oil on canvas 84×69 . Joseph H. Hirshhorn Collection, New York.

118 Tailspan 1965. Acrylic on wood $47\frac{1}{4} \times 83\frac{3}{4} \times 35\frac{1}{2}$. The Tate Gallery, London.

SMITH, Tony (b. 1912) 207 Playground 1962. Wood mockup to be made in steel 64×64 . Fischbach Gallery, New York.

SMITHSON, Robert (1938–73) 217 Broken circle 1971. Emmen, Holland. 140 feet wide.

SOTO, Jesús Rafael (b. 1923) 144 Petite Double Face 1967. Wood and metal 23§ × 15. Collection Mr and Mrs Serge Sacknoff, Washington. Photo courtesy Marlborough-Gerson Gallery, New York.

SOULAGES, Pierre (b. 1919) 57 Painting 1956. Oil on canvas $59\frac{1}{4} \times 76\frac{3}{4}$. Collection The Museum of Modern Art, New York. Gift of Mr and Mrs Samuel M. Kootz. STAËL, Nicolas de (1914–55) 67 Agrigente 1954. Oil on canvas $25\frac{5}{8} \times 31\frac{7}{8}$. Private Collection, Paris.

STANKIEWICZ, Richard (b. 1922) 193 Kabuki Dancer 1956. Steel and cast iron 80¹/₂. Collection Whitney Museum of American Art, New York. Gift of the Friends of the Whitney Museum.

STELLA, Frank (b. 1936) 82 New Madrid 1961. Liquitex on canvas 76 × 76. Kasmin Gallery, London.

83 Untitled 1968. Acrylic on cotton duck 96×192 . Collection Lord Dufferin. Photo Kasmin Gallery, London.

STILL, Clyfford (b. 1904) 27 1957-D no. 1 1957. Oil on canvas 113 × 159. Albright-Knox Art Gallery, Buffalo, N.Y. Gift of Seymour H. Knox.

SUTHERLAND, Graham (b. 1903) 32 Somerset Maugham 1949. Oil on canvas 54×25. The Tate Gallery, London.

SUVERO, Mark di (b. 1933) 190 New York Dawn (for Lorca) 1965. Wood, steel, iron 936 × 888 × 600. Collection Whitney Museum of American Art, New York. Gift of the Howard and Jean Lipman Foundation Inc.

TAKIS (Takis Vassilakis, b. 1925) 153 *Signal* 1966. Collection John de Menil, Houston, Tex.

154 Electro magnetic 1960–7. Kinetic sculpture with electromagnet. Formerly Galerie Iris Clert, Paris. Photo John Palmer.

TANGUY, Yves (1900–55) 12 The Rapidity of Sleep 1945. Oil on canvas 50×40 . Courtesy of The Art Institute of Chicago. The Joseph Winterbotham Collection.

TAPIÉS, Antonio (b. 1928) 53 Black with two lozenges 1963. Oil on canvas 162×130. Private Collection, Buenos Aires.

THEK, Paul (b. 1933) 100 Death of a hippie 1967. Pink painted hardboard, wax body 102×126 × 126. Stable Gallery, New York.

TINGUELY, Jean (b. 1925) 150 Metamachine 4 1958–9. Painted metal construction 72. Private Collection. Photo Courtesy of the Staempfli Gallery, New York.

TOBEY, Mark (b. 1890) 22 Edge of August 1953. Casein on composition board 48 × 28. Collection The Museum of Modern Art, New York.

TOMASELLO, Luigi (b. 1915) 145 Atmosphère ébromo-plastique no. 180 1967. Wood cubes 70 mm, white paint and fluorescent green and orange 783 × 783 . Collection the artist.

TUCKER, William (b. 1935) 206 Memphis 1965–6. Plaster $30 \times 56 \times 65$. The Tate Gallery, London.

TWORKOV, Jack (b. 1900) 76 North American 1966. Oil on canvas 80×64 . Collection the artist.

UECKER, Günther (b. 1930) 147 Light-disc 1960. Hardboard, sacking, nails, sprayed white, turned by motor, spotlit 39§ diameter. Kaiser-Wilhelm Museum, Krefeld. VASARELY, Victor (b. 1908) 135 Amy 1967–8. Oil on canvas $98\frac{3}{8} \times 98\frac{3}{8}$. Galerie Denise René, Paris.

136 Metagalaxy 1959. Oil on canvas $62\frac{5}{8} \times 57\frac{7}{8}$. Galerie Denise René, Paris.

WALKER, John (b. 1939) 89 Touch-Yellow 1967. Acrylic and chalk on canvas 105×204 . Collection the artist.

WARHOL, Andy (b. 1930) 1 Brillo boxes 1964. Silkscreen on wood $13 \times 16 \times 11\frac{1}{2}$. Leo Castelli Gallery, New York.

132 *Race riot* 1964. Acrylic and silkscreen enamel on canvas 30×33. Leo Castelli Gallery.

133 Green Coca-Cola bottles 1962. Oil on canvas $82\frac{1}{4} \times 57$. Collection Whitney

Museum of American Art, New York. Gift of the Friends of the Whitney Museum.

WESSELMANN, Tom (b. 1931) 128 Still-life no. 34 1963. Oil on canvas 48 tondo. Collection Mr and Mrs Jack Glenn, Kansas City.

129 Great American Nude no. 44 1963. Assemblage painting $81 \times 96 \times 10$. Collection Mr and Mrs Robert C. Scull.

WOLS (Wolfgang Schulze, 1913–51) 50 The Blue Pomegranate 1946. Oil on canvas $18\frac{1}{8} \times 13$. Collection Michel Couturier, Paris.

YOUNGERMAN, Jack (b. 1926) 73 Totem black 1967. Oil on canvas 123×81. Betty Parsons Gallery, New York.

Index

Illustration numbers are given in italics

Abstract expressionism 11, 18, 25-51, 83, 103, 110, 148, 211, 212 Abstraction-Création group 94 Agam, Yaacov 171; 143 Albers, Josef 28, 94, 99, 101, 102, 122; 69 Alechinsky, Pierre 83; 62 Alloway, Lawrence 133 Amava, Mario 134 Amis, Kingsley 63 Amsterdam 83; 62 André, Carl 240; 4 Annesley, David 235; 204 Anuszkiewicz, Richard 170; 142 Appel, Karel 83, 86; 61 Arakawa 17 Arman 128; 93 Armitage, Kenneth 205; 170 Armory Show (1913) 27 Arnatt, Keith 276; 277 Arp, Jean 202 Art informel 74-93, 119 Art Nouveau 86 Assemblage 11, 12, 51, 119, 121 ff., 220 Auerbach, Frank 62; 38 Avedisian, Edward 116; 86 Bacon, Francis 64-8, 92; 41, 45 Baj, Enrico 122; 95 Balthus 64, 67-8, 92; 44 Banham, Peter Reyner 133 Barnes, Dr Albert 18 Barzun, Jacques 102 Bauhaus 11, 22, 74, 94, 95, 164 Bazaine, Jean 71, 74; 48 Baziotes, William 38; 17 Beatles 22, 130 Bechtle, Robert 254

Belgium 18, 83, 86, 184 Bell. Clive 10 Bell, Larry 246; 214 Benton, Thomas 33 Bernini, Gianlorenzo 209 Beuys, Joseph 272-3, 275; 239, 240 Bill, Max 95; 68 Blake, Peter 135, 136; 111 Bologna, Giovanni da 216 Bomberg, David 62; 37 Bortnyik, Alexander 164 Boshier, Derek 138; 112 Boyd, Arthur 146; 120 Boyd, David 146 Brancusi, Constantin 27, 202, 228, 236 Braque, Georges 36, 55, 56; 34 Bratby, John 63; 33 Brauner, Victor 219 Breton, André 25, 26, 31, 34 Brisley, Stuart 270; 236 Britain 19, 21-2, 51, 59, 62-7, 86, 115, 116, 118, 132-45, 196-206, 228-38 Browne, Earl 51 Brus, Günter 270 Buckle, Richard 134

286

Buffet, Bernard 91; 66 Burri, Alberto 79, 80; 56 Burroughs, William 261 Bury, Pol 184; 155 Butler, Reg 205, 257; 173, 226

Cage, John 123-4, 171, 190, 240 Calder, Alexander 169, 177-8, 217, 231; 149, 184 Camargo, Sergio de 176; 146 Camus, Albert 130 Caravaggio 63 Caro, Anthony 178, 206, 228-34; 198, 209 Carracci 62 Cascella, Andrea 210-11; 179 Caulfield, Patrick 143, 145; 115 César 222; 194 Cézanne, Paul 28, 35 Chadwick, Lynn 205; 171 Chamberlain, John 222; 192 Chillida, Eduardo 231, 232-3, 234; 200 Christo 128; 101 Close, Chuck 256; 244 Clouzot, Georges 55 Cobra Group 83, 86 Collage 51, 119ff. 'Combine painting' 122 ff. 'Computer art' 191-2 Conceptual art 261 ff. Conner, Bruce 126; 99 Corneille 83; 63 Cornell, Joseph 122; 94 Courbet, Gustave 67 Cruz-Diez, Carlos 171; 141 Cuba 18 Cubism 55, 224 Cunningham, Merce 125

Dada 11, 25, 27, 38, 83, 119, 130-1, 180, 256 Dali, Salvador 26, 30, 35, 83; 8 Davies, John 455-6; 225 Davies, John 455; 227 Davie, Alan 86; 60 De Andrea, John 255; 227 Delaunay, Robert 110, 141 Denny, Robyn 116; 90 Diaghilev Ballet Exhibition (1954) 134 Dine, Jim 150, 152, 266, 268; 124, 234, 235 Donaldson, Anthony 143; 116 Donatello 209 Dorazio, Piero 170; 140 Dubuffet, Jean 50, 58, 87, 88, 90-1, 217; 65 Duchamp, Marcel 11, 27, 119, 179, 217; 3

Ecole de Paris 7, 71, 90 Environments 12, 265 ff. Ernst, Max 265 ff. Eroticism in art 12, 68, 272 Estes, Richard 251–2; 220 Estève, Maurice 71, 74; 47 Europe 51–93, 114–15, 128 ff., 193 ff., 232; see also under individual countries Euston Road School 136 Existentialism 9–10, 80, 90, 91, 194–5 Expressionism 62, 86

Fautrier, Jean 71, 74, 79, 80, 86; 49 Ferber, Herbert 212; 182 Films 55, 130, 159, 258, 263–4 Flavin, Dan 240, 246; 213 Flaxman, John 196, 198 Fontana, Lucio 122, 131; 105 Forge, Andrew 228 France 71–9, 81, 82, 83, 86, 88, 92, 122, 164, 188–90; see also Paris Francis, Sam 50; 25 Frankenthaler, Helen 50–1, 104; 77 Fried, Michael 106–7, 108 Frührunk, Günter 138 Funk art 126 Funk art 126

Gabo, Naum 179 Germany 62, 74, 75, 239; see also Bauhaus Giacometti, Alberto 193-6; 40, 161, 162 Gilbert and George 270-1, 274; 238 Goings, Ralph 251-3 González, Juan 75 González, Julio 217, 224; 188 Gorky, Arshile 28, 30-2, 224; 11 Gottlieb, Adolph 42-3; 19 Greco, Emilio 206, 207; 174 Green, Samuel Adams 159-60, 161 Greenberg, Clement 12-14, 104, 106, 200 Gris, Juan 36 Groupe de Recherche d'art visuel 189 Guggenheim, Peggy 26, 33, 81 Guston, Philip 43: 24 Guttuso, Renato 63, 208; 42

Hall, David 236; 207 Hamilton, Richard 133, 135; 109 Hanson, Duane 254-5, 256, 258; 221 Happenings 83, 130, 266 ff.; 221-3 'Hard edge' abstraction 94, 96, 99 Hartung, Hans 75, 78, 86; 51 Hauser, Erich 230; 198 Hausmann, Raoul II Held, Al 99; 72 Hepworth, Barbara 202, 210, 219; 167, 168 Herbin, Auguste 167 Heron, Patrick 51; 26 Hirschfeld-Mack, Ludwig 7 Hockney, David 138-9, 146; 113, 114 Hoffmeister, Adolph 2 Hofmann, Hans 28, 36; 16 Hopper, Edward 141 Hoyland, John 115; 87 Hundertwasser 87; 64 Hungary 164 Huxley, Paul 116

Impressionism 157 Independent Group 133, 135 Institute of Contemporary Arts 133